# Countryside
# Sketching

# Countryside Sketching

Pen & Pencil Techniques
for Drawing Covered Bridges,
Barns, Old Mills, and
Other Rustic Settings

FRANK J. LOHAN

CB
CONTEMPORARY
BOOKS
CHICAGO · NEW YORK

**Library of Congress Cataloging-in-Publication Data**

Lohan, Frank.
    Countryside sketching : pen & pencil techniques for drawing
covered bridges, barns, old mills, and other rustic settings / Frank
J. Lohan.
        p.    cm.
    Bibliography: p.
    Includes index.
    ISBN 0-8092-4519-1 : $14.94
    1. Buildings in art.    2. Country life in art.    3. Drawing—
Technique.    I. Title.
NC825.B8L64    1989
743′.94—dc19                              88-31773
                                                  CIP

Published by Contemporary Books, Inc.
180 North Michigan Avenue, Chicago, Illinois 60601
Manufactured in the United States of America
International Standard Book Number: 0-8092-4519-1

Published simultaneously in Canada by Beaverbooks, Ltd.
195 Allstate Parkway, Valleywood Business Park
Markham, Ontario L3R 4T8 Canada

To Arthur . . . seeing his
accomplishments in art and music
inspired me to strive to further develop
my drawing ability.

# Contents

# Countryside Sketching

# Introduction

My definition of countryside sketching includes natural elements, such as trees, rocks, waterfalls, streams, and mountains, along with man-made features, such as mills, old bridges, barns, farm structures and tools, castles, and abbeys. Yes, castles and abbeys also, because one chapter in this book is devoted to sketching the English countryside. Other chapters cover sketching in the American Southwest, sketching in the mountains, and sketching in rural America.

Well-done drawings of old structures such as barns, covered bridges, farmhouses and other hoary vestiges of the past are universally irresistible. You often see them reproduced on note paper, bank checks, and calendars. There is tremendous gratification in producing such drawings yourself— regardless of whether the subjects are buildings on your grandparents' farm, fading Americana that you photographed on a trip, or simply a beautiful old structure that moved you when you saw it in a book or magazine or on a trip abroad.

Natural wood and stone textures are great for pen or pencil drawing. The rough texture of these materials seems to flow from the pen and pencil. This is why old barns, covered bridges, wooden or stone structures and ruins, and other old buildings are some of my favorite drawing and painting subjects. I love sketching them for pure relaxation, and I will show you in the pages that follow how I proceed, step by step, from the composition drawing to the final sketch for different types of domestic and foreign subjects. When you see and understand how I achieve certain effects, you will be able to apply the same techniques to your own subjects.

Before you cook something from a new recipe, you must have the

1

ingredients and the utensils on hand so you can properly follow the steps of the recipe. This is similar for drawing: You must have the materials and tools (pens, ink, pencils, paper, etc.), and an adequate work space before you can properly begin. The first few chapters of this book cover these preparatory matters and describe the necessary materials. This knowledge is vital to the successful translation of what you see in your mind to an image on the blank white paper in front of you. I strongly recommend that, even if you already sketch, you at least read Chapters 1–7: *Tools and Materials; Techniques; Perspective Shortcuts; Drawing Rocks and Stone Walls; Backgrounds, Composition, and Drawing Techniques; Drawing Wood and Wooden Things; and Drawing Lakes, Streams, and Waterfalls.* Then you will better understand the terms and instructions that I use later in the book. If you have not done much prior sketching, it is essential that you understand the material and terms in these chapters if you are to properly follow the step-by-step instructions for the many demonstrations I have

included in these and later chapters.

To help you get to the hands-on sketching as soon as possible, I have included some preliminary practice exercises where appropriate in Chapters 1–7. These exercises will give you an early chance to practice using the techniques you will need in working along with the later step-by-step demonstrations of more complete compositions.

A lot of pure relaxation can be derived from sketching. Only those who have tried it understand how totally absorbed you can become. Time ceases to exist as you concentrate completely on your work without realizing that the world, for a little while anyway, is going on without your help or concern. Hours disappear, after which you find yourself completely refreshed and with a marvelous sense of accomplishment.

I hope that this book helps you achieve the same kind of personal satisfaction from your efforts that I have been enjoying for years from mine.

# 1
# Tools and Materials

*Basic Tools and Materials*
*Pens and Inks*
*Pencils*
*Erasers*
*Papers*
*Working Area*

# Basic Tools and Materials

I did all the exercises and step-by-step demonstrations in this book using pen and ink or graphite drawing pencils. The materials that beginners will need in order to follow all the instructions and demonstrations will not be expensive. For instance, the replaceable nib crowquill holder and a point for it should cost about a dollar plus some change. Five or six drawing pencils in a range of hardness including 6H, 2H, HB, 3B, and 6B should cost perhaps three dollars or less. Paper suitable for drawing with either pen or pencil is available anywhere art supplies are sold. So for well under ten dollars, you can be set up for years of sketching with both pen and pencil.

Should you really become interested in pen and ink sketching, you can upgrade to a technical pen or an artist's fountain pen, or both. Each of these implements is in the ten- to sixteen-dollar range. Again, your level of continuing interest will determine whether you invest in Bristol board or parchment paper rather than just bond or regular drawing paper. You will make these decisions based on how deeply your interest in sketching develops. You can do a lot of very credible sketching, though, with just the basic tools and materials. I will describe a full range of pens, pencils, inks, and papers in this chapter, however, since I will be making reference to them throughout the book.

# Pens and Inks

Quite a variety of pens can be used for sketching. One important factor that all suitable sketching pens have in common is the ability to produce a consistently narrow line. The best in this regard are the crowquill pen and the technical pen. These have metal points that wear well on the abrasive paper surface and that do not "mush out" and become broad from the pressure of using them hour after hour as some felt-tip or fiber-tip pens do.

*Crowquill pens*
This is a replaceable-nib pen. There are many kinds of crowquill-type points, each with a different name, such as "drawing," "Spencerian," "hawkquill," "mapping," etc. (figure 1-1.) These points are completely different from the wider ones for calligraphic pens. Points made for calligraphy, except perhaps for very narrow-pointed ones, are not really suitable for sketching. Any ink will work with crowquill pens, even the superbly black, heavily pigmented India inks that I would never put in my prized technical drawing pens because of possible clogging of the very fine ink-feed mechanism.

One of the advantages of the crowquill point is the ease of keeping it clean. You simply wipe it off with a paper towel or a tissue, dunking it in water if necessary to help remove any dried ink. A really bad case of dried ink can be fixed by soaking the point

overnight in water to which some ammonia has been added. Follow the soaking with a gentle washing in warm soapy water.

Any type of pen point will perform consistently well only when it is clean. The ink in conventional pens is fed to the paper by the very tiny slit that runs up from the point to the hole that acts as a reservoir. If any ink dries on the top or the underside of the nib, as shown in figure 1-2, the flow of ink during sketching will be erratic and unreliable. When I sketch with my crowquill pens, I subconsciously wipe the point dry with a paper towel quite frequently as I sit back to consider what I want to do next on the sketch. This wastes a surprisingly small amount of ink and ensures reliable ink flow when I need it.

I do not recommend dipping the crowquill into the narrow-mouthed bottles of ink to load it. No matter how careful you are, the rim of the bottle will pick up some ink, which then gets on the holder and subsequently on your hands, clothes and, worst of all, on your drawing. Although it appears to be an annoyance at first, I recommend that you use the eyedropper style filler that usually comes as part of the ink bottle to place one or two drops of ink on the inside curve of the point. Then wipe the outside of the point toward the tip with ink. Figure 1-3 shows what I mean. If you wipe the point clean frequently enough and keep both sides of the slit in the point wet with ink, you should have no ink flow problems as you sketch.

Be careful not to put too much ink on the crowquill. You may think more

**Figure 1-1**
**Crowquill holder and typical points.**

**Figure 1-2**
**Dried ink on crowquill points makes the ink flow unreliable.**

**Figure 1-3**
**Inking a crowquill point with the eyedropper-style filler from the bottle.**

ink will let you do more sketching between wettings, but it often lets a nice big drop of ink fall on your sketch. I know: I've done it often. It hurts to have to start over or to take a lot of time to try to save the drawing by soaking the ink up and trying to erase it when it dries. The final result is most often unsatisfactory.

If you like to use the crowquill and you want to dip the point instead of using the eyedropper to wet it (which I admit is much easier), try what some of my students thought of years ago. They poured the ink into a shot glass at the start of class. At the end of class, they poured the ink back into the bottle and washed up. This way they dipped, wiped excess ink from the nib on the side of the glass, and had no problems with ink getting on the pen holder.

Crowquill points are flexible (except for some of the very stiff ones like the hawkquill) and allow you to modulate your line width somewhat; that is to produce a varying line width as you

draw. A thicker line is produced by bearing down on the point a little bit to spread the two halves of the nib apart. Such lines are shown in figure 1-4.

*Artist's fountain pen*

The point on an artist's fountain pen (figure 1-5), resembles the crowquill point in that it is split. The ink flows from the reservoir to the paper along the slit. Having an ink reservoir, this pen does not require dipping. This is a considerable advantage, since when you want to sketch you simply take the cap off the pen and go to work. This makes sketching with ink in the field quite practical.

The artist's fountain pen, depending on the brand, is filled in one of two ways. With some models, you dip the point into the ink bottle and work a plunger mechanism by screwing the back of the pen one way and then the other way to fill it. With others, you screw the back of the body off and remove a small plastic container, which you then fill from a squeeze bottle or an eyedropper-style-ink bottle. Figure 1-6 shows a spouted ink container that is sold for this type of pen, and the way to fill the container. Some brands have pre-filled cartridges of ink that you simply load into the pen, eliminating all handling of ink.

The artist's fountain pen allows you to produce a full range of line widths by controlling the amount of pressure you use as you draw. Typical line work is shown in figure 1-7. When I do not expect to use my fountain pen for a few weeks, I usually empty it and flush it with warm soapy water.

These pens are usually available in larger art supply stores, along with ink that the manufacturer recommends for them.

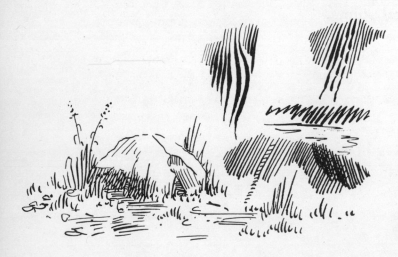

**Figure 1-4**
**Lines produced by**
**crowquill points.**

**Figure 1-5**
**An artist's fountain pen.**

**Figure 1-6**
**Filling removable ink
reservoir.**

**Figure 1-7**
**Linework from an artist's
fountain pen.**

**Figure 1-8**
**A technical drawing pen.**

*Technical drawing pens*

The technical drawing pen (figure 1-8) does not look like a fountain pen. It has a hollow tube for a point. Each point produces just one line width, which is determined by the diameter of the tube. Inside the tube is a tiny wire with a plastic weight on the end. The movement of this wire is what keeps the ink flowing through the point. A technical pen requires a shake or two every now and again to keep the ink flowing. You can usually hear the wire and the plastic weight clicking when you shake the pen.

The technical pen must be held in a more upright position than the crowquill or the fountain pen. Many people find this awkward at first, but almost all find the result worth the learning. Technical pens have replaceable points. The sizes range from 6×0, a very fine line point, to 2, 3, or 4, which make broad lines. My favorite is the 3×0. It makes a line that is 0.25 millimeter wide. I use this pen about three quarters of the time when I sketch. The extremely fine line tips, 5×0 and 6×0 can become troublesome due to clogging of the fine tubes. The 3×0 that I use works consistently well, but I clean it out if I do not plan on doing any sketching again within a week. Cleaning it takes perhaps ten minutes of shaking it under running warm water. I only use inks in it that state "For technical pens" on the box or bottle. Heavily pigmented India inks may clog the point.

There is no flexibility to the line width produced by the technical pen; each point size makes just one line

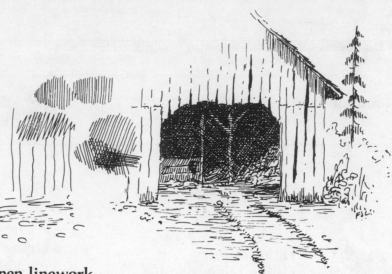

**Figure 1-9**
**3×0 technical drawing pen linework.**

width. The kind of delicate line work that my 3×0 point produces is shown in figure 1–9. Technical pens usually have a removable ink reservoir that is filled as shown in figure 1–6. These pens and the ink for them are available in larger art supply stores or drafting supply stores.

*Inks*

There are waterproof inks and non-waterproof inks. Perspiration from your hand can smear non-waterproof ink lines. Any of the inks work well with the crowquill pens because you can clean the points easily and completely. I only use inks that are made for technical pens in my technical pen because some waterproof inks contain shellac, which could really clog up the point. With crowquill pens, a waterproof India ink is the best choice.

*Felt-tip and fiber-tip pens*

Every drug and department store stationery department carries a wide variety of very fine point felt-, fiber-, or nylon-tip pens. Some of these will produce a good, consistent fine line for a while until pressure makes them

blunt. The lines gradually become wider as this happens. Still, however, it may be worth your while to experiment with these implements in your earlier efforts if you want to avoid having to wet or dip the crowquill point, or you do not want to invest in the technical or fountain pen at the outset. If these pens are relatively inexpensive, you can use one for drawing until it loses its sharpness. Relegate it then to letter or note writing and open a new one for sketching.

*Brushes*

Small, sharply pointed watercolor brushes can be used to make ink drawings also. If the brush "points up" very well, it can produce lines as fine as that of the finest pen.

# Pencils

*Hardness*

Drawing and drafting pencils are graded according to the hardness of the lead as shown in figure 1–10. The 6H has a *very* hard lead that deposits very

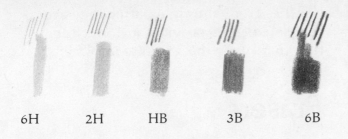

6H    2H    HB    3B    6B

**Figure 1–10**
**Range of blackness from 6H to 6B leads.**

little graphite on the paper with each stroke; this means it makes light lines. The lead gets softer as the H numbers get smaller. The usual number two writing pencil is about 2H on the scale. The HB is a nice, reasonably soft lead that puts down a fairly dark black on paper. The 6B is really soft and easily gives you as dense a black line as you will need for sketching. You should have one each of these pencils: 6H, 2H, HB, 3B, and 6B. This will allow you to draw all of the pencil exercises in this book and to do whatever sketching of your own you want to.

Pencil works a little differently on smooth paper than it does on rough paper. All pencils make a dark line on very rough, abrasive paper, because it is almost like drawing on sandpaper—a lot of graphite is deposited with each stroke. This does not happen with very smooth paper, however. The terms *rough* and *smooth* are relative. Most general-purpose drawing paper in art stores is on the rough side to take pencil well. To achieve a wide tonal range with pencil, you want a rougher paper. The smoothest of the papers work very well with ink. Experiment with different papers and see for yourself.

*Sharpening the pencils*

You do not use pen techniques when sketching with a pencil. Pens put down

a very fine line of ink with each stroke, and many strokes are required to tone an area dark. Properly sharpened pencils allow you to put down a broad line of graphite with each stroke and thereby darken an area in relatively few strokes.

Figure 1–11 shows you how properly sharpened sketching pencils look. The wood is removed with a razor blade or a sharp utility knife, leaving a cylindrical lead rather than the pointed lead a conventional pencil sharpener produces. The lead is then rubbed back and forth a few times on fine sandpaper with the pencil held in the writing position. The lead is then wiped on a piece of paper towel to

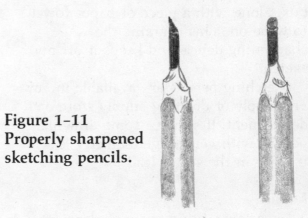

**Figure 1–11**
**Properly sharpened sketching pencils.**

remove any loose graphite. You have points then that look like those in figure 1–11. This kind of point allows you to make broad lines by using the flat part of the lead that you produced by the sandpaper. Placing a series of such broad lines next to one another lets you tone an area rather quickly, as shown in figure 1–12. The same point lets you make very fine lines by using the sharp tip as shown in figure 1–13. When this sharp edge begins to broaden out, or when the flat part of the lead gets too rounded, give it a stroke or two on the sandpaper to

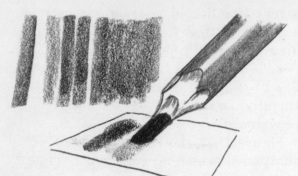

**Figure 1-12**
**Wide lines and toned area made with the flat part of the lead.**

restore it. To control the graphite mess when I am sketching with pencil, I have my small piece of sandpaper glued in the shallow cover of a small box, along with a piece of paper towel to wipe on. This contains the sharpening debris and keeps it off my sketch.

Sketching pencils are available in any art supply or drafting supply store or department. If you see some drawing pencils with very large diameter leads, try one in the softer lead.

*Fixative*

I use several thin coats of clear spray enamel to fix or protect my pencil

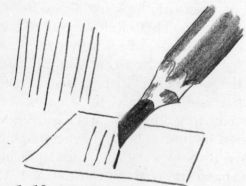

**Figure 1-13**
**Thin lines made with the sharp edge of the lead.**

sketches from smudging after they are completed. This provides a thin, clear film that keeps the graphite in place.

# Erasers

*Soft erasers*

These are usually pink, yellowish, or white and do not contain abrasive material as ink erasers do. When erasing pencil marks from your paper, you do not want to roughen up the paper, as this spoils it for either ink or pencil drawing. The soft erasers are good for removing or minimizing the lighter lines made by the harder pencils. However, they will only smudge and smear the softer leads on the paper. There is another way to handle lightening of the softer lead lines—use a kneaded eraser.

*Kneaded erasers*

Kneaded erasers are usually greenish or grayish in color and come in small rectangular cake-like pieces. You pull about one third of it off and knead it in your fingers. You can erase light pencil lines with it by the usual back-and-forth rubbing motion. You then knead the dirty part of the eraser inside, leaving a clean eraser surface to work with. You can tone down the very dark darks simply by pressing the kneaded eraser on the dark passage (no rubbing!). Then knead the dirty part inside the eraser again, and, if necessary, press it once more on the dark area. This lifts off a lot of graphite, as you see in figure 1-14. You can also shape the kneaded eraser to a sharp edge to lift off a line from a dark pencil area, as shown in figure 1-14.

The kneaded eraser is a very versatile and necessary tool when

**Figure 1–14
Areas lifted from a dark
pencil tone by shaping
and pressing a kneaded
eraser on the tone several
times.**

sketching in pencil. It lasts a
surprisingly long time even though you
knead a lot of dirty graphite into it.
Kneaded erasers are available in most
art supply stores.

*Erasing Shield*

An erasing shield is a very handy
drafting tool. It can be used to trim up
a straight edge or to clean up small
areas of excess graphite. It is shown in
figure 1–15. It is a thin sheet of
stainless steel with a number of
variously shaped cutouts. You lay it on

**Figure 1–15
Erasing shield.**

the drawing to protect the areas you do
not want to touch, and to expose the
area you want to erase. Then you erase
through the cutout that best fits the
area you want to erase. Erasing shields
are available anywhere drafting
supplies are sold.

*Paper Towel*

I use a piece of folded paper towel to
lightly brush any eraser residue from
my sketches into a wastebasket. This
minimizes or prevents smudging of my
drawings.

# Paper

Almost any kind of paper offers one
feature or another for drawing with
either pen or pencil. A slightly rough or
"toothy" paper works better than a
smooth one with pencil. Ink generally
produces smoother, unbroken lines on
a smoother paper, although I do like to
use pen on a rougher finish 140-pound
watercolor paper because of the slightly
broken line effect I get. I like this when
sketching rustic scenes such as barns.

Your best bet is to experiment with
whatever paper you come across so you
know firsthand just what happens to
ink and to pencil on different kinds of
paper. If you are just starting out,
however, plain bond writing paper will
work well with pen and with pencil.
Below are some of the kinds of paper I
will mention in the exercises and
demonstrations later in this book.

*Quadrille paper*

This is a smooth, bond paper with
light blue squares all over the sheet. It
is available in pads at all office supply
stores and some art supply stores.

I use quadrille paper for all my composition drawings. The horizontal and the vertical lines help me to keep my horizontals and verticals from tilting as I draw which they have a tendency to do on unlined paper. Once I am satisfied with the composition, which I always draw full size, I transfer it to my working paper as I will describe in Chapter 2.

### Bond typing or copier paper

This is good, inexpensive paper that takes both ink and pencil pretty well. You can get it wherever typing paper is sold. This is good paper if you're a beginning artist. You can get the bristol board or parchment paper later if you find that you have a continuing interest in sketching.

### Tracing vellum

This is a translucent paper that is frequently used in engineering offices for master technical drawings. It takes both ink and pencil very well and is a very permanent paper, being 100 percent cotton rag content. This gives it the permanence of the best watercolor papers.

Tracing vellum is available in pads at drafting and art supply stores.

I mention several uses for tracing vellum throughout the book. When backed up by a good white paper and mounted, it serves very well for final drawings. Being semitransparent, the light goes through the vellum and bounces back through it again. With regular paper, the light just bounces off the surface of the paper. This characteristic gives drawings on vellum a kind of brilliance that those on regular paper do not have. Vellum also has the advantage of allowing you to see your composition drawing when you lay the tracing vellum over it. You can start right out drawing on the vellum without the bother of first transferring the composition sketch to the paper. Being a sort of high-quality tracing paper, you can place it over photographs also and start drawing directly.

### Bristol board

This is a good, heavy, moderately smooth paper especially suited for pen and pencil work. Illustration board, a popular medium with commercial artists, is bristol board mounted on a very heavy backing. I like two-ply kid, or regular-finish bristol board. It is available in pads at art supply stores.

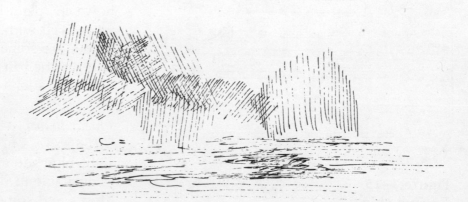

**Figure 1–16**
**Broken line effect from pen on rough paper.**

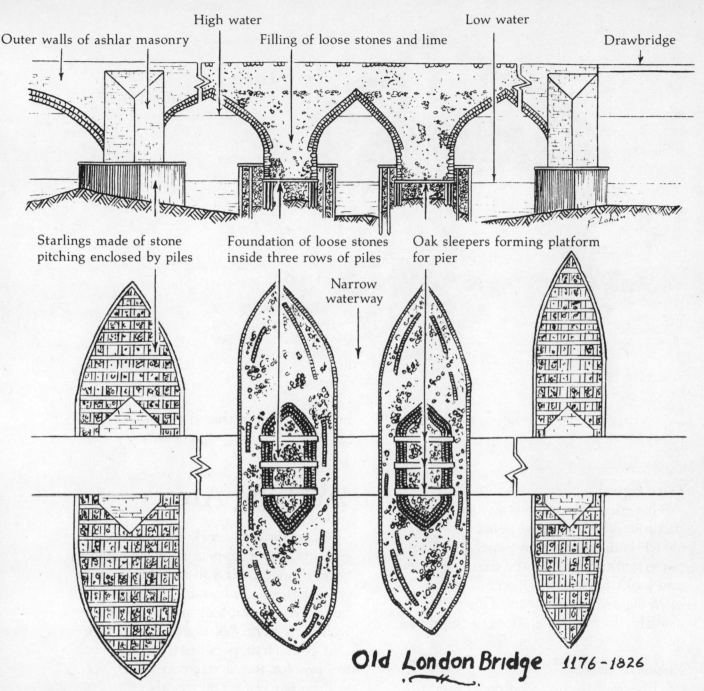

Outer walls of ashlar masonry   High water   Filling of loose stones and lime   Low water   Drawbridge

Starlings made of stone pitching enclosed by piles   Foundation of loose stones inside three rows of piles   Oak sleepers forming platform for pier

Narrow waterway

F. Lohu

*Old London Bridge 1176-1826*

**Figure 1-17**
**Detailed ink drawing on smooth paper.**

*Watercolor paper*
I do quite a bit of landscape and barn drawing on 140-pound medium-finish watercolor paper with pen and ink. On such a rough surface, the pen tends to make a sort of broken line, which I find enhances the mood of such sketches. See figure 1–16 for some idea of the broken-line effect on such watercolor paper.

Smooth or hot pressed watercolor papers have an excellent surface for pen and ink work. Such a surface is perfect for very detailed works such as those shown in figure 1–17. Art supply

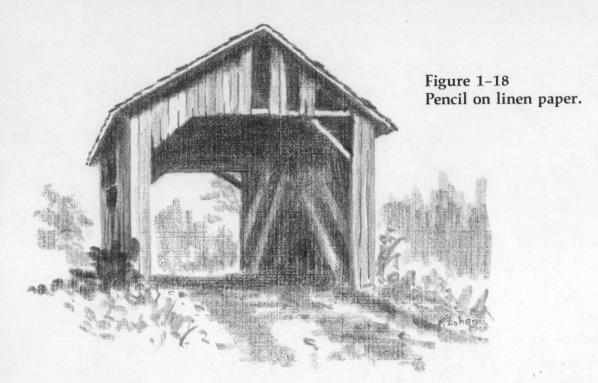

**Figure 1–18
Pencil on linen paper.**

stores carry different water color papers.

*Linen paper*

This paper is embossed with a linen pattern. When a broad-point pencil sketch is done on linen paper, the linen pattern stands out in the dark passages and looks quite attractive. For an example see figure 1–18. This paper is available in pads at stationery counters.

*Parchment paper*

This smooth-surfaced paper is a favorite with calligraphers because of the pattern and different pastel tones. It is available in art supply stores, generally in packets. Drawings of old

buildings look rather nice on the color textured parchment papers.

# Working Area

A comfortable working area is essential if you expect to do reasonably good drawings. If you cannot sit and write letters comfortably for several hours, you cannot sit and draw very well for several hours either. Be sure that your chair is neither too high nor too low for the surface on which you will be working. Light is also important. I use a 100-watt table lamp on my desk in addition to a high intensity lamp that I direct at what I am drawing.

# 2
# Techniques

*Basic Guidelines*
*Pencil Techniques*
*Pen Techniques*
*Copying, Enlarging, or Reducing*
  *Using a Grid Overlay*
*Transferring Your Drawing*

# Basic Guidelines

Whether drawing with pen or pencil, you are working with only black ink or the graphite, the white of the paper, and the gray scale that lies between them. (The use of colored ink or colored pencil are subjects beyond the scope of this book). With pen and pencil, you do not have the third dimension, as sculpture does, nor do you have color, as conventional painting does, to help visually separate the elements of your drawing. To fully utilize this somewhat limited palette, you must first learn how to create the precise tones you need. Then you must learn to interpret your subject and often distort the tones that you see so that the viewer will see what you intended to show by the drawing. These distortions are part of your legitimate artistic license to create something and to assist your viewer in interpreting your creation. One of the most frequently necessary of these distortions is that of changing tonal values.

**Figure 2–1**
**This illustrates the alternation of light and dark tones to prevent visual elements from blending into one another and losing their visual distinction.**

## Alternating the tones

Only by alternating lighter and darker tones can you provide distinction among visual elements of your drawing. Figure 2–1 demonstrates this principle with the dark shrubs silhouetted against the lighter stone and the lighter top of the little stone wall shown with darker tones both above and below it. These alternations were not accidental—I created them. The photograph I was working from showed no such distinction, as it had been taken on an overcast day. All tones in the photo were either black or darker grays. You will come to learn the great amount of intellectual creativity that is necessary to give a center of interest to an otherwise confusing or drab scene before you or in a photograph. Just how much of this creative distorting is necessary will become evident to you only through practice and by analyzing any of your unsatisfactory drawings to determine just why they did not live up to your expectations. I can give you only one general rule—leave some room for final darkening until the sketch is about finished. Only then, by examining your work at arm's length or from across the room, can you properly judge the value relationships and decide where the emphasis of further darkening is required.

With pencil drawing, you can tone down a very dark passage by pressing a kneaded eraser on it once or twice. It is virtually impossible, however, to lighten a dark ink passage. So, as you draw, make a practice of leaving your darkest areas lighter than you think they should be; when you near completion, check the tonal relationships.

# Pencil Techniques

As I stated in Chapter 1, the minimum range of sketching pencils you should have is from 6H to 6B, including the following: 6H, 2H, HB, 3B, and 6B. In addition to these, I find it helpful to also have a conventionally sharpened (pointed lead) HB, or a mechanical pencil with 0.5 millimeter (very small diameter) HB lead. I use these to sharpen up some of the dark edges that I create using the broad-point pencils. I mention when I do this in the various lessons and demonstrations throughout the book.

## Sharpening the edges of dark passages

Figure 2–2 shows you what I mean about sharpening up the edges of dark passages. In figure 2–2A, I have just filled in the dark areas with a broad-point 6B pencil. These darks did not run tightly up to the lines on my guide drawing, as I did not want to get the dark 6B lead on the places that I wanted to be very light. I used my pointed, conventionally sharpened (in a pencil sharpener) HB pencil, and my mechanical pencil with 0.5 millimeter HB leads to bring the dark areas right up to the construction lines in figure 2–2B. See how sharp and crisp this makes the drawing? This sharpness is necessary if every element of your final sketch is to stand distinctly visible and give the feeling of dimension to your drawing.

The post shown deep inside of the barn was toned with my HB broad-point pencil. I made it dark, but not so dark that it disappeared, in figure 2–3.

## Working drawings

Whenever I draw, I first make a

**Figure 2–2**
**(A) The initial darkening of the black areas with the broad-point soft pencil leaves the edges somewhat indistinct.**

**(B) After filling in the edges of the dark areas with a sharp, soft pencil, the boards all become more distinct.**

composition drawing on quadrille paper. I do my adjusting and erasing on this drawing to get perspective and relationships right. Then I transfer the correct elements to the paper on which I will do the final drawing. Transferring of drawings is covered later in this chapter.

This procedure saves my final paper from a lot of abuse from erasing. If the fibers of your paper are roughened up from erasing, neither ink nor pencil will take uniformly. The ink will feather out and the pencil marks are caused to be darker in roughened areas than in the unerased areas.

The drawing that I transfer shows up as barely visible pencil lines. If I tried to use such working drawings in the illustrations in this book, the lines

would not print and you would not be able to see what I was describing. For this reason, I have made the working drawing lines in many of the illustrations in the book very dark so you can see them. *Your* working drawing should be barely visible to you. Then you do not have to worry about erasing anything on your final pencil drawings. Figure 2–2A is an example of this; *do not make your lines this dark.* If I have to do any drawing on my final paper, I use a 6H (very hard, therefore very light) pencil and I do not press much on the paper.

*Showing shades and shadows*
The study of part of a barn with a shed attached shown in figure 2–3 gives you an idea of the sometimes

subtle changes of tone that are necessary to create dimension and to suggest textures, shades, and shadows in your drawings.

I planned for the sun to be shining from the upper right in this sketch, so that the front face of the barn and the horizontal boards of the shed would be in full sunlight. I have already described how I did the darks and then sharpened their edges up. Next, I will describe how I drew the area where the shed connects to the barn.

Figure 2–4B shows how I proceeded by first using a broad-point HB pencil, lightly, to tone the two surfaces that are in shadow. Next, as in 2–4C (1) and (2), I darkened the tops of these areas where they are shaded by the overhang of the shed roof, and do not get much reflected light. Then, as in figure 2–4D (1), I used a broad-point 2H to lightly tone the one board that, although in shadow, is facing the sunlight and getting some reflected light from the ground. Note that this surface should not be toned as dark as the two adjacent surfaces. If it does not stand out, the two adjacent surfaces have to be darkened a little to make it distinct, or the kneaded eraser must be used on the surface you want lighter. If you do use the kneaded eraser in such cases, you will want to use it with an erasing shield so as not to lighten the surrounding dark tones. Figure 2–4D (2) shows where I used the broad-point 2H to put a little shadow on the lintel above the doorway where part of it would be in the shadow of the main part of the barn. A few touches on the vertical boards, first toned in figure 2–4, this time with the HB mechanical pencil brought the visual relationships to where I wanted them.

*Showing the wood texture*

In figure 2–5, I added a few indications of the actual grain pattern in the wood on the front, or sunny, side of the barn. This graining was done after I first toned these boards a

**Figure 2–3**
**A pencil study of part of a barn showing the use of subtle toning and sharpening of the edges of the dark areas.**

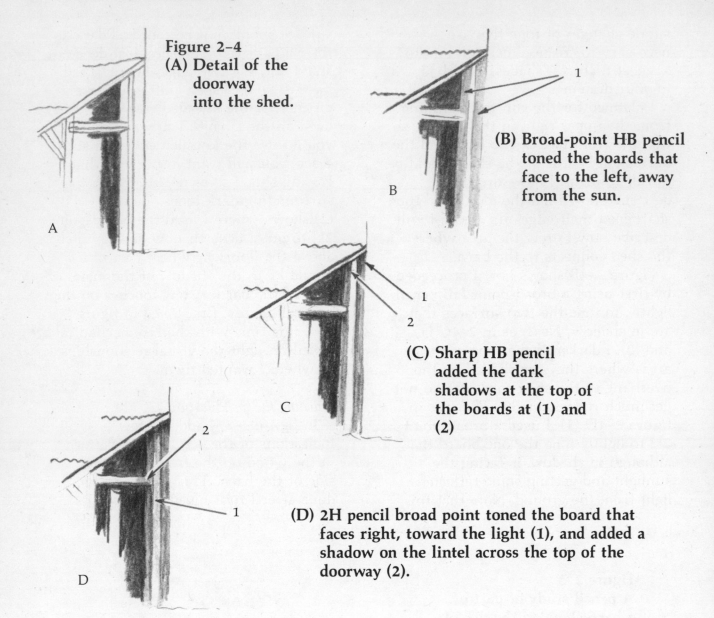

Figure 2–4
(A) Detail of the doorway into the shed.

(B) Broad-point HB pencil toned the boards that face to the left, away from the sun.

(C) Sharp HB pencil added the dark shadows at the top of the boards at (1) and (2)

(D) 2H pencil broad point toned the board that faces right, toward the light (1), and added a shadow on the lintel across the top of the doorway (2).

little, and very lightly, with my broad-point 2H pencil as shown in figure 2–5A (1). When you do this kind of toning, try to make each board a little different in tone than its neighbors. This will help to get across the separateness of these boards.

The idea of separate boards is further enhanced by showing some of the spaces between the boards as I did in figure 2–5B (2) with my sharp HB pencil point. I used this same point to put the little shadows in from the roof

overhang and from the overlapping upper boards as in Figure 2–5B (1) and (3).

The final step was the addition of wood grain on individual boards with my sharp HB pencil. When you do this, do not grain every board; instead, try to do some at random. Perhaps two together, then skip one and do one. Then skip two or three and do another one. Sprinkling some wood grain around like this will get the idea across without creating a monotonous pattern.

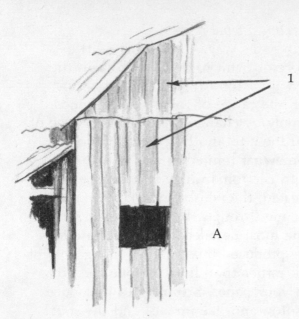

**Figure 2-5**
**(A) Broad-point 2H pencil**
**used to tone the boards lightly (1).**

Also, make the grain pattern a little different on each board. Look at figure 2-3 to see how I changed the grain on the different boards.

*Showing the corrugated roof*
    The visual signals that spell out the corrugated roof are simply the repeating curves in the ends of the corrugated sheets, and the lines running the length of the sheets representing the corrugations. The way I indicated these features is shown in figure 2-6.
    First I lightly toned part of the roof—the part that was in the shade. I did this, as you see in figure 2-6A (1), using my broad-point 2H pencil. Then, as you see in figure 2-6B, I emphasized

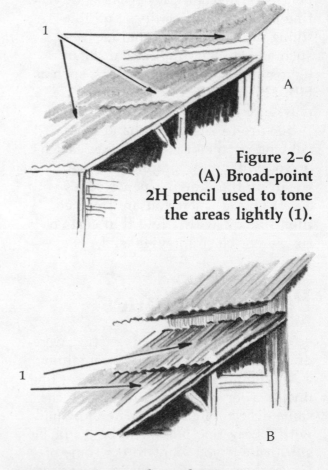

**Figure 2-6**
**(A) Broad-point**
**2H pencil used to tone**
**the areas lightly (1).**

**(B) Sharp HB pencil used to:**
**(1) Place shadow under the**
     **roof overhang.**
**(2) Emphasize some of the spaces**
     **between the boards.**
**(3) Indicate shadow where the upper**
     **boards overlap the lower ones.**
**(4) With sharp HB lightly indicate some**
     **wood grain.**

**(B) Sharp HB pencil emphasizes**
**the corrugations.**

the corrugation pattern at the ends of
the sheets with the sharp HB pencil
and added a few lines, using the same
pencil, running the length of the sheets
to suggest the corrugations.

*Showing the ground*

The ground in this sketch (figure 2-
3) was simply done with a few
horizontal marks using my sharp HB
pencil, or the sharp tip of my broad-
point HB pencil and with a few vertical
grass marks and some dots and tiny
circles to suggest pebbles.

*Summary*

In summary then, use your broad
points to lay down larger areas of tone
and use the sharp tips of the broad
points, or separate sharp pointed
pencils or mechanical pencils with very
fine leads, to do fine lines and fine
filling in of tones. The harder leads,
such as 6H, 4H, and 2H put down a
lighter mark; the softer points, such as
HB, 3B, and 6B put down darker
marks.

Be sure to keep your hand from
rubbing on the drawing as you sketch,
or you will smear graphite all over.
Clean up the drawing paper edges with
a soft eraser when you are finished,
then spray it with a few thin coats of
fixative or clear spray enamel.

# Pen Techniques

The illustrations in this section were
drawn with a technical pen containing
a 3×0 point. This point produces a fine
line; heavier points will not create the
same delicate line work. The crowquill
with a very fine point will be a suitable
substitute if you want to try some of
these illustrations as practice exercises.

*Creating a tonal range*

In some ways, the pen is a little
more difficult to draw with than the
pencil is. You can produce an almost
infinite range of tones with a pencil
simply by changing from one degree of
hardness to another. I find the pen
somewhat limited in this regard. Still,
with the tonal range that can be
created, the pen has worked very well
for me through thousands of drawings.
The most detailed of pen techniques
are produced by *stippling*—using dots of
ink rather than lines to tone the areas
on your paper. Stippling can produce
photograph-like images and the most
subtle of shading differences. It is a
somewhat laborious technique,
however, since you put down so little
ink with each dot. When you see good
stipple work, you realize that the labor
involved can be worth the effort.

Figure 2-7 shows tone ranges created
by ink lines (2-7 A and B), as well as
tones created by stipple (2-7 C). To
make lighter areas, you must space the
tone lines, or dots, further apart; to
make darker areas, you must pile lines
on top of lines (*crosshatching*), or pile
dots on top of dots, until you are
satisfied with the degree of darkness
(figure 2-8). Remember that you can
always make it a little darker if at the
end you see that it needs darkening;
however, you cannot lighten an ink
passage easily, if at all. So hold back a
little on the darks until your arm's-
length appraisal near the end of your
sketch.

To be effective, crosshatching must
be done with reasonably uniform and
evenly spaced lines. Figure 2-9 A and B
show the result of nonuniform line
spacing in hatching and crosshatching.
One of your early aims in using the
pen should be to be able to produce

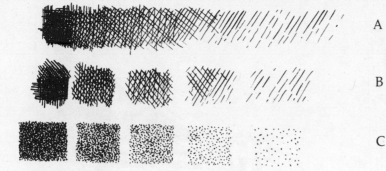

A

B

C

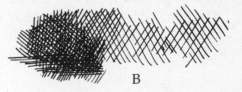

**Figure 2–7**
**Hatching, crosshatching,**
**and stippling to create**
**tones with pen and ink**

**Figure 2–8**
**Hatching and**
**crosshatching with closely**
**spaced lines creates a**
**darker tone than when**
**widely spaced lines are**
**used.**

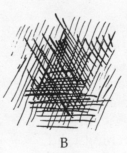

A

Hatching

B

Crosshatching

A

Improper hatching

B

Improper crosshatching

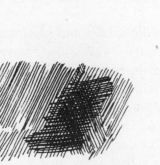

C

Proper uniform hatching and
crosshatching

**Figure 2–9**
**When you hatch and**
**crosshatch to create a**
**toned area, it is essential**
**that your line spacing be**
**uniform. Compare A, B,**
**and C.**

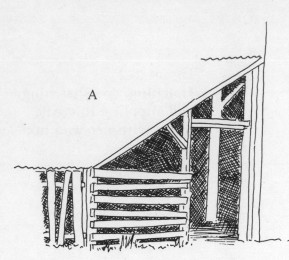
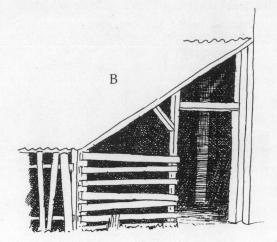

**Figure 2-10**
**The first two layers of crosshatching the dark are shown in (A).**
**The final crosshatching, four layers in all, brought tightly up**
**against the lighter features is shown in (B).**

uniform work as shown in figure
2-9C. Make this a frequent practice
exercise until you are quite comfortable
in reproducing it well.

*Sharpening the edges of dark passages*

As with the pencil illustration of this
shed connected to a barn, an ink
rendition requires that the dark areas
be sharply brought up to the edges of
surrounding features. Figure 2-10A
shows the initial layer of hatching I did
on the dark interior of the shed and
barn. This first layer often does not fill
in right to the edges of the dark areas,
so when you add the second and
succeeding layers, be sure to get rid of
those little slivers of white that do not
belong there at the edges of the dark
areas. Figure 2-10B shows this
properly done.

A completed pen and ink study of
the shed and barn is shown in figure
2-11. This is the same subject as
rendered in pencil in figure 2-3 so that
you may see the differences in
approach between pen and pencil.

*Working drawings*

I always make composition drawings
first, generally on quadrille paper so
that my verticals and horizontals do
not drift off at slight angles. I do all
my erasing on the composition
drawing, then transfer what I need
from it to my final paper. Transferring
is covered later in this chapter. This
procedure saves my final paper from a
lot of abusive erasing, since when the
paper fibers are disturbed, the ink does
not take uniformly. Feathered ink lines
can spoil an otherwise good sketch.

*Showing shades and shadows*

Figure 2-12 shows how I continued
after doing the dark areas to show the
shaded and sunlit parts of the shed
doorway. I used somewhat widely
spaced ink lines to lightly tone the sides
and underparts of those posts and
beams that were not in the sunlight.
This is shown in figure 2-12A (1), (2),
and (3). This same illustration shows
how I used only vertical lines to show
the shaded side of the barn.

To make sure that the front of the vertical post at the right side of the doorway opening kept its distinction after it was toned slightly, I lightly crosshatched the shaded side of the barn to make it darker still and thereby let the post show lighter. This added crosshatching is shown in figure 2–12B (1). This same figure also shows, at 2–12B (2), how I darkened the undersides of the corrugated roof to be sure that the idea of corrugations came across.

*Showing the wood texture*

Just as I showed a little of the actual wood texture in the pencil version of this study, I also did in this ink version. It is here that you will see, if you try to draw both pencil and pen versions, how it is somewhat more difficult to delicately tone in ink than it is in pencil. Figure 2–13 shows the sunny side of the barn and the steps I followed in completing it. Figure 2–13A shows the wood grain I put on some of the boards. When you do this, remember to only do it to some of the boards, and do it in a random manner.

A little will suggest to the viewer that all the boards are textured. Note in figure 2–13A(2) that I did no toning at all as yet on the first board in the sunlight. If I had put one or two strokes too many on this board I would have immediately lost the appearance of the corner of the barn. The front would have tonally blended right in with the darker side. For this reason, I left this board until last and just put a few of the lightest strokes I could make on it.

The final step on this side of the barn was to very lightly tone the ungrained boards with the fewest strokes, as in figure 2–13B (1), and then to indicate the shadows cast by the roof overhang and by the overlapping boards at the top half of the barn. This was done using closely spaced hatchmarks as shown in figure 2–13B (2).

**Figure 2–11**
**A pen and ink study of the same subject rendered with pencil in figure 2–3.**

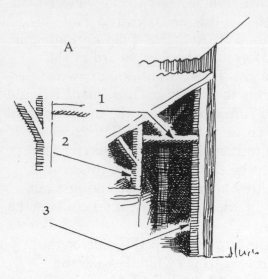

A

1

2

3

Figure 2–12
This shows how the
shading is put in around
the doorway to the shed
after the interior darks
are completed (A), and
how the right side
support post is finished
(B).

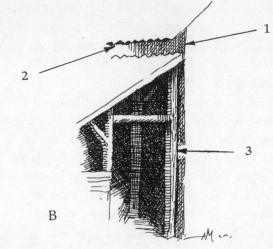

1

2

3

B

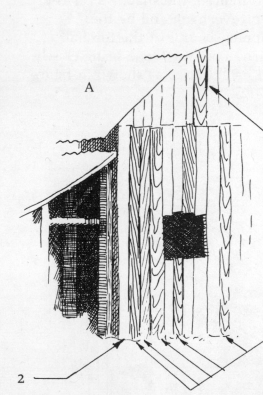

A

1

2

Figure 2–13
This is how the sunny
side of the barn is
finished with a few of the
boards grained (A) and
the little shadows added
(B).

2

1

B

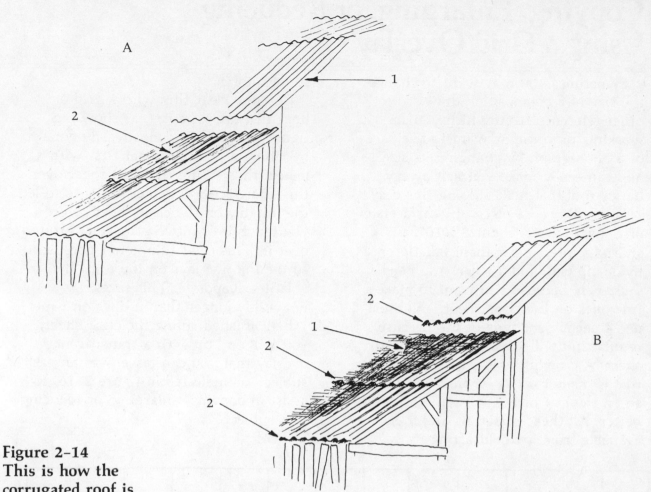

**Figure 2–14
This is how the
corrugated roof is
completed.**

*Completing the corrugated roof*

The corrugated roof was completed
as shown in figure 2–14A and B. First I
put in lengthwise lines representing the
corrugations, A(1); then I shaded the
part of the roof that was not getting
any direct sunlight, A(2). To deepen the
contrast between these shaded
corrugations and those in the sunlight,
I crosshatched with horizontal lines
B(1). Then I emphasized the dark
undersides of the corrugations to be
sure that this feature became evident to
the viewer, B(2).

*Summary*

In summary, be sure to leave your
darks a little underdone as you go
along on your ink sketch. You will be
better able to appraise their value near
the end of the sketch when most of the
surrounding tone is on the paper. If
the darks need to be darker, then you
can add it easily. If they are too dark,
well, there is not much that can be
done without risking the drawing.
Erasing ink is tough. Also, when you
have lights next to darks, do not be too
quick to put tone in those light areas.
Just as I let the one board on the barn
go until last, so you should be wary of
toning light areas until near the end of
your sketch.

# Copying, Enlarging, or Reducing Using a Grid Overlay

Sometimes you may want to change the size of a composition drawing or other reference from which you are working, or you may want to use part of a photograph by changing its size. You can easily make yourself a very handy tool that makes doing this easy.

You will need a piece of clear acetate or a mylar sheet, about 8"×10", a sharp, pointed, permanent felt-tip or nylon-tip pen, and a ruler. You need a *sharp* pen, because you want to make fine lines on the clear sheet. You must use a permanent type of ink because regular ink will not mark on the clear sheet. A crowquill pen and India ink that is made for use on film (it will say so on the box or bottle) will work even better. All these materials and tools are available from art or drafting supply stores.

Rule the clear film with a grid of lines that are ½" apart, as shown in figure 2–15. This is most easily done by ruling a piece of paper first with a pencil, then laying the clear sheet over this and tracing the lines. Be sure to let the ink dry on the clear sheet before you touch it or move your ruler around over it. This clear film is not porous, so the ink just lays on top until the volatiles evaporate. This takes noticeably longer than it does on paper. When finished ruling the clear sheet, you will end up with a transparent overlay that you can place over any flat subject, as indicated in figure 2–16, to assist in copying, enlarging, or reducing that subject.

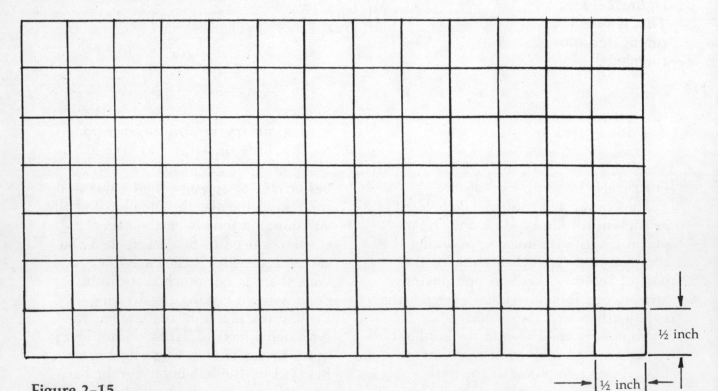

½ inch

½ inch

Figure 2–15
Rule your clear acetate or mylar overlay this way.

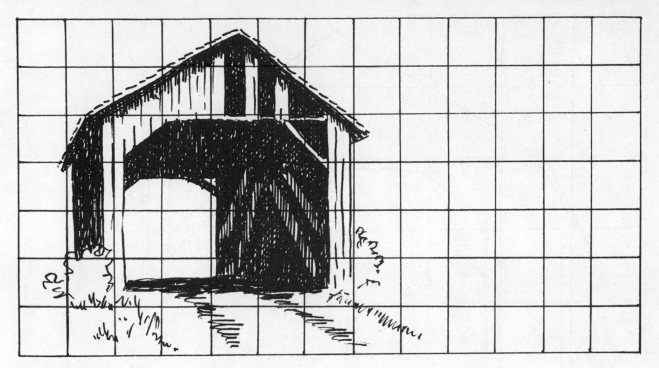

**Figure 2-16**
**Transparent overlay with ruled grid placed over another sketch.**

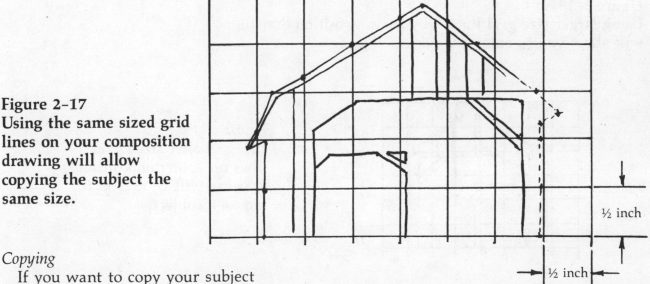

**Figure 2-17**
**Using the same sized grid lines on your composition drawing will allow copying the subject the same size.**

½ inch

½ inch

*Copying*

If you want to copy your subject with no change in size, lightly rule lines on your composition paper that are the same size as those on the transparent overlay, that is, ½" on each side. The drawing you make on this composition sheet by using all the squares and intersections as visual guides will be the same size as what you are copying, as shown in figure 2-17.

*Enlarging or reducing the size of the subject*

If you want to enlarge the subject, draw the squares on your composition paper larger than those of the overlay. For instance, if you use squares that are ¾" on a side, as in figure 2-18,

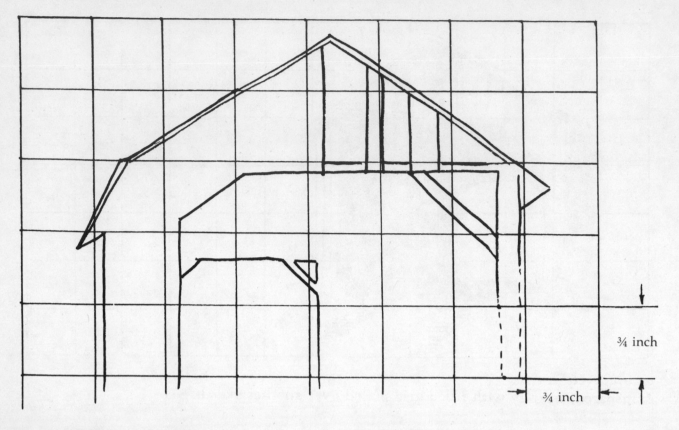

¾ inch

¾ inch

**Figure 2–18**
**Using larger size grid lines on your composition drawing**
**will allow you to enlarge a subject.**

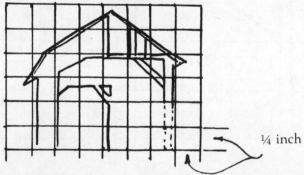

¼ inch

**Figure 2–19**
**Using smaller sized grid**
**lines on your composition**
**drawing will allow you to**
**reduce a subject.**

your resulting sketch will be larger than the original. A 5″ × 7″ subject will turn out 7½″ × 10½″.

If the squares on your composition paper are made smaller than those on the overlay, your drawing will be smaller than the original. This is shown in figure 2–19 where the squares are drawn ¼″ on a side. A 5″ × 7″ original will be drawn 2½″ × 3½″ in size.

# Transferring Your Drawing

Once your composition drawing is complete, you want to transfer it to the paper on which you will be doing the final drawing. *Do not use carbon paper.* You want lines that will be easily erased if necessary if you are going to do a pen drawing, or lines that will be light and barely noticed in a final pencil sketch. Carbon paper does not meet either of these needs. You can make your own carbon paper in effect if you take a broad-point HB pencil and darken the back of your composition drawing as shown in figure 2–20. Then lay this blackened composition drawing, blackened side down on your final paper, and with a sharp 2H pencil trace over those lines on the composition that you want as guidelines on the final paper. This will leave you with a light, easily seen and easily erased drawing, as shown in figure 2–21, that you may now complete either with ink or with pencil.

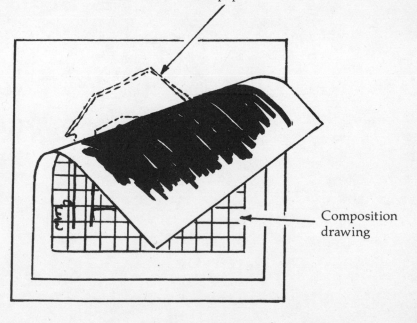

**Figure 2–20**
**Blacken the back of your composition drawing in preparation for transferring it to your final paper.**

Back is blackened with an HB pencil

Lightly transferred drawing on final paper

**Figure 2–21**
**By drawing over the composition drawing lines, you transfer a light copy to your final paper.**

Composition drawing

# 3
# Perspective Shortcuts

*About Perspective*
*The Horizon*
*One-Point Perspective*
*Two-Point Perspective*
*Adjusting the Vanishing Points*

# About Perspective

Most of us know that the part of a barn, covered bridge, or other object that is farther from our eyes appears smaller than the part closer to our eyes. This difference in apparent size is called *spatial perspective*.

Architects use different views of buildings and make some projections on their drafting boards to construct drawings that are perspectively correct.

That is, they "look right" because the amount that the back is made smaller than the front is correct. For general casual sketching, however, these techniques are far more complicated than you need. There are quicker ways to estimate the perspective closely enough to do the job well and allow you to produce drawings that look "right" to everyone.

**Figure 3–1**
**An artist looking into a covered bridge.**

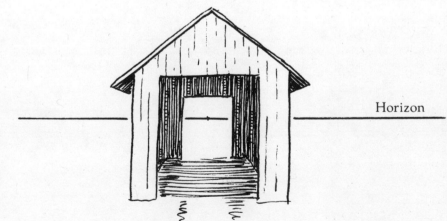

Horizon

**Figure 3–2**
**What the artist sees.**

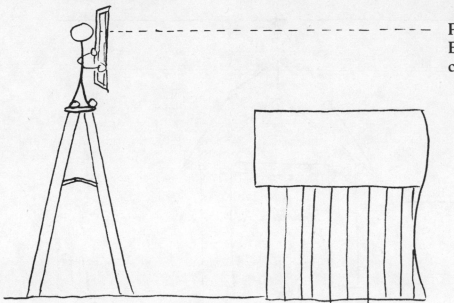

**Figure 3–3
Eye level is above the
covered bridge.**

**Figure 3–4
What the artist sees from
the high point of view.**

Horizon

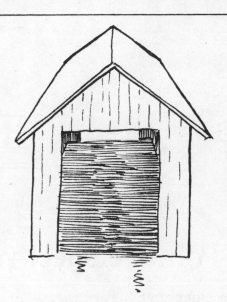

# The Horizon

All drawing must be in reference to the horizon. The location of the horizon, even if it is not visible in your work, is the key to getting all perspective elements of your art work "looking right."

There is just one primary rule to remember: *the horizon is always at eye level*, except when you are looking straight down or straight up; but these are rare viewpoints for a drawing or painting. Consider the little stick figure artist in figure 3–1 who is standing in the middle of a country road looking at a covered bridge. The artist is holding up a picture frame that contains only a piece of glass. If the artist closes one eye and draws the bridge outline on the glass, just as he or she sees it, the result will look something like figure 3–2. The horizon, which is at eye level, is also shown in this figure.

Now let's have the artist climb on a ladder so that eye level is above the top of the covered bridge, as in figure 3–3. If that view were drawn on the glass in

the frame, it would look like figure 3–4. Since the artist is up high and the horizon is at eye level, the horizon appears above the entire bridge. The location of the bridge below the horizon is what gives the viewer the impression of a high point of view. Notice, however, in figure 3–5 that in both cases, the view from road level and the view from above the bridge roof, all the receding horizontal lines converge at one point, and *that point is on the horizon.*

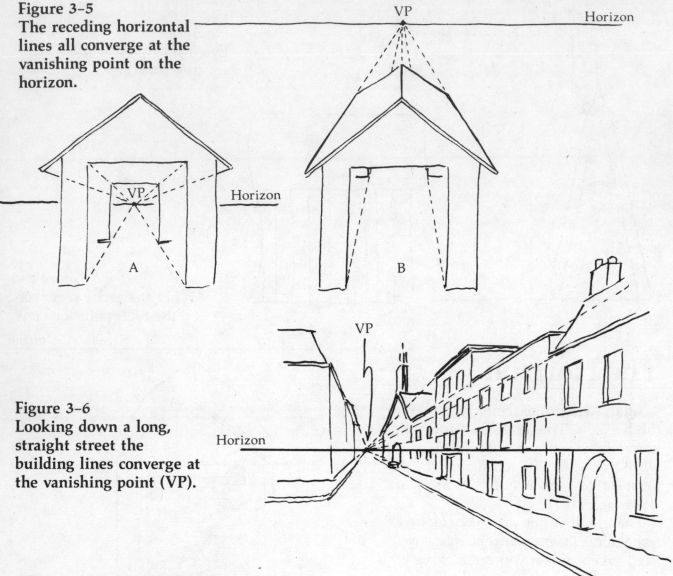

**Figure 3-5**
**The receding horizontal lines all converge at the vanishing point on the horizon.**

**Figure 3-6**
**Looking down a long, straight street the building lines converge at the vanishing point (VP).**

# One-Point Perspective

The preceding drawings of the covered bridge demonstrate simple one-point perspective. All horizontal lines that recede from the viewer converge at a point, the *vanishing point*, on the horizon. Horizontal lines that pass across in front of the viewer, however, appear to be parallel to the horizon. This is illustrated in the two sketches in figure 3-5. If you stand in the middle of railroad tracks on level ground, the tracks will also appear to converge at a point in the distance. So will the receding roof and window lines of buildings on a long street, as shown in figure 3-6.

Knowing this basic principle of one-point perspective will often allow you to quickly and correctly sketch a simple composition. However, you seldom view buildings and scenes head-on where one-point perspective is the only principle that applies. More often, you will have what is called a three-quarter view, in which both visible sides of a structure recede. In these cases, two-point perspective comes into play.

# Two-Point Perspective

Let's continue with the example of the covered bridge and this time have the artist move off the road to his or her right and look at the bridge through the glass. The artist will see something like the view in figure 3–7. From the top of the ladder, the view would look like the one in figure 3–8. In both cases, the primary horizontal lines converge to two vanishing points, both of which lie on the horizon. The VPL (left vanishing point), however, is located off the page to the left, while the VPR (right vanishing point) remains on the paper, close to the

sketch. This illustrates *two-point perspective*.

You can quickly set up a three-quarter view of a structure with pleasing perspective by making yourself a setup like that shown in figure 3–9. All this is to allow you to draw a long horizon line that extends beyond the edges of your composition drawing. I do this by placing some newspaper on a flat table and lightly taping my composition paper to it. Placing a yardstick across the paper, I draw a long horizon line. On this horizon I place a dot about an inch to

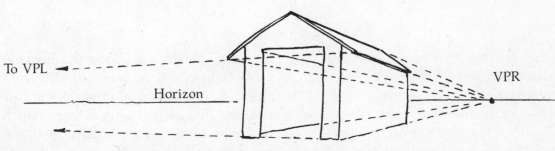

**Figure 3–7**
**The artist's view from off to the right of the bridge.**

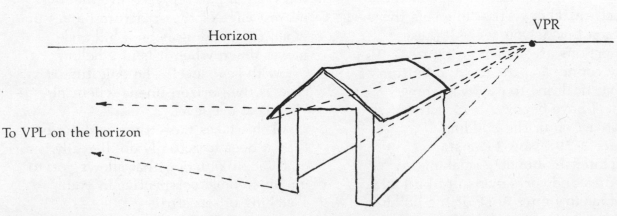

**Figure 3–8**
**The artist's view from the right and above the bridge.**

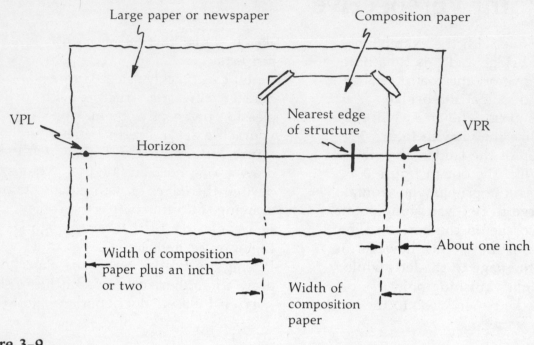

**Figure 3-9**
**The setup to establish vanishing points off the composition paper.**

the right of the right-hand edge of my composition paper. This is the VPR. Then I place another dot on the newspaper, about the composition paper's width, plus an inch or two, to the left of the lefthand edge of the composition paper. This is the VPL. Now toward the right side of my composition paper I draw a vertical line representing the nearest edge of the structure. This vertical line cuts the horizon line as you see. All these proportions are shown on figure 3-9.

By connecting the top and bottom of the vertical line to each vanishing point, I have begun a perspective construction of the building (figure 3-10). Now I can start sketching the building, making my erasures and corrections until it looks right, as in figure 3-11. If the building is above my eye level, such as on a hill,

it will all be drawn above the horizon as in figure 3-12A, but will still use the same vanishing points on the same horizon line as in the eye-level sketch. If the building is in a hollow, below my eye level, all of the drawing will be below the horizon line, but will still use the very same vanishing points and horizon line (figure 3-12B). Note that the vertical line representing the nearest edge of the structure moves up when the building is on a hill and moves down when it is in a hollow below the eye level. The only time it crosses the horizon line is when the view is at eye level.

All this takes more time to describe than it does to actually do. It really is a quick approximation that allows you to obtain credible perspective in your sketching of structures.

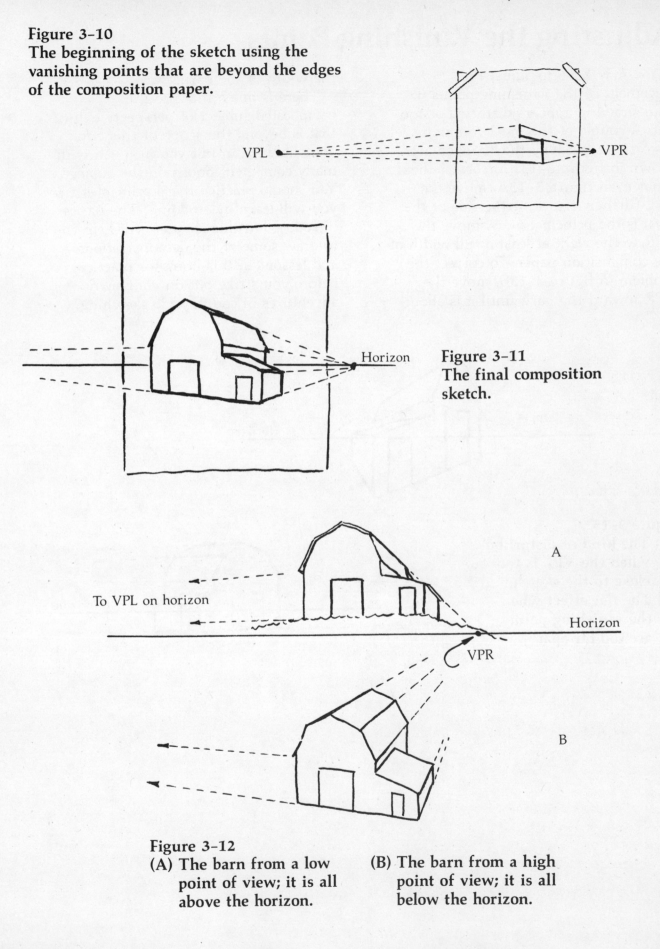

**Figure 3-10**
**The beginning of the sketch using the vanishing points that are beyond the edges of the composition paper.**

VPL

VPR

Horizon

**Figure 3-11**
**The final composition sketch.**

A

To VPL on horizon

Horizon

VPR

B

**Figure 3-12**
**(A) The barn from a low point of view; it is all above the horizon.**

**(B) The barn from a high point of view; it is all below the horizon.**

# Adjusting the Vanishing Points

You may have to adjust the placement of the vanishing points if your drawing appears distorted or too flat. A couple of the most common distortions and why they happen are shown in figure 3-13. To correct the problem in figure 3-13A, move the VPL further left; or, if the side of the barn is the principal view, move the VPR to the right at least a full width of the composition paper. To correct the problem in figure 3-13B, move the VPR toward the barn until it is about the width of the barn away.

There is much more to the complicated subject of perspective, but that is beyond the scope of this book. Your library can put you in touch with many competent books on the subject. You should practice these principles and you will learn by so doing. The basics introduced in this chapter will help you to draw some of the demonstrations and lessons in this book for practice before you strike out on your own adventures in countryside sketching.

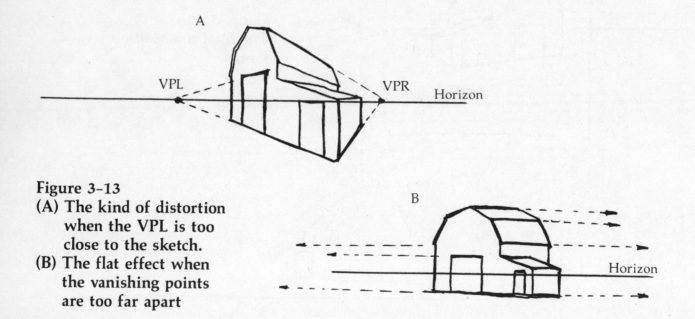

**Figure 3-13**
**(A) The kind of distortion when the VPL is too close to the sketch.**
**(B) The flat effect when the vanishing points are too far apart**

# 4
# Backgrounds, Composition, and Drawing Techniques

*Background and Middle Ground*
*Pairing Subjects with Backgrounds*
*Creating a Center of Interest*
*When to Stop Drawing*
*Different Techniques: Practice Exercises*

# Background and Middle Ground

*Types of backgrounds*

Backgrounds for countryside sketching will almost always contain trees or distant hills. There are many ways to represent such features with the pen and the pencil; there are no "right" or "wrong" ways to do this. Even though we are dealing with strictly black, white, and gray tones, you can use many different techniques to create plain or textured patterns to represent things in the distance. In some cases, you will want to eliminate any background and just present your subject as a vignette against the stark white of the paper. This can be quite effective; later in this book I will show you several examples of material presented in this manner. The next step toward drawing a specific background is to just show the top of the tree line or hill line with a light solid or broken line (figure 4–1). In this case, there is no attempt to indicate the lights and darks of the foliage masses or more distant hills. A related way of showing background, which might be trees or distant hills, is to present a solid tone indicating that *something* is there. This can be a light, medium, or dark tone depending on the needs of your particular sketch. Ways to address this question will be presented throughout the book in terms of the particular objectives of different demonstration sketches. Figures 4–2, 4–3, and 4–4 show such monotone backgrounds.

Figure 4–2 was drawn using a medium- to heavy-point pen, closely spacing the vertical lines of the background hills to create a *dark* tone. Such a dark background often works well when you can show your subject

as white or mostly white superimposed on the background.

Figures 4–3 and 4–4 are almost identical. They show a monotone background in a *medium* tone. This was accomplished by spacing the vertical lines a little farther apart than in the previous illustration. Figure 4–3 was done using the same medium point as the previous figure, while for figure 4–4 a fine point was used. The difference between these points is best seen in the little bit of roadway and grass that is presented below the hills. For distant vistas, a medium point is often too coarse and is not capable of the delicacy required for credible presentation of distance. You will see later in this chapter how both the fine and the medium points can do beautiful work when the scene goes no farther than the middle ground. One point is not any more correct than the other; one is just more appropriate than the other under certain circumstances.

Monotone backgrounds may be appropriate for showing distant backgrounds in which you need a bit of tone to indicate the presence of something, but you want all attention focused on the primary subject. However, for sketches that are limited to showing nothing farther than the middle ground, such background representation gets very boring. The viewer often expects to see more detail, or at least an indication that more detail exists, or becomes confused about the spatial relationships in the drawing. Showing middle-ground detail such as this requires that you model the tree texture to suggest the detail by drawing modulated lights and darks

**Figure 4–1
The minimum
representation of
background trees**

**Figure 4–2
A dark representation of
background trees using a
medium-point pen.**

**Figure 4–3
A monotone background
with no attempt to model
any texture. This was
done with a medium-
point pen.**

**Figure 4–4
The same drawing as the
previous figure but done
with a fine-point pen—a
3×0 technical pen.**

**Figure 4–5**
**Hatching piled on top of hatching, all in the same direction to create the impression of foliage masses.**

**Figure 4–6**
**Horizontal monotone gives the impression of trees in the haze or mist.**

**Figure 4–7**
**Hatching piled on top of hatching, all in the same direction used to show individual background trees.**

and let the viewer mentally supply the rest.

*Not-too-distant middle ground*

Figure 4–5 indicates one way of bringing the background forward by suggesting some detail in the foliage. Now, at a glance the viewer can see that the background tone does not

represent mountains in the distance, but rather that it shows trees that are not too distant. Here there is a little indication of the darker parts of the foliage masses and of the tree trunks and branches. Just the slightest bit will give the viewer the idea and allow him or her to get on with looking at and interpreting the rest of your sketch.

This is one of my favorite ways of showing background trees; you will see it quite a few times in this book.

If the trees are near but you want a hazy impression, you should not show any detail. Figure 4–6 shows one way of doing this. The detail here is contained just in the shape of the trees and the trunks. They are shown in a light, monotone silhouette but at a scale that implies they are close by. Vertical lines would work as well in this instance, the idea being to eliminate the explicit representation of leaf masses and branches by using only a flat tone.

Figure 4–7 shows a way to represent individual trees as well as a shrub line in the middle distance. This approach can be very pleasing and can provide a really good representation of specific scenes. You must remember in such cases that the type of tree being drawn can be quite important to the realistic impression the sketch will evoke. Figure 4–7 shows some types of pine trees you might find in the pine barrens of New Jersey or Georgia, or other places where low pine trees abound. If a scene is set in the midwestern United States, elm or oak trees might be in the sketch instead. The precise silhouette used for this kind of tree representation should be plausible for the locale. Figure 4–8 shows typical silhouettes of other types of trees; 4–8A shows the umbrella shape of the American elm; 4–8B shows the loose, drooping shape of the weeping willow. The black willow, shown in 4–8C, has a very distinctive trunk structure; a number of trunks fan out from one place in the ground. Figure 4–8D shows the squared shape often characteristic of the black and red oak trees. A good tree identification book will show you the shapes of many more kinds of trees and will

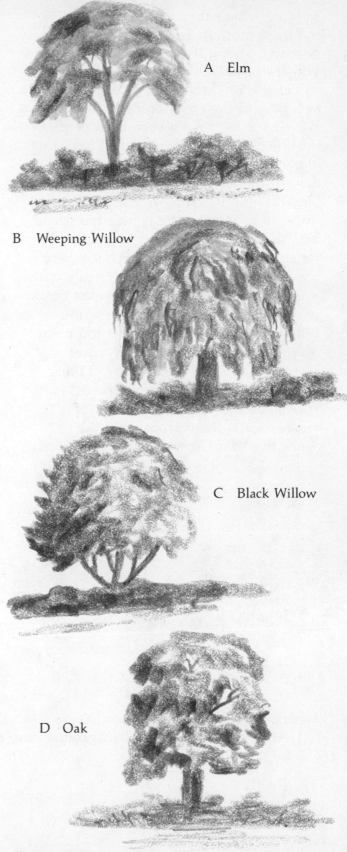

A Elm

B Weeping Willow

C Black Willow

D Oak

**Figure 4–8**
**Each kind of tree has a unique shape.**

indicate where they grow.

I used more or less horizontal hatching for figure 4–9. I suggest that you try to draw this figure as practice in getting the kind of pen control you will need. When you do draw it, remember to make a very light pencil outline first, even using pencil lines to show where the light tree trunks cut across the darker background band. Then do the hatching of the darker areas first, leaving the lighter trunks and shrubbery clean and white. Finally, when you have the darks about where you think they should be, carefully put a few of the lightest pen lines you can make across these white places. You will see that one or two lines too many will immediately make the feature blend in with the background. Taking the time to do little practice pieces like this, and doing them a number of times so you learn from what doesn't work the first time, will be very

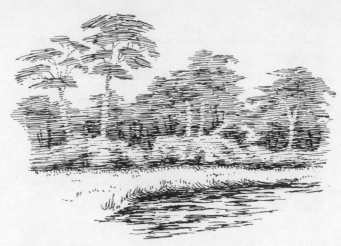

**Figure 4–9**
**Horizontal hatching with some overhatching to model foliage masses in background trees.**

valuable in making the early sketches you do of your own subjects more satisfactory.

Pine trees that have the typical "Christmas tree" shape can easily be suggested, as shown in figure 4–10A. The individual strokes used to build up this shape are shown in 4–10B. This is the general silhouette of spruces, firs, and hemlocks.

You might want to make the background somewhat more representational by using strokes of the pen that directly suggest the leaves rather than just suggesting the tones of the leaf masses. Figure 4–11 shows a way of doing this. Here, I used little loops to create the dark areas rather than using slanted or horizontal

**Figure 4–10**
**(A) An easy way to draw background pine trees.**

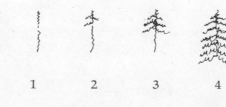 

**(B) The steps in drawing each pine tree.**

1    2    3    4    5

**Figure 4–11**
**A representational way of drawing middleground and background trees.**

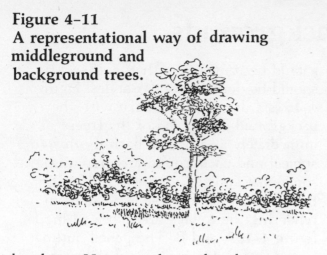

hatching. However done, the object is the same—to create patterns of tone that define and suggest the shape and texture of the picture element to the viewer. Yet another way to do this by

using hatching is shown in figure 4–12A. Here, I created a little more interest in the background by varying the direction of the groups of hatch marks I used to make the tones I wanted. Figure 4–12B, C, and D show the steps I used in developing this background. Remember that light pencil lines do not print, so in 4–12B, I show dark outlines for what was a barely visible set of outlines that I used to guide my pen work. Your guide lines should be very faint, and should be erased when you no longer need them to guide your pen strokes. They are dark in this illustration just to get them to show up in the printing of this book.

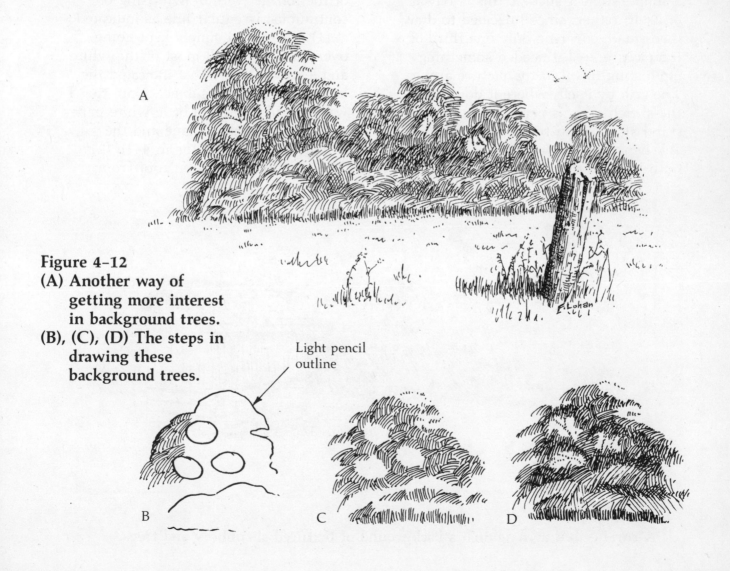

**Figure 4–12**
**(A) Another way of getting more interest in background trees.**
**(B), (C), (D) The steps in drawing these background trees.**

Light pencil outline

# Pairing Subjects with Backgrounds

Backgrounds do not in themselves make interesting sketch material. They are simply used to complete a sketch by suggesting the locale, the season, the weather, and so forth. Almost any style of background representation, but not all, will "go with" almost any subject style. Figure 4–13 shows a small Appalachian-style farm crib and storage shed against one of the backgrounds discussed earlier in this chapter. The crib is rather simple, so I decided to try a somewhat elaborate background representation to keep the sketch from being too trivial. Not that a simple subject such as this is trivial in itself, rather, since I decided to draw it so small, covering only one third of the picture area, I needed something interesting to fill in the picture area. The crib by itself, where it dominates the sketch area, is perfectly suitable to stand alone, as in figure 4–14.

When you draw in a specific style, both background and foreground should be compatible; that is, they should be done in similar styles. Figure 4–15 is a drawing of a barn with the background comprised of the trees immediately around the barn. Both subject and background are drawn in a somewhat stylized manner, and therefore are compatible. The steps in rendering the foliage are indicated in figure 4–16A and B. The pencil outline I used as a guide for inking is shown in 4–16A. As before, this is shown so dark just for purposes of printing the illustration. You actually draw your guide lines very faintly. The dark areas of the foliage were drawn using one continuous, irregular line as indicated at (1) in 4–16B. I simply kept going over the area to kill most of the white and leave a texture that indicated the leafy nature of the subject. Note that I was careful to leave a little white paper show between the foliage and the shingles on the barn, as in 4–16 (2). This prevented the barn roof from

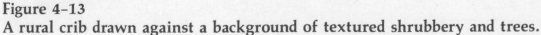

**Figure 4–13**
**A rural crib drawn against a background of textured shrubbery and trees.**

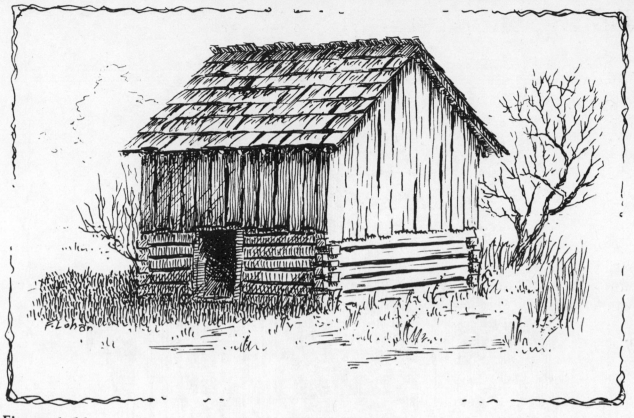

**Figure 4-14**
**A vignette of the crib shown in the previous figure.**

blending into the darks of the foliage. Finally, when the darks were about right, I put a few leaf indications in the lighter parts of the foliage as shown in 4-16B(3).

In contrast to the stylized treatment just discussed, figure 4-17 shows a representational sketch of some fishing buildings placed against a representational background. Again, there is compatibility here between subject and background. This also is a good exercise to develop your dexterity with the pen. I did this sketch with my 3×0 technical pen, the finest point I normally use. There is a need for delicacy in a small sketch such as this, with all the clutter of the pilings under the wharf, and all the nets, lobster pots, rocks alongside the buildings, and floats in the shade behind the main building. At this scale, a medium point-

pen could not have done the job.

Figure 4-18 shows you the basic composition for this sketch. Use this as a guide to make your own composition, then transfer it to your final paper, as described in Chapter 2, and try inking it with a crowquill point or, if you have one, a technical pen. Such a small drawing as this (the illustrations in this book are all reproduced at very close to the size that I drew them) requires considerable abstraction in showing such things as the lobster pots. You cannot actually draw them at this size; you have to suggest them to the viewer. Figure 4-19 shows how I abstracted them to a few vertical lines and a few horizontal ones. An enlarged idea of this can be seen in 4-19A, while 4-19B shows a cluster like the one on the wharf in the sketch. All the features of the drawing were completed

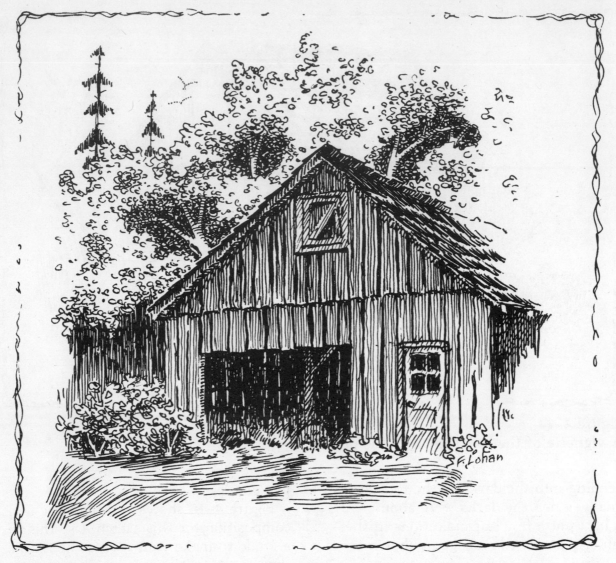

**Figure 4–15**
**A somewhat stylized barn drawn against stylized background trees.**

**Figure 4-16**
**The steps in drawing the background trees: (A) Pencil outline,**
**(B) Inking within the outline.**

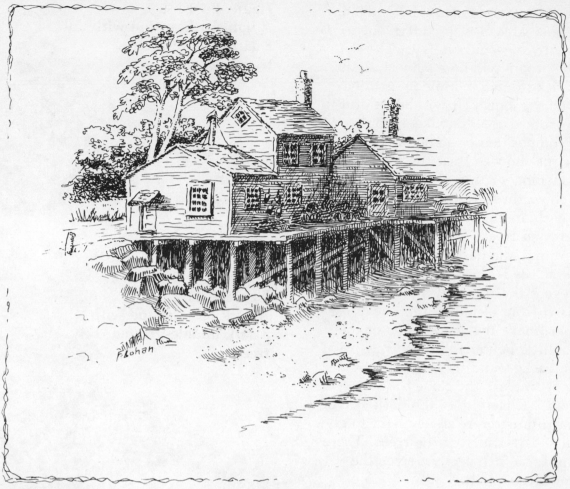

**Figure 4–17**
**Fishing buildings set against background trees drawn in a representational manner.**

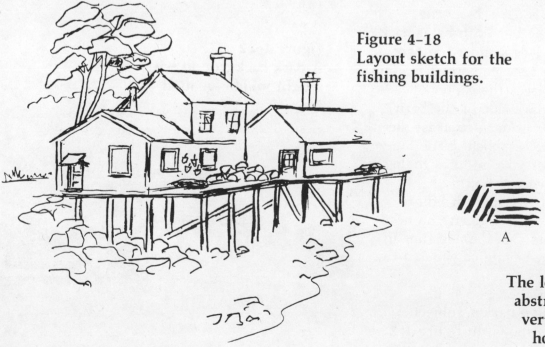

**Figure 4–18**
**Layout sketch for the fishing buildings.**

**Figure 4–19**
**The lobster pots are abstracted to a few vertical and a few horizontal lines.**

before I drew the shading by hatching over those areas I wanted darkened.

In many of your countryside sketches there will be a subject, and both background and middle-ground trees or shrubbery. It will be helpful to you in some cases to make a small tonal composition or so before you decide just how to treat the tonal relationships. Figures 4–20, 4–21, and 4–22 show three such tone studies of a barn with an adjacent tree and a line of background trees. The minimum background and dark treatment of the adjacent tree is shown in figure 4–20. To prevent the tree and the dark side of the barn from blending into one another, make the shaded side of the barn a little lighter than the tree.

The background trees and the adjacent tree are the same tone in figure 4–21. Here, too, the dark side of the barn must be relatively light to give visual separation from the trees. There is little aerial perspective, since the adjacent tree and background are of the same tone. In figure 4–22, I reversed the tonal values of the adjacent tree from that of the background. Here the tree is light and the background is dark. Now the shaded side of the barn can be as dark as I want, since it is against the light tree. This value arrangement is the one to use since it places the center of interest on the dark side of the barn because of the light/dark contrast the light tree lets me establish. Little tone compositions just take minutes to do, but they can save you hours of dissatisfaction if they permit you to know just what tone pattern you need before you invest considerable time in a drawing without having considered this vital aspect.

Another application of a light background with a darker subject superimposed is shown in figure 4–23.

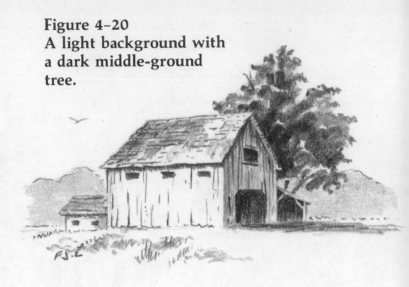

**Figure 4–20**
**A light background with a dark middle-ground tree.**

**Figure 4–21**
**A dark background with a dark middle-ground tree.**

**Figure 4–22**
**A dark background with a light middle-ground tree.**

This is a sketch of a small, prehistoric stone circle in Cornwall, England. This sketch sort of conveys the impression of a dreary day even though shadows are somewhat evident. To get the idea of a bright, sunny day across, I changed the background to a dark band of trees and contrasted very light stones against

it in figures 4–24 and 4–25. These two illustrations show the identical composition rendered first in pencil, then in ink. The tonal treatment is the same in each one; only the way the tones were generated changed. The human figure is included to give a reference as to the size of the objects.

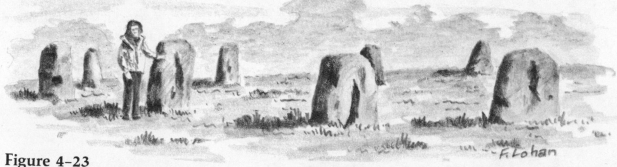

**Figure 4–23**
**A light background requires darkening of the foreground elements to get sufficient tonal separation.**

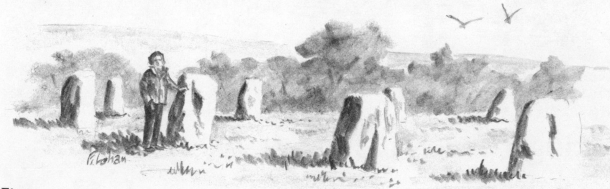

**Figure 4–24**
**A pencil sketch showing how a dark background enhances the impression of bright sunlight when the foreground elements are shown very light and superimposed on the dark background.**

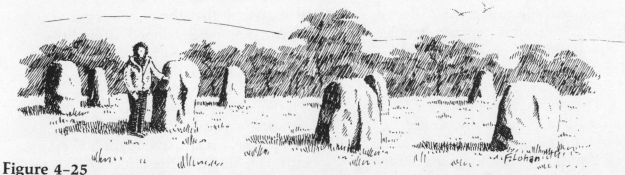

**Figure 4–25**
**A pen sketch of the same scene as the preceding figure—light foreground elements against a dark background.**

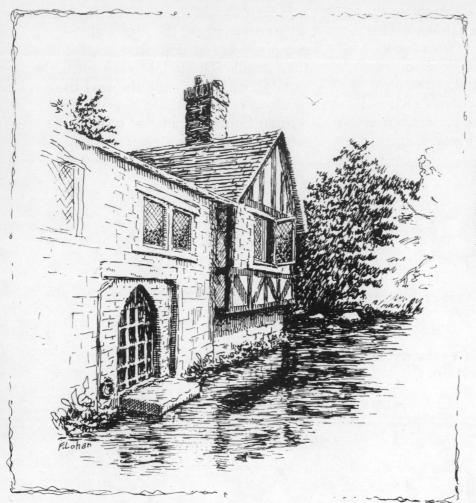

**Figure 4–26**
**A very dark background helps create the center of interest at the open window.**

# Creating a Center of Interest

*Contrast*

Every drawing you make should have a deliberately created center of interest. This should be the heart of the sketch, the main point of your effort that is supported and enhanced by the rest of the piece. Generally this place in the sketch has the greatest contrast because the eye is drawn to contrasting values.

In figure 4–26, I have drawn part of an old English manor house on a small river. I want the center of interest to be around the open window on the part of the building with the beautiful exposed beams. The first thing I did to make this the center of interest was to place that area near the center of the drawing, although it should not necessarily be *at the center* of the drawing. The next thing I did was to make the background trees very dark in that area so that the necessary contrast could be developed around the window. The post and beam construction shows up fairly dark when drawn so I had to be sure to make the background even darker. This illustration was done with my technical pen and a 3×0 point, about the finest point I use. To show the effect that the tone of the background has on the

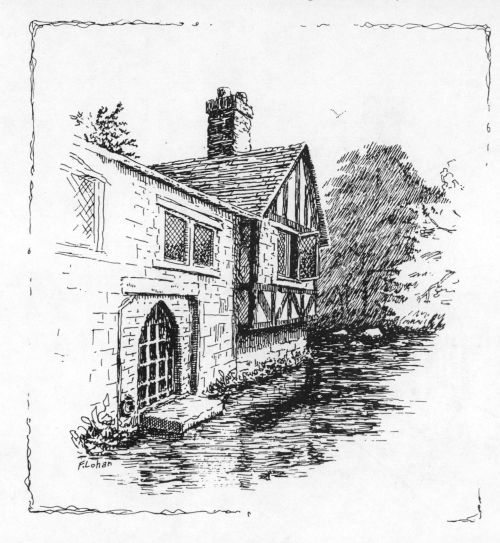

**Figure 4-27
A medium-tone
background in this case
reduces the visual
emphasis at the open
window.**

center of interest, I show in figure 4-27 what it looks like with a much lighter tone used for the background trees. A comparison of the two illustrations shows that some of the visual impact is lost when the background is lightened in this case.

*Composition*

Composition, how the subject matter is organized in the picture area and how the space is broken up, is also vital to establishing a center of interest. The lines of your drawings and the way that the lights and darks tend to lead the viewer's eyes must be planned in addition to the contrasts if your drawing is to be successful in

establishing a natural center of interest.

The visual flow of the manor house composition is shown in figure 4-28. The sketch design leads the viewer's eyes to the area of the open window from both sides and from the bottom of the drawing. From the right side, the leafy branches of the white tree point at the window area and lead the eye there as indicated in figure 4-28 (1) and (2). From the bottom, the arrangement of the dark reflections in the water carry the eye up and around to the window area as shown in 4-28 (3).

The perspective lines of the building converge toward the right and therefore carry the eye in this direction

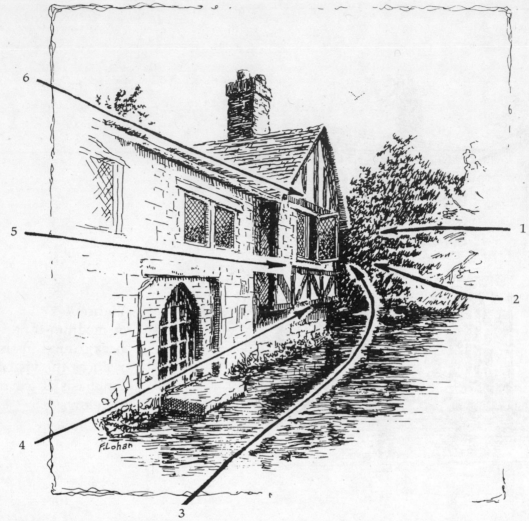

**Figure 4–28**
**The composition leads the viewer's eyes toward the center of interest.**

when the gaze enters the drawing from the left side. These points of visual entry are shown in 4–28 (4), (5), and (6). This is the reason lines in a drawing should not converge out of the picture; they tend to carry the viewer's eyes out of the picture.

The matter of composition, as it influences the way the viewer's eye will travel through the drawing, is the first thing that must be considered when planning a sketch. Then the contrast arrangement must be worked out before actual drawing commences. The compositional problems of the practice exercises throughout this book will be discussed with each such exercise.

# When to Stop Drawing

One of the most difficult things for beginners to figure out is when to stop drawing. Many just keep going until they come to the edge of the paper, or to the line they drew indicating the size of the drawing. You should stop drawing when your center of interest is established along with enough of the surrounding area to make the setting

apparent and to create the visual flow to the center of interest from each edge of the drawing.

In the case of the manor house, putting in more detail of the building at the left side would have proven to be a distraction rather than an enhancement. Being nearer to the eye, such detail would tend to dominate and attract the eye, greatly weakening the visual force of the open window area.

Similar reasoning applies to the lower right. It would be counterproductive to include more of the water there. The viewer understands that there is more water in that direction; there is no need to show it just because the paper is there inside the frame lines. This is not to say that you never complete a squared-off drawing. Just keep in mind that it is *not always necessary* to do so.

# Different Techniques: Practice Exercises

Ink can be applied to the paper in many different ways to create tone and thereby create drawings. One of these methods is stippling: placing of dots on the paper and piling them up to make dark passages, spreading them out to make intermediate tones, and eliminating them altogether to make the lightest tones. Figure 4–29 is a stipple rendition of the manor house.

You can create almost photographic detail with stippling. Indeed, most newspaper illustrations are comprised of dots of ink—look at one with a magnifying glass sometime. I did figure 4–29 with a medium-point pen: it makes a reasonably large dot with each touch to the paper.

A stipple drawing takes longer to complete than does a crosshatched one, because with one stroke you place a line of ink on the paper, but it may take twenty dots to represent that same line. That means twenty hand movements for stipple for one of hatching. The effect of a well-done stipple drawing is worth the effort, however.

I mentioned several times earlier that a medium or coarse pen point is inappropriate to drawing the delicate

indications of far distance. Only the finest point can convey the impression. However, if the most distant vista in a sketch is not very far off, the coarser points can do a very good job. Figure 4–30, the manor house, was drawn with a medium-point pen. Compare it with the fine-point rendition of the same scene in figure 4–26. The drawing done with the medium-point pen required the least time to complete because there were fewer lines to put down—the medium point covers more paper with ink at each stroke than does the fine point. Verify this by looking at and comparing the number of lines required to draw the shadow under the overhanging part of the building. The finer point gives a more delicate result, but both approaches are valid. In fact, it might be best when sketching on the spot to use the coarser point to get the necessary information down on paper in a reasonable time, then go back to your studio and do a fine point drawing based on the field sketch.

Don't forget the pencil. In general, pencil drawings require less time to complete than ink drawings do. Figure 4–31 is a pencil version of the English manor house. This sketch was done

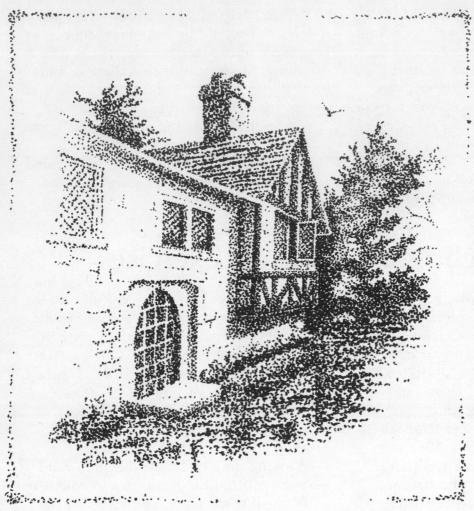

**Figure 4-29**
**A pen stipple rendition of the manor house. A medium-point pen was used which created large dots.**

using 6B, 3B, and HB broad-point pencils, and a sharp HB pencil to sharpen the edges here and there and to indicate the fine lines in the stone work and windows.

*Practice exercises*

I have included a good bit of detailed explanation about the ways in which I illustrated the manor house. This is an excellent subject for practice on your part—practice with both hatching and stippling pen techniques and pencil rendition. You can use the discussions to guide you when completing this subject in several different ways.

The perspective layout for the manor house is shown in figure 4-32. Use this

as a guide for making your own composition drawing, then transferring it to your working paper and trying your hand at completing it. You will be able to get several transfers of the layout to other paper from one composition with the back blackened as shown in Chapter 2.

*Summary*

Backgrounds are treated in a monotone way when they are far off in the distance. If detail is added in such cases, it only tends to bring the background forward and destroy the aerial perspective of distance.

If middle ground is treated in a monotone way, it will look as if it is

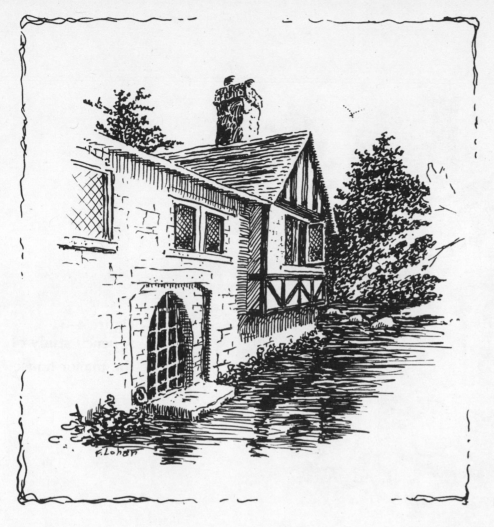

**Figure 4-30
A heavy pen study of the manor house.**

being viewed through haze or mist. Generally, except in the case of a hazy atmosphere, middle ground and not-too-distant backgrounds should be treated in a manner that shows some tone or structure modulation. This tends to bring them forward and not confuse the viewer as to whether they are far off or close.

Contrast is a necessary element in creating a center of interest. You should choose to make your background or middle-ground elements dark or light, depending on what contrasts you need to get your desired effect. If you want a dark or shaded side of your subject to be the center of interest, you should surround it with a lighter tone to create

maximum contrast in that area. The opposite holds if you want a light part of your subject to be the center of interest.

Your composition should contain picture elements that point at the center of interest or that lead the eye to it by sweeping paths through the drawing.

- Avoid lines that converge outside the picture; they will lead the eye out of the drawing.
- Stop drawing when you have created your center of interest and surrounded it with enough elements to establish the setting and to work as the necessary compositional

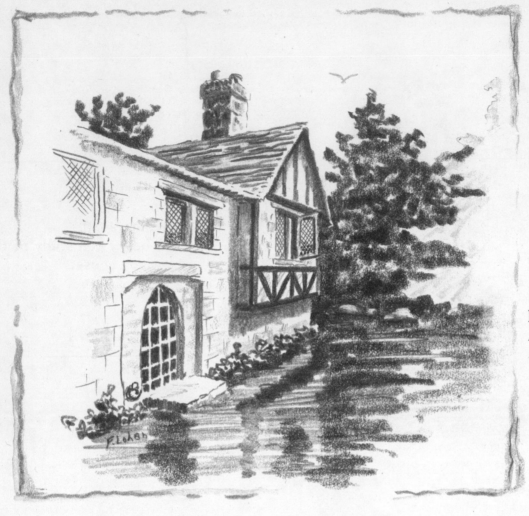

**Figure 4–31**
**A pencil study of**
**the manor house.**

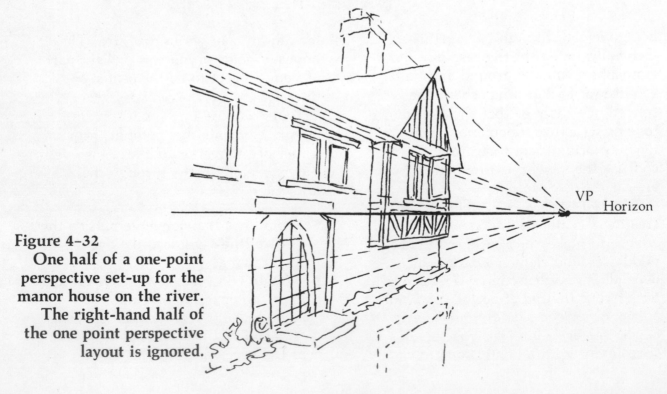

VP   Horizon

**Figure 4–32**
    **One half of a one-point**
**perspective set-up for the**
**manor house on the river.**
**The right-hand half of**
**the one point perspective**
**layout is ignored.**

guides to lead the eye to the center of interest. Anything additional to fill in the paper may detract from the impact by simply creating meaningless diversions for the viewer.

Broader-point pens put more ink down with each stroke than the fine ones do. This means that you can draw faster with the broad points. You will not, however, be able to create delicate detail with the broad-point pen as you can with a very fine point. Each produces a sketch with a different feeling. You will find each appropriate at different times.

It is a good idea to create several small pencil compositions to establish the compositional flow and the lights and darks before you start on a final drawing. A few minutes spent this way can make the difference between satisfaction and disappointment with the completed drawing.

# 5
# Drawing Rocks and Stone Walls

*Basic Structure*
*The Shapes of Rocks*
*On-the-Spot Sketches*
*A Stone Quarry*
*Foreground and Background Rocks*
*Drawing Stone and Brick Walls*
*Underground Stone Chamber*

# Basic Structure

Rocks come in all sizes, shapes, and textures and are found in every countryside area from mountains to ocean to desert and forest. Rocks vary as widely in texture and character as foliage does, so there are many ways to approach drawing them. In some instances all you will want to show is a simple outline to indicate that some rocks are there. Other times you will want to show the shaded and sunlit surfaces and planes to assist in your compositional needs. How you treat the rocks that appear in your sketches will depend on the compositional requirements of your particular drawing. Sometimes they will be among the primary elements of your drawing and other times they will be supporting elements.

In this section I will show you some ways to represent different kinds of rocks under different circumstances, and to put them in stone walls of various types and under different compositional requirements. At the end of the chapter are a number of suggested practice exercises that I recommend you try, putting some of the principles that are discussed in the chapter to use. This will help to bed them down in your mind and make it easier for you to recall them when needed for use in your original sketching.

# The Shapes of Rocks

The shapes that rocks have developed over time depends on their material and how long they have been exposed to weathering as well as to what kind of weathering. The softer limestones and sandstones tend to crumble into sand or coarse gravel with time, while the granites and basaltic rocks, being harder, tend to remain more massive and become rounded with time by the action of heat, cold, wind, and water. These are not, however, the most important considerations in sketching rocks. Your composition is the most important thing to take into account, so take whatever artistic license is necessary in depicting your rocks so that the purposes of your drawing are served. This does not mean that you should sacrifice the subject. I will discuss the kind of artistic license I mean at different times in the demonstration and exercise drawings throughout this book.

*Rocks as Individual Masses*

Regardless of their shape—rounded, or sharply angular—rocks can be treated as individual masses for compositional purposes. In fact, it is a very good idea to make a quick, thumbnail composition sketch of the arrangement of such masses before you start to make your final composition drawing. By doing so, you can quickly spot repetitive shapes or repetitive placement of elements that might weaken your composition.

Consider a rocky shoreline with well-worn, massive rocks. Neglecting any

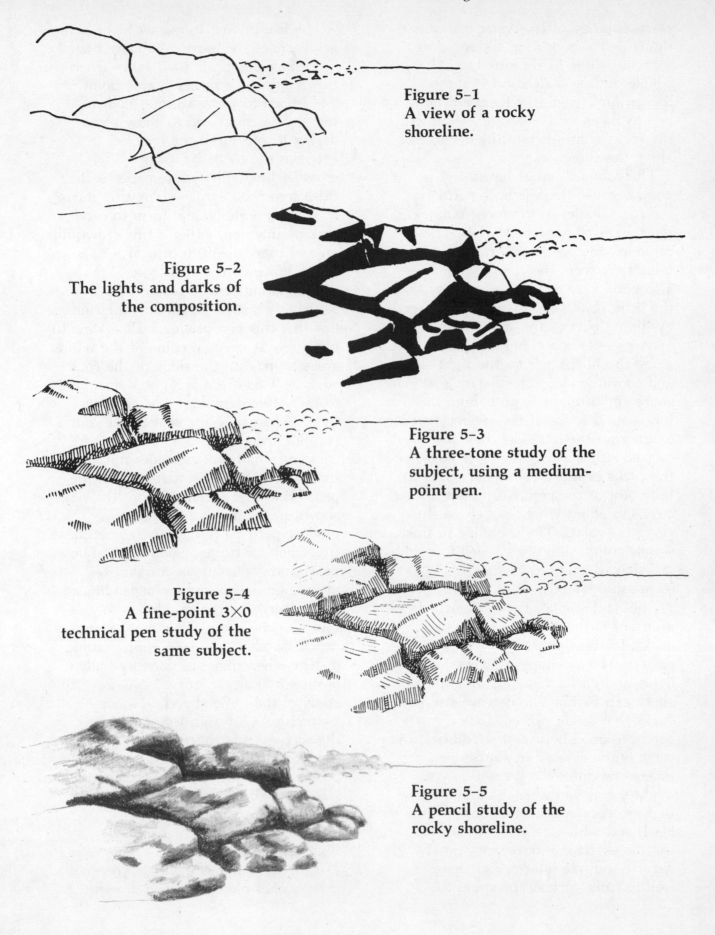

**Figure 5–1**
**A view of a rocky**
**shoreline.**

**Figure 5–2**
**The lights and darks of**
**the composition.**

**Figure 5–3**
**A three-tone study of the**
**subject, using a medium-**
**point pen.**

**Figure 5–4**
**A fine-point 3×0**
**technical pen study of the**
**same subject.**

**Figure 5–5**
**A pencil study of the**
**rocky shoreline.**

representation of the water just yet, figure 5–1 shows what the receding shoreline view might look like. This simple outline sketch shows the foreground rocks that form a little peninsula as well as an indication that the rocks continue into the distance along the shore.

The composition of figure 5–1 is good because there is no repetition of the rock shapes in the foreground, and their sizes all vary somewhat. This removes one possible source of monotony from the composition. It is also good because of the curiosity that the little peninsula of rocks generates by hiding part of the shore line. The viewer's eyes come into the sketch along the horizon from the right side and continue along the distant rocky shore and attempt to go behind the foreground rocks. If the viewer's eyes enter from the left side, they are carried either along the lower edges of the rocks or along the upper edges to the point of the peninsula. Here the curiosity about what lies behind the rocks is evoked. The shoreline in this simple composition has a well formed "S"-shaped curve as its major compositional axis.

The next compositional element to be aware of is the pattern of lights and darks. In figure 5–2, I have broken this pattern into its simplest form—just the lights and darks. Here again, a quick check can be made to detect patterns of darks that might not enhance the composition. The use of solid black and stark white creates an almost abstract interpretation of the scene that you might use if you were making a poster that incorporated such a subject. Pure black and white are seldom used in routine sketching, however. You always need to indicate intermediate tones as well to fully portray the subject.

The use of *three* tones, with the pen, is illustrated in figure 5–3. Here I used a medium-point pen (as I said earlier, this really has a rather coarse point) and I tried to show an intermediate tone by hatching and to show some darker tone deep in the crevices between the rocks by using crosshatching. The white paper is the third tone. You can see how this starts to give more individual form to each rock. A fine pen, either a fine crowquill or, as I used, a 3×0 technical pen, is better however for a realistic interpretation of this subject. Figure 5–4 shows such a rendition. The fine line that this pen produces allows me to use a few strokes on some of the white areas to indicate the slope of the rock surface. This often is a good visual aid to the viewers, making it easier for them to visualize the shape that your pen lines represent.

Doing small sketches does not allow too many gradations of tone with the pen. I find that sketches about the size shown in this book allow me to produce perhaps four tones, sometimes five when I include a solid black. The pencil, however, allows an almost infinite gradation of tone depending to some degree on the roughness, or tooth, of the paper. This is what makes pencil sketches approach photographic quality when they are done by truly proficient artists. Figure 5–5 is a pencil study of the same shoreline scene. Compare it with figure 5–4 and note the softness and more smoothly rounded surfaces produced by the pencil. This study was done using an HB and a 4B pencil on regular pencil drawing paper.

*Blocking in Rock Groupings*
Figure 5–6 shows a simple group of three stones blocked in and drawn

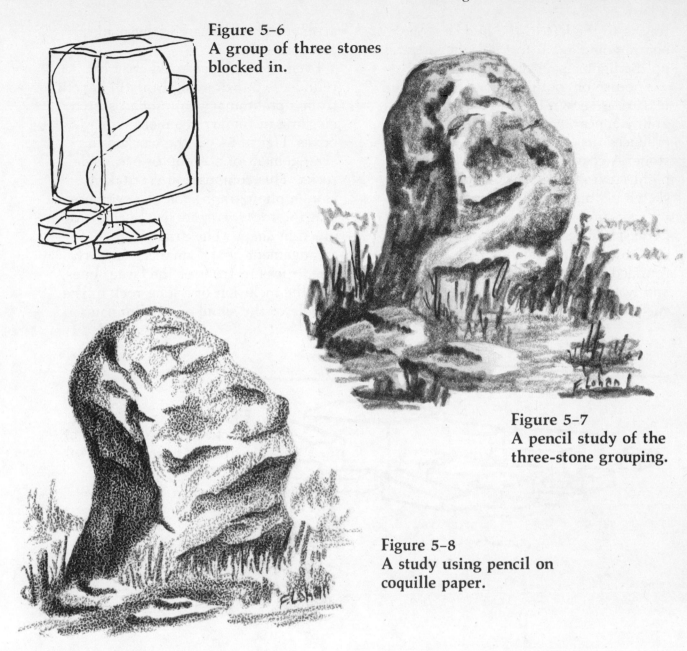

**Figure 5-6
A group of three stones
blocked in.**

**Figure 5-7
A pencil study of the
three-stone grouping.**

**Figure 5-8
A study using pencil on
coquille paper.**

within the blocks. While not always necessary for such a simple grouping as this, the practice of blocking in the masses can be very important in organizing what appears to be an impossibly complicated grouping of rocks. This simple case demonstrates the principle of blocking in the masses and then developing the individual rocks within each block. This is vital when you are simplifying a scene that lies before you and selecting just a few of all those subjects that you see to use

in characterizing the scene.

The pencil study in figure 5-7 presumes the light coming from high on the right side of the viewer. You can see that the left side of the rocks are shaded, as are the undercut parts of the surface that are not receiving any direct sunlight. Note that compositionally this study uses the same "S"-shaped curve as did the earlier shoreline study. If the viewer's eye enters at the bottom of the sketch, it comes to the lower stone, then

travels to the left to the middle stone before going again to the right to travel up the lighter part of the large one.

The use of coquille paper to indicate texture is shown in figure 5–8. The grainy appearance that coquille paper produces fits well with the texture of stone. A coarse paper would also give a highly textured appearance to a pencil sketch of this subject.

*Oceanside Rocks*

Many times, oceanside rocks are rounded from years of action of waves and waterborne sand. Groupings of such rocks can often provide beautiful arrangements that are ready-made compositions.

Even though such rocks may be rounded, your drawing can still benefit from a preliminary thumbnail sketch blocking in the arrangement with boxes. Figure 5–9 is the blocked-in arrangement of a group of oceanside rocks. This composition was taken from a photograph. You can see here that the rocks vary in size but not too much in shape. The random arrangement of the smaller, similarly sized rocks in front of the larger ones, and the inclusion of a long rock in the middle of the small ones, eliminates

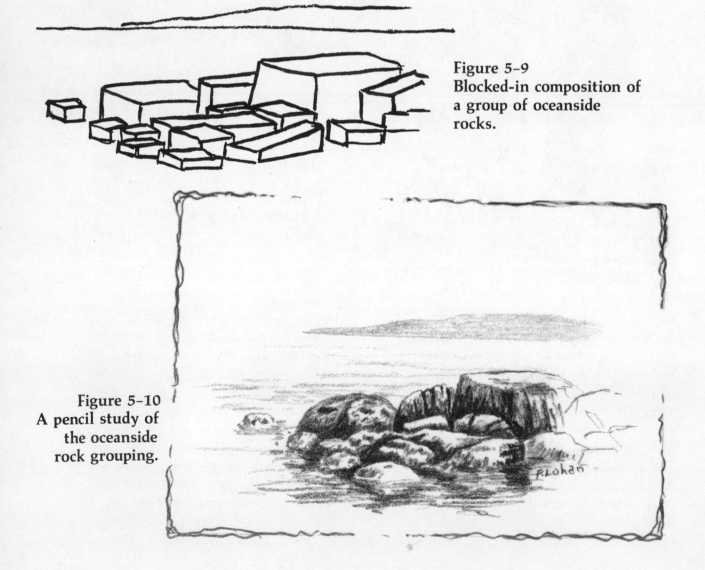

**Figure 5–9
Blocked-in composition of a group of oceanside rocks.**

**Figure 5–10
A pencil study of the oceanside rock grouping.**

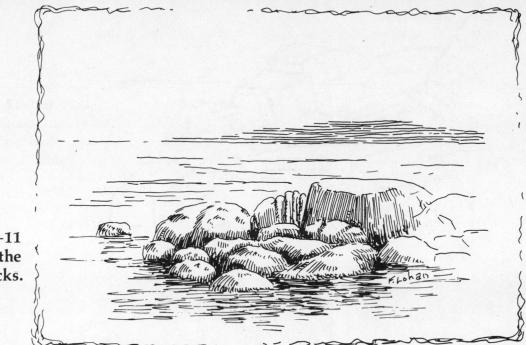

**Figure 5-11
A pen study of the
oceanside rocks.**

monotony from the composition. The
final pencil drawing, shown in figure
5-10, was done using only a sharp HB
pencil on vellum that was quite
abrasive. The almost sandpaper-like
surface of this paper allowed me to
achieve the blackest darks with the HB.
When I just lightly touched the paper
with the pencil, I was able to get the
intermediate tones and those lighter
ones for the water and the background
landmass.

The center of interest in this drawing
lies in the middle of the cluster of
rocks, since it is there that I have
created the greatest contrast; the
lightest rocks are adjacent to the
darkest darks.

Figure 5-11 shows a pen version of
the same composition. This is basically
a three-tone study, very dark,
intermediate, and pure white paper. I
used only horizontal lines for the far
background to try for a foggy feeling.
This sketch was done with my 3×0
technical pen.

*Rugged Hillside Rocks*

Rocky outcroppings of rocks on
isolated hillsides in the United States
and in other countries frequently
consist of hard granite, basalt, or other
rock that is fairly resistant to
weathering. Such outcroppings often
present angular surfaces rather than
rounded ones characteristic of the
oceanside. The hard angular formations
really simplify to a series of planes, and
if the light is chosen properly, can be
drawn as shaded planes, those of
intermediate tone, and those brightly lit
ones that are shown by the white paper
and a bit of outline. Figure 5-12 is the
block composition for just such a rock
formation. The subject for this section
was from a photograph taken near
Leicester, England. The block
composition is a tremendous
simplification of a very complex
terraced hillside. I wanted to get the
spirit and feeling of this hillside, so I
eliminated most of the actual visible
detail of small pieces of loose rock, and

**Figure 5-12
The blocked-in
composition for a rocky
hillside.**

**Figure 5-13
A pencil drawing
of a rugged rocky
outcropping on
a hillside.**

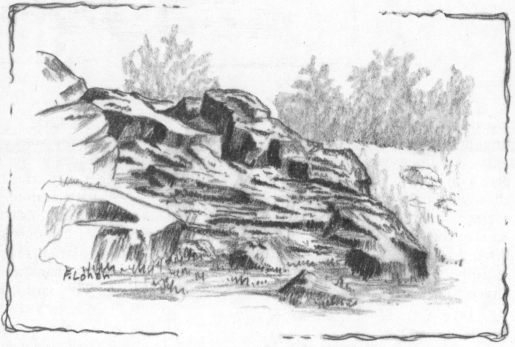

of additional terraced, step-like sections of the rock. The pencil drawing of figure 5-13 is the result of completing the block composition. Notice that in order to get the impression of sharpness and angularity in the sketch, the dark planes come right up to the light ones with no intermediate tone that would make the corners appear rounded as in the previous sketch of the oceanside rocks. This same treatment drawn with pen (figure 5-14) gives the feeling of angularity to the

formation. Note that the silhouette treatment of the background trees keeps them from competing with the detail of the rock formation. Also note in the pen version of figure 5-14 that I used generally vertical lines to create the darks of the rocks and generally horizontal lines to show the shadows and texture of the ground. These visual clues are usually not obvious, but do help the viewers subconsciously interpret what they are looking at.

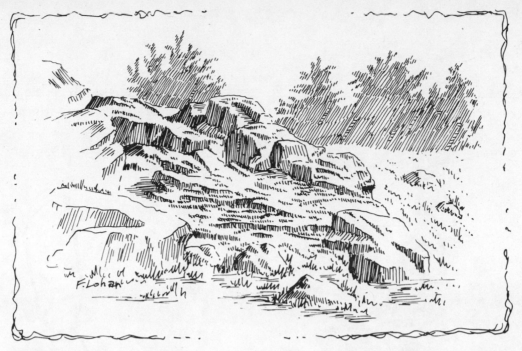

**Figure 5-14**
**A pen and ink version of the rocky outcropping.**

*Weathered Desert Rock Formation*

The strange block composition of figure 5-15 is for a sketch of an isolated, extremely weathered, mostly sandstone desert formation in Arizona. This composition simplified to a pile of cones and a cylinder. This kind of subject simplification is necessary when you are looking at the real thing because the infinite amount of visible detail can be quite intimidating and blind you to the basic forms that you are dealing with. Working from a photograph can sometimes be even worse in terms of the intimidation, because it is more difficult, sometimes impossible, to squint at a photograph to eliminate the detail and perceive just the forms and shadow pattern of the overall subject. This sketch was, like the previous one, also done from a photograph. The resulting pencil sketch can be seen in figure 5-16.

The amount of shadow detail visible in the photograph was indeed overwhelming. I had to study it to see

that there were two kinds of surface irregularities in the formation. Each kind of irregularity was casting its own kind of shadow. First, there were numerous little indentations, each making a little round or slightly elongated shadow. These features were all over the formation. Second, there were almost horizontal bands of somewhat different material that formed strata, some of which did not weather as much as the softer sandstone. This harder material formed overhanging layers, each of which cast a stripe-like, roughly horizontal shadow on the material below it. I chose to concentrate first on establishing the pattern of these horizontal shadows as shown in figure 5-17A, then darkening them all before I started to put in some of the millions of little round shadows that I could see. This resulted in something like figure 5-17B. The final step was to shade the entire mass, going over the stripes and the round shadows, as you see in 5-17C.

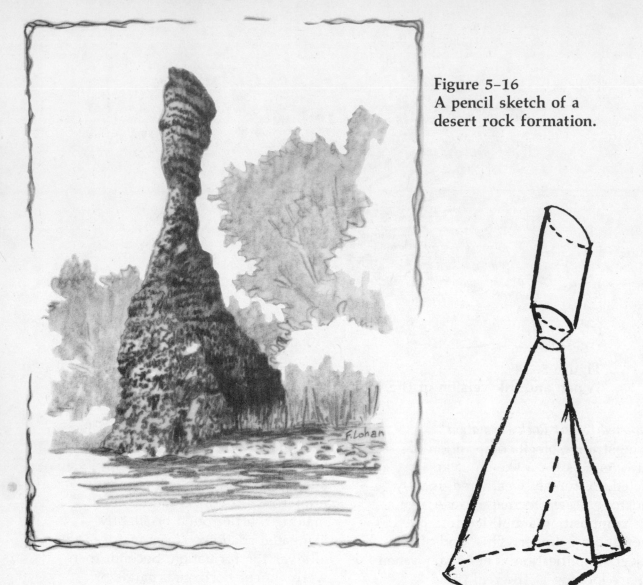

**Figure 5-16**
**A pencil sketch of a**
**desert rock formation.**

**Figure 5-15**
**The blocked-in**
**composition for a desert**
**rock formation.**

**Figure 5-17**
    **The basic steps in**
**developing the pencil**
**sketch of the desert rock**
**formation.**

 A

 B

 C

# On-the-Spot Sketches

*Little Rocky Waterfall*

As you travel, it can be helpful to supplement your photographs with quick, impressionistic sketches done on the spot. If you want to do some drawing later at home, these sketches can be of great help in reminding you of just what it was that appealed to you in the particular scene. Any photographs you may have taken can then be more easily abstracted to make your drawing show what you thought was of significance when you saw the scene in person. Figure 5–18 is the block composition for a little waterfall in the Catskill Mountains. It shows about fifteen rock masses where the eye could detect many times that number on the spot. I blocked in these fifteen masses *very lightly* then proceeded to use a dull 6B pencil to show the outlines and the shaded planes. I later used a sharp HB pencil to make some of the edges sharper,

especially in the immediate area of the little waterfall. The final result is seen in figure 5–19. This is just a quick impression sketch. The steps I followed are shown in figure 5–20. At 20A, you can see the broad, soft line that my dull 6B pencil made. This made the next step, shown at 20B, produce a recognizable, but almost out-of-focus rendition of the scene. The next step, at 20C, shows how the sharpening of some of the edges of the rocks made things a little more distinct. This sharpening, often accompanied by deepening of some of the darks, is very often useful to help strengthen the contrast and sharpness around the center of interest. Note that the vegetation in this case is almost totally untextured—it is primarily rendered in outline. I wanted the entire attention to be focused on the little waterfall just left of the center of the drawing. See

**Figure 5–18**
**Blocked-in composition of a little rocky waterfall.**

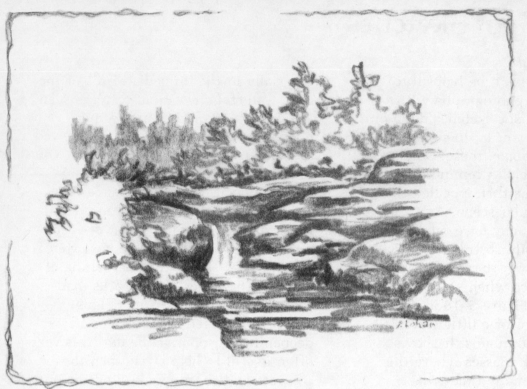

**Figure 5–19
Rocks and a small
waterfall—a quick
pencil sketch.**

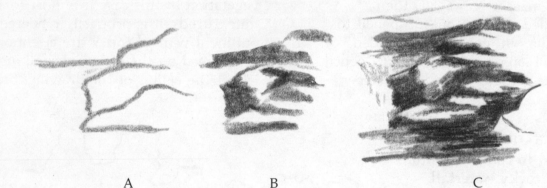

A                                    B                                    C

**Figure 5–20
Steps in completing the rocks and the waterfall.**

how the "V" shape of the rock mass on the right points directly toward the waterfall?

*Footbridge and Stream*

I sketched this little scene (figure 5–21) using my artist's fountain pen. It has what is called a medium point, which makes a rather bold line. It is little more than an impression of the footbridge and the rocks that support

one side. The sketch was done directly on the paper with no preliminary pencil organization. Twelve rocks are shown either in full or in part. This is a simplification of the actual scene, which is perfectly legitimate to do in trying to abstract the essence of a scene attractive enough to sketch. In this case I even created the little splash where the water tumbles over a stone. The actual scene lacked this feature;

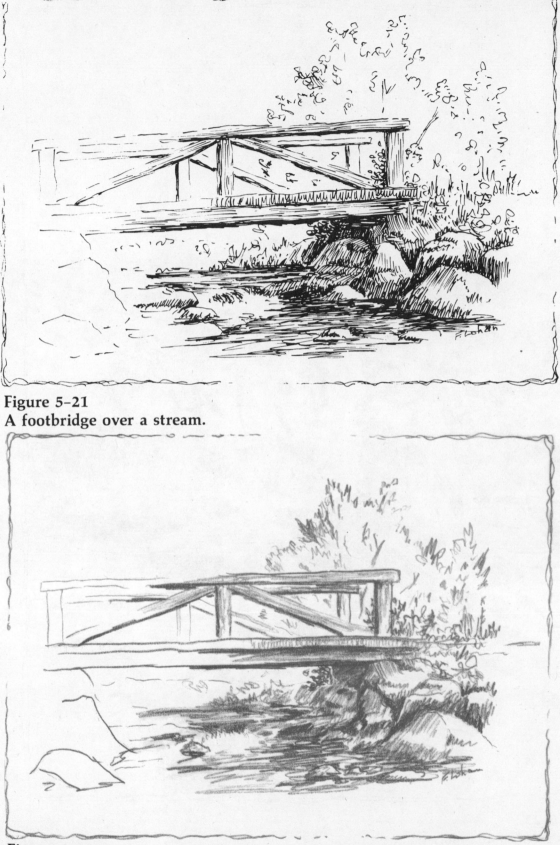

**Figure 5-21**
**A footbridge over a stream.**

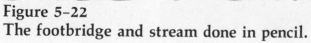

**Figure 5-22**
**The footbridge and stream done in pencil.**

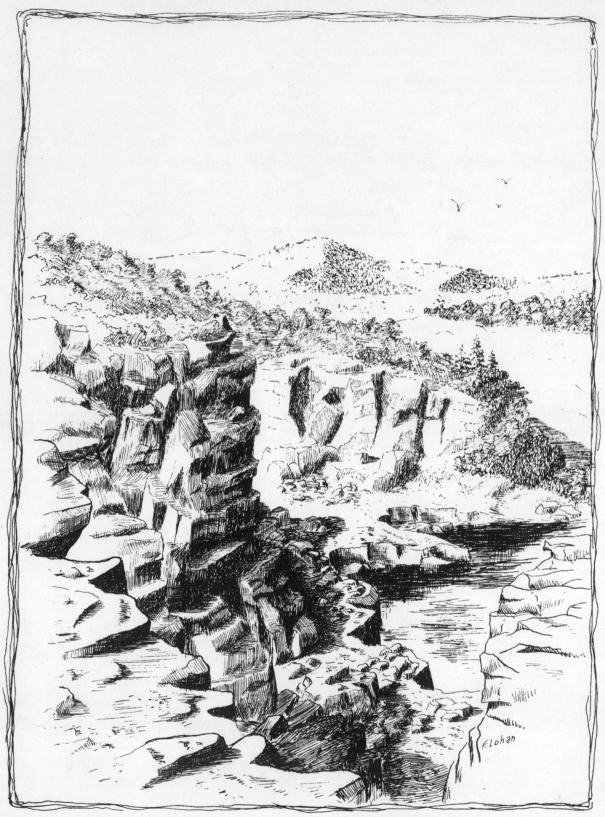

**Figure 5–23**
**A view into an abandoned**
**stone quarry.**

indeed, the water part of it was rather dull. It is to your advantage to use some artistic license to rearrange a few rocks and add little interesting compositional aspects to your sketches of actual places.

The same scene executed with an HB pencil on very abrasive vellum can be seen in figure 5–22. This, like the corresponding pen sketch, is done in a loose manner. There is no picky detail in the sketch, just the disposition of light and dark masses with some outline to carry the shapes. When I use the pen a lot I tend to get very tight in my drawing. It is easy to get away from tightness when I do a quick little pencil study or so. You may find this true also.

# A Stone Quarry

I guess in terms of the subject of sketching rocks, attempting to sketch a stone quarry is about the ultimate challenge. As the last two scenes were both carried out in a very loose, comfortable manner, I found the detail necessary in properly depicting the stone quarry shown in figure 5–23 to require the very pickiness that the pen often brings out in me.

This scene required a very careful layout with a sharp pencil to locate the main features of the rocky faces of the quarry. The amount of detail can be seen in figure 5–24 which shows part of the dark, vertical cliff near the center of the drawing in figure 5–23. When I started to do the actual inking, with my 3×0 technical pen, I went very slowly and carefully, as you see in figure 5–25. I did not want to lose any of the carefully drawn features of the quarry, so I inked each face and surface individually and relatively completely before I went on to the next. This was a fun piece to work on and to see develop as I went along. It took quite a few hours to complete. Note that I modeled the rocky surfaces by using vertical lines on the vertical faces and horizontal ones on the horizontal surfaces.

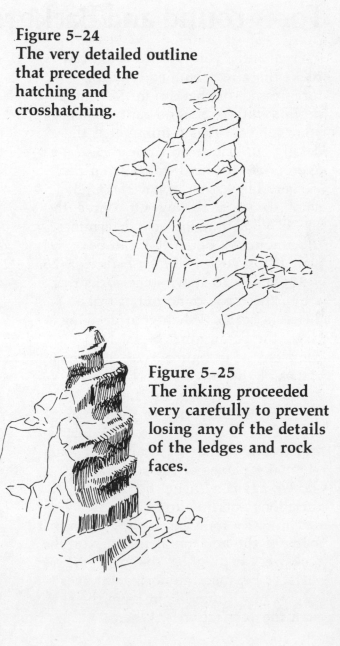

**Figure 5–24**
**The very detailed outline that preceded the hatching and crosshatching.**

**Figure 5–25**
**The inking proceeded very carefully to prevent losing any of the details of the ledges and rock faces.**

A complex subject such as this quarry scene is certainly not impossible to do; it just requires careful study beforehand to determine which features to keep and which to eliminate from the sketch. Then you have to organize what you keep into a pleasing arrangement of lights and darks. This drawing was done from a photograph. Although it would not be impossible to do this kind of drawing on the spot, it would require a number of visits and still a considerable amount of work at home to trim up the contrasts and give necessary emphasis to certain features that might lose their distinction. This is not a subject for a beginning artist, although I would recommend that it be attempted as a practice exercise when you get a little experience with the pen and feel somewhat comfortable with it.

# Foreground and Background Rocks

Frequently, you will want to draw rocks that are prominently in the foreground, or that are in the middle ground but are a significant element of your subject. This requires that the detail you include on those rocks be appropriate to the distance from the viewer. They have to have enough detail to be convincing. Of course, the size of your drawing also determines the amount of detail that can be included in such features. Figures 5-26, 5-27, and 5-28 show some rocks that are in the foreground but at three different scales. When your drawing is large, the detail must be fairly complete, as in figure 5-26. Here many planes of this angular rock are indicated by the slight differences of tone and the direction of the hatching lines. Cracks are also shown. When the scale is smaller, as in figure 5-27, only the major planes of the rock can be shown, again by using both tone variations and line direction when hatching. By tone variation, I mean that many of the horizontal surfaces on the rock are toned lighter than the vertical surfaces because the horizontal ones receive much more light from the sky than the vertical ones. When the drawing is very small, as in figure 5-28, about all that can be shown are the lighted and shaded sides of the rocks.

I used my 3×0 technical pen for these drawings.

The same principles apply when you draw such a scene with the pencil. Figure 5-29 shows the same cluster of angular rocks drawn with 6B, 3B, and HB pencils on paper with a moderate tooth. My first step was to lightly outline the rocks and their major dark planes in pencil. Then, as you see in figure 5-30, I used my broad-point 6B pencil to fill in the dark planes. Then I used my sharp HB pencil to sharply define the edges of the dark areas and the outlines of these dark areas against the sky. I used the 3B pencil to tone the light areas on the rocks where these light areas were against the sky, but I left the light areas white where they abutted the dark, shaded sides of the rock. I wanted to lend visual emphasis to these centers of interest. Finally, I used my kneaded eraser to lift off some graphite on some of the horizontal planes as these were darker than I wanted, and I added the cracks with the sharp HB pencil and added the grass strokes.

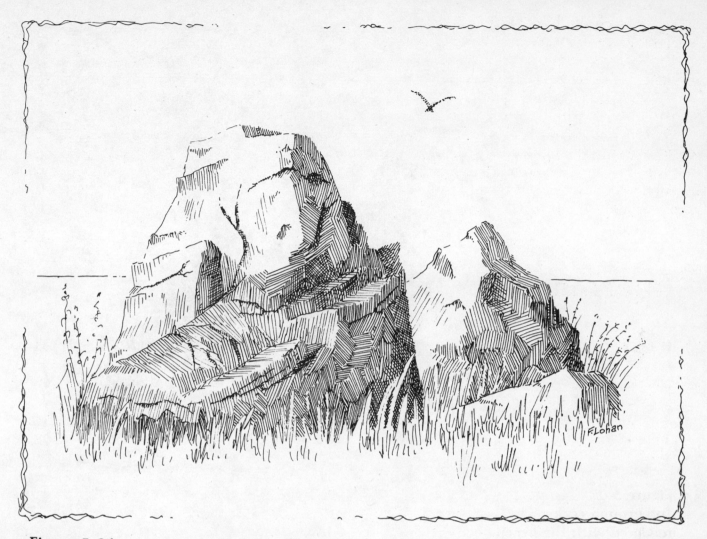

**Figure 5-26**
**Some foreground rocks drawn at a large scale.**

**Figure 5-27**
**Foreground rocks drawn**
**at a medium scale.**

**Figure 5-28**
**Foreground rocks drawn**
**at a small scale.**

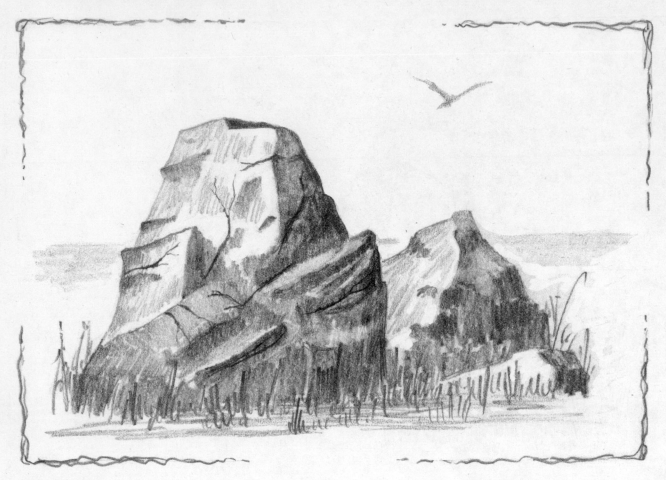

**Figure 5-29**
**Foreground rocks**
**rendered with the pencil.**

**Figure 5-30**
**The first step in the**
**pencil drawing of the**
**foreground rocks.**

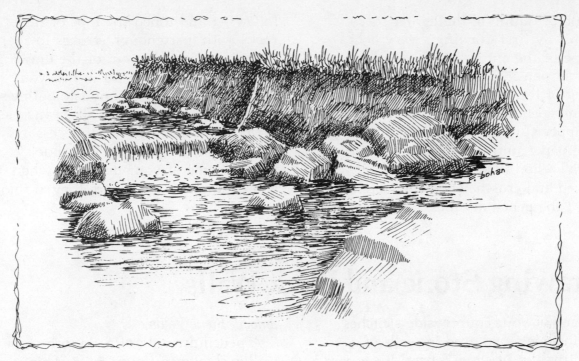

**Figure 5-31**
**A scene with foreground, middle-ground and background rocks.**

**Figure 5-32**
**Inking starts around the pencil outlines of the rocks. These outlines are drawn very lightly so they may be easily erased later on.**

**Figure 5-33**
**Dark tones are built up to show the shape of each rock. Outlines are not necessary when the pencil guide lines are erased.**

Figure 5-31 is a little forest stream with rocks in the foreground, middle ground, and background. This pen sketch, for which I used my 3×0 technical pen, shows the detail on the middle-ground rocks that lie immediately by the little waterfall and the increasingly less detail on the rocks that lie farther back in the scene. The most distant rocks are shown as nothing more than curved outlines. The most prominent rock in the lower right foreground is also barely indicated, and not developed in any detail. This is because, although it is the closest subject to the viewer, I did not want it to be the primary sketch element. Therefore I simply indicated that it was there and saved all the detail for my center of interest area around the waterfall.

It was unnecessary for me to draw outlines in ink around these rocks. I planned the darker stream bank to do

the job of outlining the lighter rocks. I did this by first drawing a very light outline of the entire scene and all the rocks in pencil. Then I started the toning of the rocks and the bank of the stream as shown in figure 5–32. I let the upper surfaces of the rocks remain white paper until the last step of the sketch. When I had the background hatched and crosshatched adequately, I erased the pencil outlines I had been following and toned the tops of the rocks with just enough strokes to keep them from jumping out of the drawing as shown in figure 5–33. When you can, you should also eliminate outlines in your pen sketches. By all means use them when they are really necessary, but you can avoid a "coloring book" look to some of your drawings when you eliminate them where they are not needed.

# Drawing Stone and Brick Walls

Some of your countryside sketches will include stone used in walls of structures or in stone fences. Such uses will include all manner of stone types from very rough to very smooth.

## Textured Stone Walls

A textured stone wall is shown in the pencil drawing of figure 5–34. The steps in completing this sketch included a very light pencil outline of the wall and each stone, then a base toning of each stone with my broad-point 6B pencil trying to get dark stones and light ones as well as making most of them a medium tone. This step is indicated in figure 5–34A. To get the final effect as shown in 5–34B, I used the sharp edge of the 6B pencil to indicate the shadows from the rough parts of each stone and my sharp-point HB pencil to sharply define the mass of each stone. Note that I did not draw every stone; in two areas I just used a medium tone to show that something is there. Brick and stone walls can easily become monotonous to look at if every single one is drawn. The trick is to suggest enough of them and let the viewer's imagination supply the rest.

## Smooth Stone Walls

A pencil drawing of a smooth stone wall is shown in figure 5–35. This drawing started with a *very* light pencil outline over which I used the broad point of a 3B pencil to tone each stone. While doing this, I tried to make a few of the stones a little darker. Then I used my kneaded eraser to remove some of the graphite along the top edge of each stone. This is indicated by the A's in figure 5–35A and B. Some of the stones were made lighter than the others by pressing the kneaded eraser on them to pick up some of the graphite. Finally I used a sharp HB pencil to show some of the intersections between the stones and to add the grass marks. When you show the joints between stones such as these, do not draw all the lines. Draw them here and there with a broken line.

## Rubble Walls

If you travel and visit ruins of any kind, in the southwestern United States, Central America, Europe, anywhere that stone was used in the distant past for structures of any kind,

**Figure 5–34**
**A textured stone wall.**

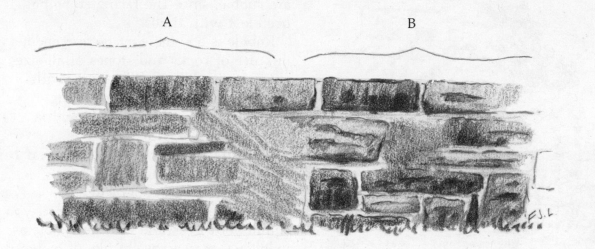

**Figure 5–35**
**A smooth stone wall.**

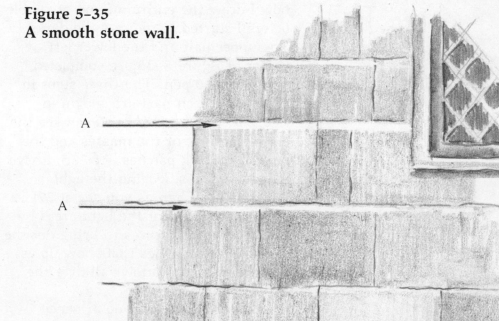

**Figure 5-36**
**A rubble wall.**

A

B

C

**Figure 5-37**
**Steps in drawing the rubble pieces.**

you will find rubble walls. Rubble is used inside of the finished surfaces of cathedrals, Central American pyramids, and other ancient structures. Many of the Roman ruins around the Mediterranean Sea and in Great Britain are rubble, since the facing stone has been lost with time.

Rubble is a somewhat heterogeneous mixture of rocks and stones of all sizes chosen primarily to fill a space with bulk that is capable of supporting weight. Usually, it is covered with a more decorative, finished stone.

Drawing rubble can at first appear to be an overwhelming task. The challenge can be brought to a manageable proportion, however, if you squint your eyes and see the rubble as individual masses or chunks of material with just dark and light features. Then draw these masses, ignoring all the fine detail that clutters such a scene. This degree of simplification is illustrated at "A" in figure 5-36. This shows you how I drew the entire mound of rubble before I started to indicate the darks. The upper half and the lower left corner of figure 5-36 are completed with my 3×0 pen. The three steps in completing each part are shown in figure 5-37. In 5-37A, you can see the outline, in ink, of the masses and the prominent dark patches. At 37B, I have toned the darks, leaving the lights a white paper. Then as you see at 37C, I show the texture of the light areas by little marks and curves to bring out the surface irregularities that show up as millions of tiny shadows all over the exposed surfaces.

Rendering such a scene in pencil requires about the same sequence of steps. A pencil sketch of part of the same rubble wall is shown in figure 5-38. I used a 6B pencil on very toothy paper for this illustration.

**Figure 5-38
A pencil version of the
rubble wall.**

*Cathedral Ruins*

Figures 5-39 and 5-40 show an
application of the drawing of smooth
stone walls. This is a small part of a
ruined cathedral in Great Britain. The
walls were smooth and by and large
remain so to this day except for a few
areas of chipping and pitting of the
stone. Figure 5-39 is a technical pen
drawing of one small part of the ruins.
Note that to indicate the smoothness of
the stone surface with ink I either used
white paper with a few vertical hatch
marks or very regularly spaced vertical
lines to show the shaded areas. The
pitted stone areas were done in the
same manner as the pitted surface of
the rubble walls just discussed. The
pencil treatment of this same scene is
shown in figure 5-40. The steps
discussed around figure 5-35 were
used here, including the use of the
kneaded eraser to lift out graphite to
make some of the stones a little lighter
than others.

*Random Stone Wall*

A random stone wall, with smooth
stones of different shapes, sizes and
colors, is illustrated in the pencil
drawing of figure 5-41. The first step
here was a very light pencil outline of
the wall and each stone which I then
toned with the broad point of a 3B
pencil as shown in figure 5-42 at A.
The second step involved darkening a
few of the stones and darkening the
underside of some of the light ones as
you see in figure 5-42B. To get some
further variation in the tone of the
stones, I pressed a kneaded eraser on
some of them to lighten them. This can
be seen in figure 5-42C. Then, using a
sharp HB pencil, I sharpened the
outline of each stone, simply making it
distinct rather than fuzzy as the initial
toning left it. When I do this, I try not
to let an actual outline show. Rather, I
sharpen the edge then blend this into
the general tone of the stone so no hint
of an outline can be seen. The concrete
cap was done with the broad point of
an HB pencil. I used both the broad
point and the sharp edge of a 6B pencil
to put the shadow under the cap and to
draw the vegetation in front of and
behind the wall.

Figure 5-42D shows where I broke
up the monotony of all the stone
shapes by just including a tone rather
than drawing every stone. This is a
way of saying "etcetera" when there
are a lot of the same things in a
drawing of a wall.

*Drawing Brick Walls*

By their sheer number, bricks en
masse in a wall can easily become
monotonous to draw and to look at. To
help avoid this, try not drawing all the
bricks you see in a scene; just draw
some and cover large areas just with
tone. The viewer will fill these toned

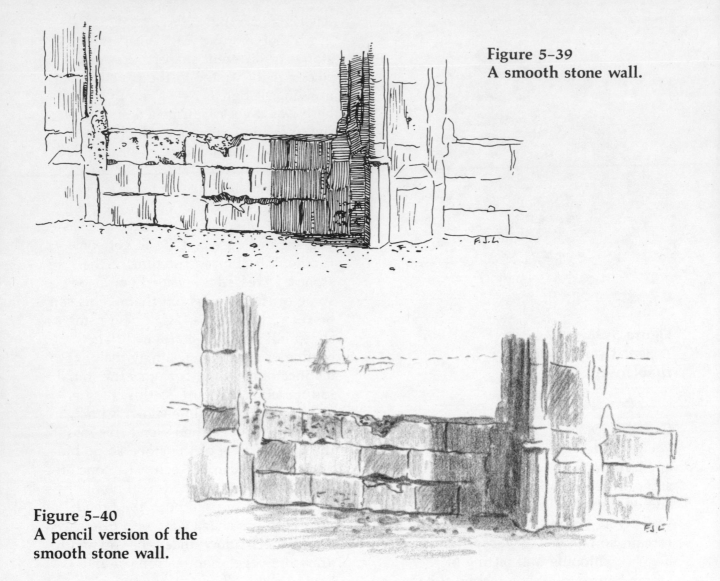

**Figure 5-39
A smooth stone wall.**

**Figure 5-40
A pencil version of the
smooth stone wall.**

areas in with bricks without even realizing it. Further, to relieve the monotony slightly vary the tone of the bricks. Make most of them an intermediate tone with a few being lighter and a few darker.

   If the scale of your drawing requires that individual bricks be shown, try the approaches of figures 5-43 or 5-45. The first of these illustrations shows a brick garden wall rendered in pencil. You can see the three tones on the bricks that lend a little variety to them. Also you can see the areas where I did not draw bricks at all, just a flat tone. These steps are shown in figures 5-44

and 5-46. The usual very light pencil drawing preceded each of these sketches. The one done in ink allowed me to erase these pencil guide lines when the inking was complete. The one in pencil did not, of course. Figure 5-44A shows how I carried the general brick tone over into those areas that I did not intend to detail with actual bricks. At 44B you can see how I underlined some of the bricks, and at 44C you can see how I darkened some of them. These same things were done in the ink drawing as shown in figure 5-46.

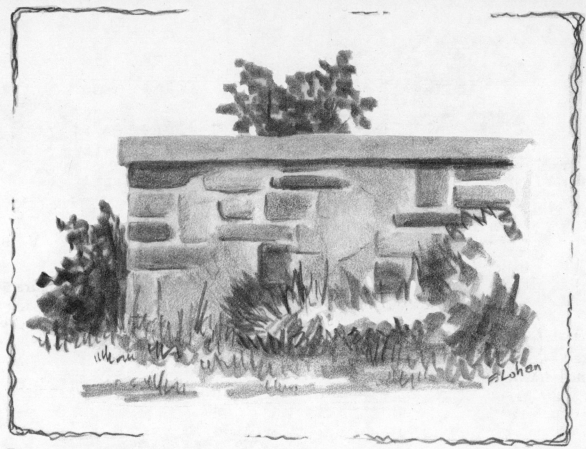

**Figure 5-41**
**A random stone wall.**

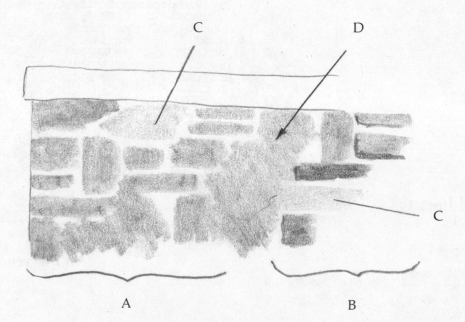

**Figure 5-42**
**The first steps in drawing**
**the random stone wall.**

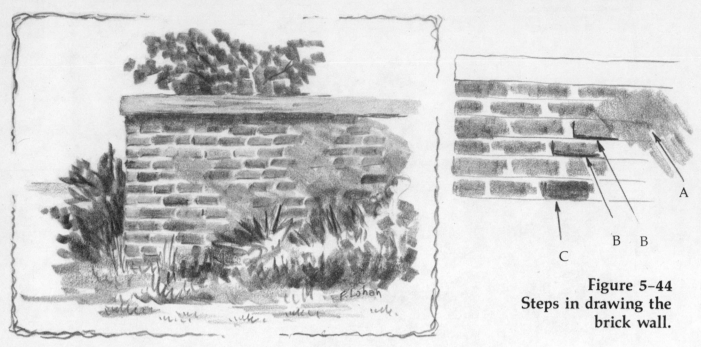

**Figure 5-44**
**Steps in drawing the**
**brick wall.**

**Figure 5-43**
**A pencil drawing of a**
**brick wall.**

**Figure 5-46**
**Using slanted lines to**
**show the bricks.**

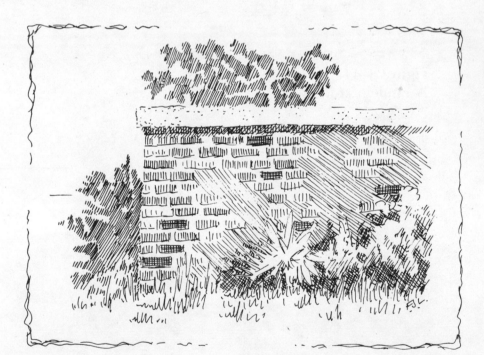

**Figure 5-45**
**An ink rendition of the**
**brick wall.**

**Figure 5-47**
**A country stone wall.**

*Country Stone Walls*

New England abounds with old stone walls. Robert Frost acknowledged them in his poem, "Mending Wall." These stone walls are of a random nature, being little more than piles of various stones. Figure 5-47 is a very quick pen sketch, with a fairly coarse pen point, showing a typical New England stone wall bordering a ploughed field. The stones used in such walls, or fences as they are sometimes called in New England, are not too large generally—perhaps one to two feet in the largest dimension. There were enough of the stones in the scene in figure 5-47 that I did not want to show all of them individually. You can see the areas where I simply indicated a shadow tone rather then draw each one.

When the rocks are large and there are not too many in view, there is nothing wrong with drawing each one

as I did in figure 5-48. Note, however, that those stones farthest away are just hinted at with a few curved lines. Drawing them out in full would have destroyed the illusion of distance, since detail tends to bring a sketch element forward.

The apple trees were put into these sketches for interest's sake. The walls just by themselves would be of limited interest. Drawing trees like this is easy if you follow the steps shown in figure 5-49. First, as in 5-49A, draw an irregular line in the direction shown. At each irregularity bring out another irregular line as shown in 5-49B. Then continue this process until you have filled out the tree enough to satisfy yourself. You can add major branches as shown in 5-49C. Finally make the trunk and major branches heavier as shown in figure 5-49D.

**Figure 5-48**
**A wall of large stones piled up.**

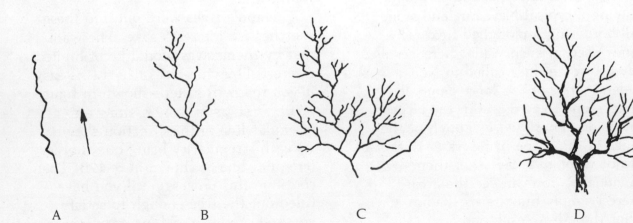

A                B                C                D

**Figure 5-49**
**The steps in drawing trees with no foliage.**

*Fieldstone Walls*

Many barns were constructed with fieldstone foundations on which a wooden structure was built. This is a combination that you will run into often in the eastern half of the United States. Figure 5–50 shows the outline drawing of the corner of such a barn. I will show you a few ways of drawing this kind of stone foundation in pencil.

The first way is with a sharp 3B pencil only. I selected a few stones to make dark as you see in figure 5–51. Notice also that I did not draw every stone. To minimize the monotony of so many individual pieces, as discussed earlier in this chapter, I left areas just for filling in with tone rather than showing each stone. As you can see in figure 5–52 I continued on with the 3B pencil to tone the other stones as well as the mortar between them. I darkened the bottom of each one to indicate the roundness of the forms. I also used the kneaded eraser several times to lighten individual stones as well as larger areas. I did this in a back-and-forth manner, adding darkness here and there with the pencil and lightening selectively with the kneaded eraser, until I was satisfied. Then I used my sharp HB pencil to get the barn boards to show up sharply and to trim the darks between them. The back-and-forth work with the kneaded eraser and the 3B pencil gave a smooth texture to the stone surfaces.

In figure 5–53, I used a sharp HB pencil only. Here I made no effort to hide the pencil strokes by blending them. I still made some of the stones darker than the others and left the obvious outline around each stone. This is the kind of approach you will often use on the spot when you are making notes for use back at your studio when

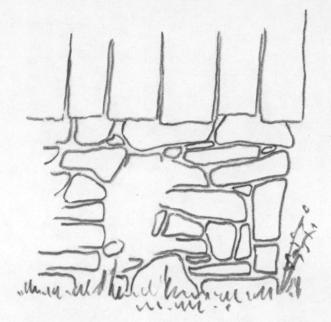

**Figure 5–50
Outline drawing for several pencil studies of ways to draw a fieldstone wall. Leave blank places where the stones are not drawn.**

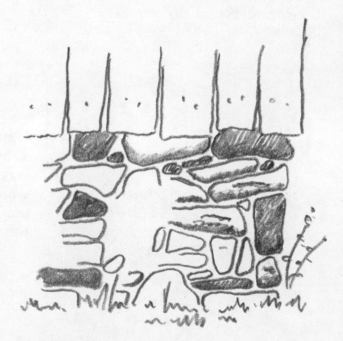

**Figure 5–51
First make some of the stones dark.**

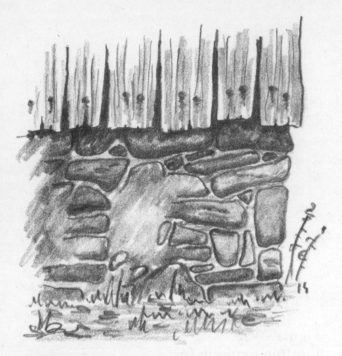

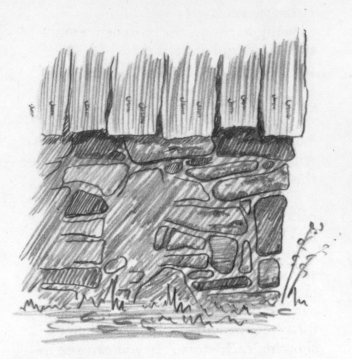

**Figure 5–52**
This was completed with a sharp 3B pencil and liberal use of a kneaded eraser pressed over places. A sharp HB pencil created the edges around the boards.

**Figure 5–53**
This was drawn with a sharp HB pencil only.

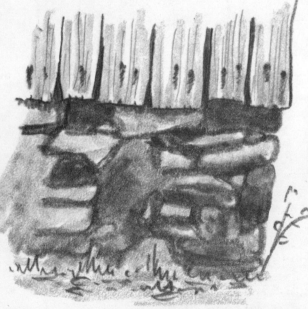

**Figure 5–54**
A broad-point 4B pencil was used to outline each stone (A), then the same point was used to tone the stone (B).

B

A

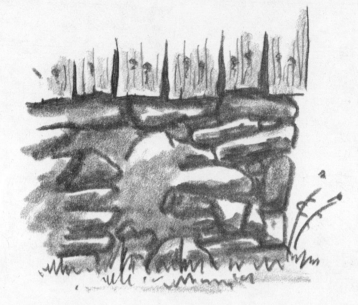

**Figure 5-55
A sunny effect is achieved by leaving white paper highlights. This version was done with a broad-point 6B pencil.**

doing a more thorough drawing.

In both figures 5–52 and 5–53, the mortar between the stones is indicated as being light in color. Sometimes it is dark, as I show in figure 5–54B. To start this sketch, I used a broad-point 4B pencil to outline each stone, as in 5–54A. The broad point does not make a definite line, and the outline around each one is therefore emphasized much less. In this sketch I also used the kneaded eraser a little to get some variety into the tone of the different stones. If you want to get the effect of sunshine on the stones, you have to create some highlights as you draw. Since it is rather difficult to erase the pencil enough to get back to white paper, it is best to leave the white paper alone if you want it to show in the final drawing. I did this in the sketch in figure 5–55. Here, I used a broad-point 6B pencil and proceeded as in the previous figure except for leaving the white paper untouched by the pencil in the areas where I wanted

the highlights.

Fieldstone walls can be just as effectively rendered in ink as in pencil. Two ways of using ink to draw dark stones in such a wall are shown in figures 5–56 and 5–57. The "A" sketch in each of these figures shows how I started the drawing and the "B" sketch shows what it looked like when completed. Figure 5–56 shows a wall with mortar between the stones, and 5–57 shows one without mortar, that is, with the stones put up dry, just piled on top of one another.

Dark mortar can be drawn as in figure 5–58. In this figure, I made some of the stones dark by hatching over the texture marks. Light, highly textured stones are shown in figure 5–59 and the same kind of stone as it would appear if whitewashed or painted white in figure 5–60. The whiter the stone, the more delicate your line work must be. Figures 5–56 through 5–60 were done with my 3×0 technical pen.

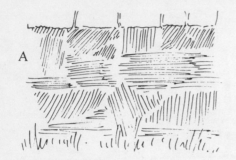
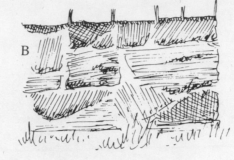

Figure 5–56
Dark stones and light mortar.

Figure 5–57
No mortar shown.

Figure 5–58
Dark mortar with both light and dark stones.

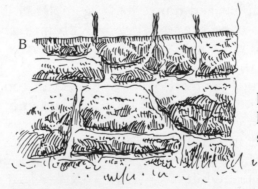

Figure 5–59
Light, highly textured stones with light mortar.

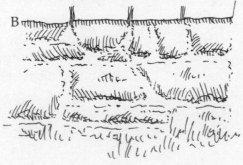

Figure 5–60
Very light, highly textured stones. An approach in drawing a white-washed stone wall.

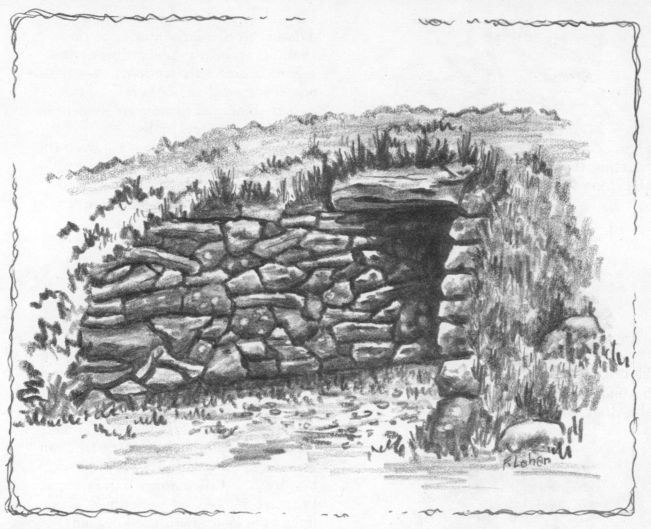

**Figure 5–61**
**An underground stone chamber.**

# Underground Stone Chamber

To wrap up this section on drawing rocks, stones, and stone walls, I have included several studies based on some photographs of underground stone chambers in Wales.

The drawing in figure 5–61 is a composite for illustrative purposes only. It represents no particular place. There is a large lintel stone over the opening and dry stacked stones on either side forming entryway walls. The whole is covered over with earth and sod. The view shows one wall and the edge of the other. The wall shown is composed of randomly sized stones stacked in a dry fashion—that is, with no mortar.

Each stone is drawn with the dark space between prominent. To do this kind of drawing, you must be sure that you do not repeat sizes or shapes adjacent to each other. The challenge is to capture the randomness of the arrangement. I tried to make some stones darker and some lighter to get some variation in the pattern. Further,

**Figure 5–62
Starting the drawing of
the stone wall.**

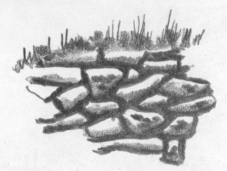

**Figure 5–63
Second step in drawing
the stone wall.**

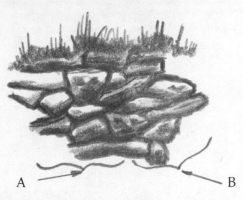

A                        B

**Figure 5–64
Completing the stone
wall.**

**Figure 5–65
How to add lichen to the
dark stones.**

I let the brightest highlights fall adjacent to the dark interior of the chamber to help establish this as the area that draws the viewer's eyes. I also added some lichens on a few of the darker stones, as these were evident in some of the photographs.

Figure 5–62 shows how I started the drawing of the wall. Each stone was lightly drawn in place and then the deep, dark spaces between them was filled in with a dark 6B pencil.

In figure 5–63, you can see how I started to show the texture of individual stones by adding the little dark shadows caused by the roughness of the stones. Also in this view you see how I started to tone some of the stones all over with the 6B pencil just lightly touching the paper. I proceeded in this manner, adding tone and sometimes pressing my kneaded eraser on large areas covering several stones. The lightening effect of doing this can be seen in figure 5–64B. I went back and forth in this manner darkening as in figure 5–64A and sometimes lightening again with the kneaded eraser.

To add the lichens, I proceeded as in figure 5–65. At 5–65A, I pressed a pointed kneaded eraser to the dark area several times, kneading the dirty part into the eraser between applications. When I had a light enough spot, it was larger than I wanted, so I outlined in pencil the part I needed, as you see at B. Then using a sharply pointed HB pencil, I toned around the little lichen to eliminate the drawn circle of B.

When you hold figure 5–61 at arm's length, or prop the book up and look at it from ten or twelve feet away, you can see that the individual stones are far too prominent. The pattern of dark spaces between the stones catches and holds your eyes no matter where in the

drawing you want to explore. This is undesirable in a drawing unless it is one that documents an archeological site. This kind of overwhelming prominence removes the drawing from any consideration as a piece of acceptable art, although it may well be a good and accurate documentary drawing. If the message of the piece is to be the dark opening, the stone work must be made subservient. One way to achieve this is to lessen the emphasis on the pattern of dark areas between the stones. Two things will help in this regard. First, the darks between the

stones should be made less dark—there should be less contrast between these darks and the general tone of the stones. Second, not every stone has to be drawn. Earlier in this section, when we considered brick walls and stone walls, I showed you that you do not have to draw each brick or stone. The same principle can be applied to this study as I show in figure 5–66. Here, I only show every stone in the area around the dark entrance to the chamber. I show the spaces between the stones very dark here also as well as concentrating some of the brightest

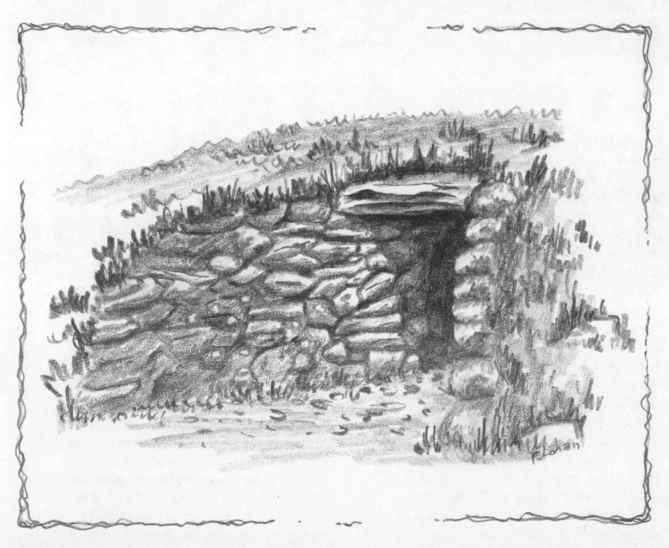

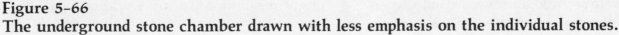

**Figure 5–66**
**The underground stone chamber drawn with less emphasis on the individual stones.**

**Figure 5–67**
**Use of the kneaded eraser**
**to suggest rainfall.**

highlights at this center of interest. To the left of this area, I only drew a few stones in full and used tone to indicate that there were more. Look at this sketch from a distance of ten or twelve feet. See how your eyes are drawn to the entrance area and are not continually pulled back out by the pattern of darks as happened when you viewed figure 5–61 in this manner.

Remember that both of these drawings have merit: the one as a documentation of exactly what was at the site, and the other as a sketch that emphasizes the mystery of this ancient hole in the ground.

One last study of this subject, figure 5–67, shows how the mood of a rainy day can be brought into a drawing. Note that there is no indication of shadows, there are no very dark darks and no very bright brights. Everything is a somber middle tone. I used the kneaded eraser, pinched to a sharp

edge between my fingers, to lift out the narrow, slanted light areas to suggest falling rain.

This subject is a very good one for practice with the pencil. I suggest that you try drawing it, just about the size it is reproduced here, several ways. See for yourself how easy it is to overwork elements like the dark spaces between the stones. Try to get a sunny day effect by using strong contrasts and then try for the rainy-day mood by bringing everything to just middle tone. To assist you in using this for such valuable practice, I have included figure 5–68, the layout of the study showing every stone in the wall. Use this as a guide to make your own working drawing. Just remember to make your outline very light. Mine is shown dark here simply to make it reproduce well in the book. I used very faint pencil lines in my working drawing.

**Figure 5-68**
**The layout of the**
**underground chamber**
**drawing.**

*Summary*

Where possible, avoid the repetition of the same shape over and over when you are drawing rocks. A quick thumbnail sketch before you do your working drawing will often show you undesirable repetition of shapes and sizes.

When doing pen and ink drawings of rocks, use line direction to indicate the slope of the surface being drawn. That is, draw vertical surfaces with vertical lines and slanted surfaces with slanted lines. When you show surfaces that are catching a lot of light, add a few lines to them, *very lightly*, to show the surface direction. If it is the top of the rock, then use horizontal lines.

Create your lightest lights and darkest darks near the center of interest of your drawing, since these will tend to attract the viewer's eyes.

When drawing with the pencil, your kneaded eraser is a valuable tool. Press it onto the drawing to lighten overly dark areas, or shape it between your fingers to selectively lighten places to show highlights that are not prominent enough.

You do not always need outlines in your finished drawing. If you plan a dark background, then you can let the dark area form the lighter elements that lie in front of it.

When you draw stone or brick walls, you do not always have to draw every stone or every brick. This can sometimes lead to monotony for the viewer. In random places, just use a tone in place of groups of the stones or bricks. The viewer's imagination will fill these areas with the proper elements.

Use figure 5-68 as a guide for drawing several different studies of the underground chamber. Try the sunny day effect, then try the rainy day mood. Do the drawing in pencil on very rough paper, then try it on smooth paper. Try it in ink. It is only by doing studies like this as practice that you will achieve success when you strike out on your own with original drawings.

# 6
# Drawing Wood and Wooden Things

# Basic Structure

You will come across the necessity to draw wood in one form or another many times in your countryside sketching. There are trees of course, and you will often want to drawn them in the foreground where detail of the bark structure will be required. There are also fence posts, wagons, and wooden siding on barns, covered bridges and other structures. In this chapter, I will show you how to approach drawing some of these things. Your own practice will lead you to develop your own personal style, but at least some of the hints from this chapter will allow you to get going by using some of my techniques.

Drawing trees is covered more fully in my earlier book, *Wildlife Sketching*, where a complete chapter is devoted to this subject.

Wooden objects in drawings are generally recognized as such because either the object is recognized as being made of wood, or there is some indication of wood grain and texture to help the viewer see that it is of wood. Figure 6-1 shows seven sketches of wooden items, from a piece of a tree branch to a wooden bushel. In each of these sketches there is an indication of the grain and the texture of the wood. The fence post is obviously rougher than the two boards because the ink lines are bold and choppy to indicate the roughness. The bushel basket has a smooth appearance because of the short straight lines that show the wood texture.

I will cover trees to some extent and barn siding in this chapter. In the later chapters, when specific subjects are treated, I will go into further detail about the approach to sketching wooden things under various circumstances.

# Drawing Rough-Barked Trees

*Pen Drawing of a Log*

The rough bark of an oak, maple, or elm tree looks impossibly complex at first glance. If you squint at it, however, you will see that the many furrows form definite patterns of vertical dark lines. It is this impression that you want to convey when you draw such a texture. A log, cut down by a chain saw, will be the subject to show one way to draw rough tree bark.

Figure 6-2 shows you the pencil drawing I used to start the sketch. Remember, as I mentioned earlier, the pencil working drawings shown in this book are dark only to allow them to reproduce in the illustrations. When I draw on my working paper, I make the pencil lines as light as I can so that they can be very easily erased if the drawing is done in ink and so that they do not show very much if the drawing is done in pencil. Your working drawings should be as light as you can make them. In figure 6-3, I have my 3×0 technical pen to go over the pencil lines which were then erased in this illustration. The next thing I did was to start to develop the long, deep furrows in the bark with groups of short hatch marks as you see in figure 6-4. Since

**Figure 6–1**
Drawings of wooden objects are usually
recognized by some indication of the
wood grain and texture; or because we
recognize the object and know it is made
of wood.

**Figure 6-2**
The pencil layout of a log.

**Figure 6-3**
Inking started and pencil layout erased. Darkest furrows located by lines.

**Figure 6-4**
Shadows from deep furrows in the bark shown.

**Figure 6-5**
(A) Shading started on underside of the log.
(B) Shading carried part way up the side.
(C) Other marks put in light areas to show the roughness of the bark.

**Figure 6–6**
**Complete ink sketch of the log.**

**Figure 6–7**
**Two things to watch out for:**
**(A)** *Do not* **leave a white space between the log and the ground.**
**(B)** *Do not* **make the log darker than the ground where they meet.**

the light is coming from the top of the drawing, I left a lot of white paper at the top of the log to suggest a highlight there. The shadow on the underside of the log was then put in as at figure 6–5A. I did this all the way across the log, then I did it again but starting higher and going over what I had already shaded as you see at figure 6–5B.

A lot of bark texture was actually visible in the area that I left as highlight, so, as you see at figure 6–5C, I used the pen to indicate this roughness. The final steps were to add a few weeds at the ends of the log and to complete the ground. This is shown in figure 6–6, the completed sketch.

This simple subject is a good one to practice creating this kind of texture. I recommend that you use figure 6–2 as a guide to make a working drawing of your own to complete according to the steps I have outlined above. When you do this be sure that you show this massive log lying firmly on the ground. Do not leave any white paper showing under the log where it touches the ground as I show in figure 6–7A. In removing any white that may be left, do not overdo the dark. If you do you will have the log become darker than the ground, as you see in figure 6–7B. This, just as much as the extra white under there, should be avoided because each tends to separate the log from the ground. You want them to blend into one another.

**Figure 6–8
Start of a pencil sketch of
the log.**

**Figure 6–9
Completed pencil sketch of the log.**

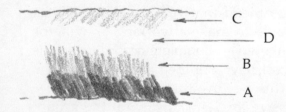

**Figure 6–10
Steps in toning the log.
(A) Darkest underneath.
(B) Intermediate tone on
the side. (C) Light tone
on the top. (D) Highlight.**

*A Pencil Drawing of the Log*

When drawing the log in pencil, your objectives are the same as for the ink drawing—to show the texture and the shading. Figure 6–8 shows the start of a pencil version of this subject. I have made the furrows heavy on the lower half of the log and made them finer on the upper, highlighted half. Figure 6–9 shows the completed pencil sketch after the shading and the ground indication was added. The entire sketch was done with a sharp 3B pencil. Note in figure 6–10 the four shading tones I used. The darkest is underneath the log and the lightest, no pencil at all, as you see at 6–10D, creates the highlight.

**Figure 6–11
A pen sketch of a rough-
barked tree.**

*Pen Drawing of a Tree*

The weight of a pen point can make a big difference in the effect created in an ink sketch. Figure 6–11 is a pen sketch of a rough-barked tree. I used a medium-point pen for this. The steps in building up the texture are shown in figure 6–12A and B. They are essentially the same as those used for the ink sketch of the log in figure 6–6. Compare these two sketches, 6–6 and 6–11, and note the delicacy that can be obtained with the fine point and the boldness of the one done with the coarser point. The coarse point can be used to advantage to quickly, and loosely, capture a subject's essence. Figure 6–13 shows the same subject drawn rapidly with a coarse fountain pen. Here, I made no attempt to use the same technique as I did with the fine technical pen in doing figure 6–6. Rather, I took advantage of the ability of the coarse point to quickly lay down a lot of ink and just used long interlocking and overlapping strokes to show the roughness of the bark.

I recommend that you practice this subject with both a fine and a coarse

point in your pen. See for yourself the
advantages of each one. Figure 6–13
required just a few minutes to
complete with the coarse point—
considerably less time than figure 6–6
required with the fine technical pen.
Remember, each tool has its own
application.

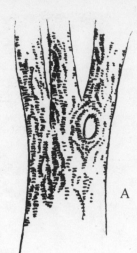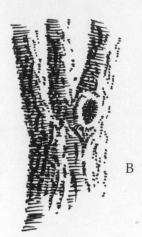

**Figure 6–12
Steps in completing the
bark on the tree:
(A) Texturing the deep
furrows in the bark.
(B) Adding the shading
on the left side.**

**Figure 6–13
A loose sketch of the
rough-barked tree, made
with a coarse-pen point.**

# Drawing Smooth-Barked Trees

Some trees have relatively smooth bark without deep ridges and furrows. Notable among these are the beech, the birches, and some maples. The challenge in sketching these trees close up is to convey the smooth character of the bark at the same time that you use tone to create the cylindrical form of the trunk and branches.

*A Pen Drawing of a Birch Tree*

Figure 6–14 shows a technical pen sketch of two birch tree trunks. You can see in this figure that no outlines were necessary for the sketch. The shading lines and the bark texture marks I used were enough to form the outline of the trees without the need to draw boundary lines for the trunks. Since these tree trunks are very white, the shading I used to show the roundness of the trunks had to be delicate so I used my 3×0 technical point for figure 6–14. The way I went about it can be seen in figure 6–15. I had decided that the light would be coming from the left, so I first shaded the right side of the trees with fairly widely spaced lines as you see in figure 6–15A. Then I superimposed the dark markings that characterize this bark as in figure 6–15B. This latter figure shows the pencil guide lines I used, but it shows them much darker than I actually had on my paper to be certain they would reproduce in the book.

To use pencil to draw this kind of bark, proceed as in figure 6–16. The first thing is to establish the outline of the trees without actually drawing one. The shading does this for you. In figure 6–16B I used a broad-point 3B pencil to show a wide band of tone at the right to indicate the shaded side of

**Figure 6–14
Outlines are not needed
for some subjects. These
birch trees are an
example.**

the trunks and a narrow band at the left to show the edge of the tree image—with my sharp HB pencil I made these edges sharp and distinct, as in figure 6–16C, then I put the dark markings on. The complete approach can be seen in figure 6–16A.

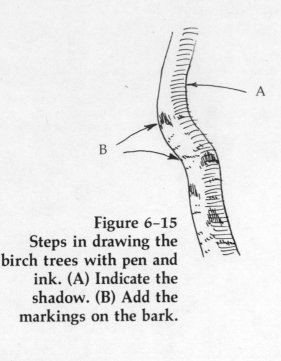

**Figure 6–15
Steps in drawing the
birch trees with pen and
ink. (A) Indicate the
shadow. (B) Add the
markings on the bark.**

**Figure 6–16
(A) Pencil drawing of part
of a birch tree. (B)
Strokes with 3B pencil.
(C) Darker shadow
sharpened.**

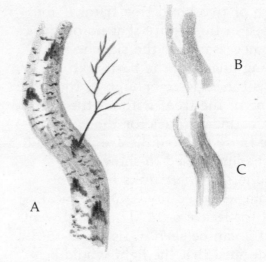

*Pen Drawing of a Beech Tree*

The beech also has a smooth bark. It is a silvery gray in color and except for some undulations in the older trunks, is quite smooth in texture. Figure 6–17 shows a 3×0 technical pen drawing of a beech tree trunk. The way I built this sketch is shown in figure 6–18. First, I made a pencil working drawing, parts of which can still be seen in figure 6–18A. Using these pencil marks as guides, I started to ink the shaded areas as in 6–18A. When they were no longer needed, I erased these pencil lines. Then I went on with the groups

of hatch marks to show the undulations in the trunk of the tree. This is indicated in figure 6–18B. Note that I deliberately left some white paper showing between many of these groups of hatch marks to show where sunlight was hitting the high places. The final step shown in figure 6–18C was to darken some of the areas that were receiving no sunlight. This kind of sketch requires the delicate line of a fine-point pen to successfully capture the feeling.

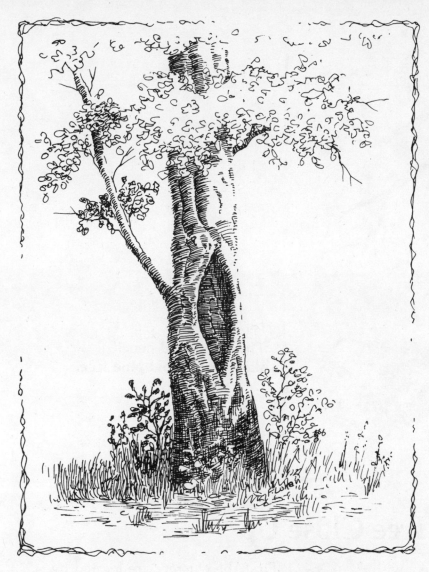

**Figure 6–17
A pen sketch of a smooth-barked beech tree.**

**Figure 6–18
Steps in drawing the beech tree bark. (A) Inking using the pencil lines as guides. (B) Continuing the inking leaving white highlights. (C) Final darkening.**

A                                          B                                          C

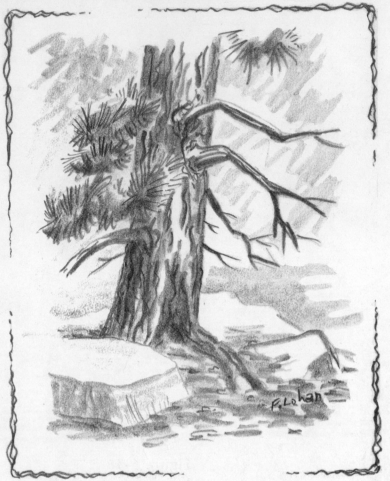

**Figure 6–19
The completed pencil
sketch of an old pine tree.**

# Drawing a Pine Tree Close Up

This subject can get quite busy with many branches and tufts of needles seemingly all over the place. It requires a good deal of simplification to produce a suitable sketch. One way to carry it off is shown in figure 6–19, a pencil sketch of the lower part of an old pine tree. The bark on this tree is similar to that treated in figure 6–9. In this case, I first made the working drawing (light as explained earlier, not dark as shown in these illustrations) and toned both sides of the tree trunk, leaving a highlight down the middle. You can see this stage in figure 6–20. Also shown in this figure are the completed bundles of pine needles. These are drawn in two steps as you see in figure

6–21. First the clusters are located by dark areas made with a broad-point pencil as at 6–21A. Then a few of the needles are indicated with a sharp point, as in 6–21B. The bark is treated as you see in figure 6–22. First the broad point is used to put some bark furrow marks over the shading, as at 6–22A, then a sharp point is used to overlay a few sharper bark marks after the shading is deepened somewhat, as at 6–22B. Finally, a few of the many branches are shown and an understated foreground and background are added. A broad-point 3B pencil was used for most of this sketch, with a sharp HB for the needles and the fine bark marks.

**Figure 6–20**
**The start of a pencil sketch of the base of an old pine tree.**

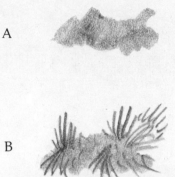

A

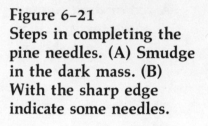

B

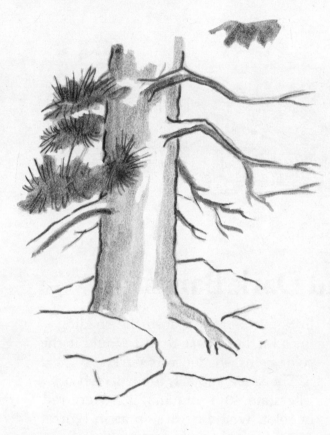

**Figure 6–21**
**Steps in completing the pine needles. (A) Smudge in the dark mass. (B) With the sharp edge indicate some needles.**

A

B

**Figure 6–22**
**Steps in completing the bark. (A) Broad-point texture lines. (B) Sharp point to detail a few texture marks.**

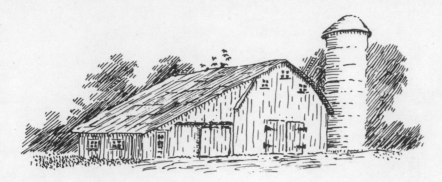

Figure 6-23
A white or light colored
barn—fewer texture lines
are shown.

Figure 6-24
A red or dark colored
barn—more texture lines
are shown.

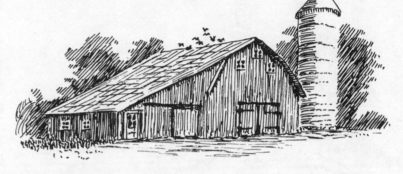

# Drawing Light Barns and Dark Barns

Barns are either light or dark in color. Sometimes the unpainted wood weathers to a marvelous silver color or the barns are painted white. Both of these must show up as a light color in your sketches. Figure 6-23 shows a distant view, done with a 3×0 technical pen, of a light-colored barn. When you are trying to portray light colors, you must take it easy when shading. A shaded white appears very much lighter than a shaded red, so when I shaded the left side of the barn

in figure 6-23, I spaced the shading lines farther apart than I would if the color being shaded was dark.

The same subject, a barn seen off Interstate 90 in Indiana, if it were red in color, would be drawn as in figure 6-24. Here, I used more texture lines to show the dark color and also more shading lines to show the shadow side on the left. To prevent everything from blending in with the dark trees, I lightened up a little on the roof in figure 6-24.

# Drawing Board and Batten Siding

Some outbuildings you may run across will be constructed of board and batten. The battens are narrow strips of wood nailed over the cracks left between the sections of wider boards that cover the structure. A section of such a structure is drawn in figure 6-25. The one I used as a model was made of knotty pine, so I put the spots on to indicate the dark knots. When drawing board and batten, you should first establish the direction from which the light is coming. Then you can make the shaded side of the battens darker, as in figure 6-26A, before you start to show other shadows and the tone of the wood. These later steps are shown in figure 6-26B and C.

**Figure 6-26
Steps in drawing board
and batten siding.**

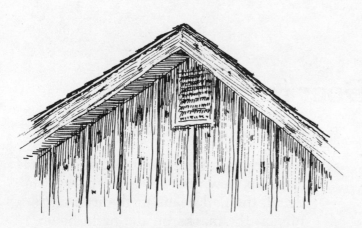

**Figure 6-25
Board and batten siding.**

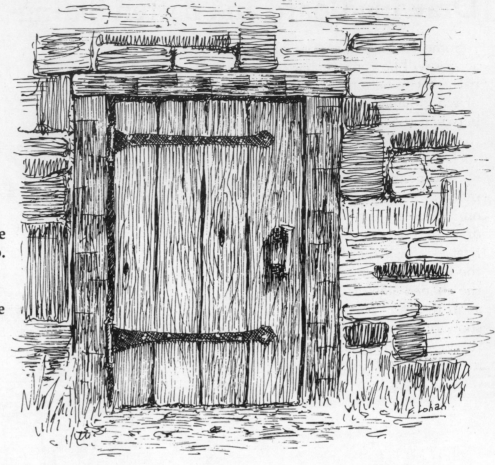

**Figure 6–27**
**A wooden door in a stone barn wall drawn close up. All the details such as nail heads in the hinges and hewing marks on the door frame must be shown.**

# Drawing a Wooden Door from Different Distances

The closer that an object is to the viewer's eye, the more detail must be included in drawing it. It is this detail that helps the viewer interpret the scene properly. I covered this topic in Chapter 5 with a pair of rocks drawn at three different distances from the eye in figures 5–26, 5–27 and 5–28. In this section, I will do the same thing with a wooden barn door set into a stone wall.

Figure 6–27 is a close-up pen and ink study of a barn door. I used my 3×0

technical pen for this drawing. Such a close-up view must include appropriate detail: the nail heads in the iron hinges, the marks on the hand-hewn beams that frame the door, the grain pattern in the boards that make up the door. If you sketch a subject like this from life, you must be certain to observe such details and include them in your sketch. Sometimes, a photograph will not show sufficient detail to allow proper drawing back at your studio. This is where some notes

taken on the spot help, notes in the
form of quick sketches on the character
of the detail that may not show in your
photo.

As the subject recedes toward the
middle ground of your sketch, it
becomes impossible to include the same
amount of detail. In figure 6–28, the
only details preserved are the knotholes
in the boards, the cracks between the
boards, and the dark iron of the
hinges. Texturing lines run the length
of each board, but no grain pattern or
hewing marks are shown.

As the subject moves still farther
back in the drawing, just the most
prominent and descriptive detail can be
drawn. Figure 6–29 shows the door in
context to the entire barn of which it is
a part. In this sketch, there are fewer
than two dozen lines in the whole door
and frame. A real economy of line is
required, and each line must help tell
the story. In this sketch I used just
four lines to tone the door boards to
keep the value of the door about the
same as that of the surrounding stone
wall. Another line or two of tone and
the door would become too dark.

**Figure 6–28**
**The wooden door in the
middle distance. Very
little detail can be shown.
Only essential lines and
tones can be drawn.**

**Figure 6–29**
**The wooden door farther
away. Fewer than two
dozen pen strokes must
define the door.**

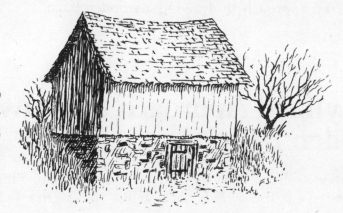

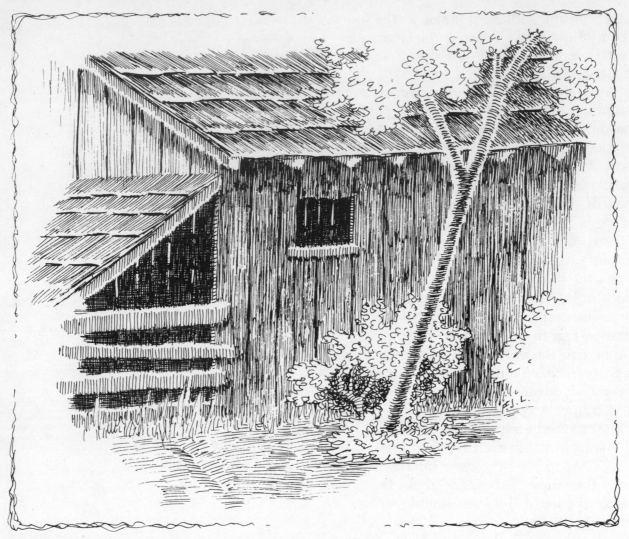

**Figure 6–30**
**A stylized approach to drawing a wooden barn.**

# A Stylized Approach to Drawing a Wooden Barn

Well-done stylized drawings can be very attractive if the style is consistent throughout the entire drawing. Mixing representational and stylistic approaches in one drawing seldom works well. Figure 6–30 is a 3×0 technical pen sketch of a corner of a barn. This is done as shown earlier in figure 4–15, where the emphasis was on the stylized background trees.

Note in figure 6–30 that there is very little use of outlines. Instead, I have left white paper along the edges of most features to act as outlines.

Doing this requires a careful pencil working drawing before the inking starts and then careful inking so that the features are not inadvertently lost as you complete the drawing. Eighteen steps in the completion of this drawing are illustrated in figure 6-31. In the center of the figure is the pencil working drawing. Remember that it is shown dark here only so that it prints well. Actually, it should be as light as you can make it so it can be easily erased after the inking is complete.

Starting with the roof, the first thing I did was put in some heavy, dark lines, as in figure 6-31A to show the overlap shadows of the shingles on the roof. Then the tone and texture of the shingles was added by hatch lines running the length of each shingle as in 6-31B. Note here that I left white paper showing at the end of each shingle; I had a pencil mark there to remind me to stop the ink lines just above the dark overlap shadows. Finally, in 6-31C I piled more hatch marks on the upper half of each shingle. The shingles on the shed roof were completed in the same manner as described above.

In figure 6-31D, I toned the outermost rafter with vertical lines that stopped short of the bottom edge to let the white paper do the outlining there. Then in 6-31E I used heavy, dark lines to show the separation between the siding boards before using vertical hatch marks for the tone in 6-31F. Then I added the shadow on these siding boards just below the rafter as shown in 6-31G.

The large area of barn siding was in shadow, so I toned it darker than the part over the shed. The steps are shown in 6-31H and I; first a layer of vertical hatching, then another layer

put on top of it. When I did this part, I left clean white paper for the ends of the rafters. After the siding was toned properly, in 6-31I, the sides of the rafters were lightly toned, in 6-31J. The ends were left white.

The tree trunk is outlined by white paper on both sides, as you see in 6-31L. The toning of the trunk consists of slightly curved hatch marks that contour the cylindrical trunk in 6-31K. Note in figure 6-30 that the curvature of these horizontal lines is upward below eye level and downward above eye level. This is to carry the proper perspective suggestion and give a feeling of roundness to the tree trunk.

The interior of the barn, seen through the shed, is all dark except for the slivers of light showing through the cracks between boards on the other side of the barn. These slivers of light are marked in pencil on the working drawing in the center of the figure. I inked around these marks with crosshatching, as you see in 6-31M and N, first with vertical hatching, then with horizontal crosshatching.

The horizontal boards across the opening of the shed are outlined on the top side with white paper in 6-31P. The tone on these boards is just a light hatch in 6-31Q, with a slight shadow under the ends in 6-31R. To show the thickness of the siding boards, I used horizontal hatching in 6-31O. If vertical lines were used here, the edge of the siding would disappear.

The foliage was completed as outlined in the discussion for figure 4-16 in Chapter 4. The ground is indicated by horizontal hatching with this hatching tilted slightly to show irregularities in the ground.

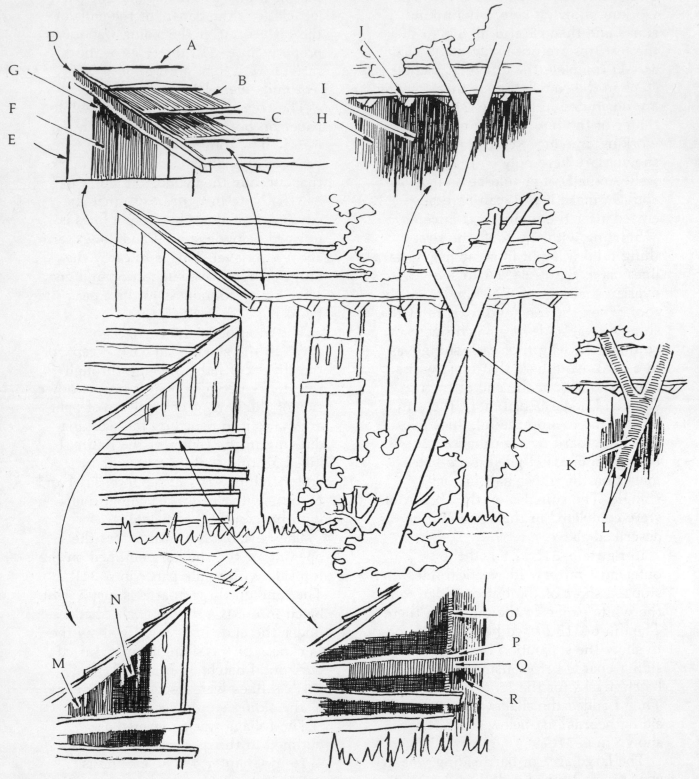

**Figure 6-31**
**Eighteen steps in completing the stylized**
**barn drawing using the light pencil lines**
**as guides for inking. When the ink is dry**
**the pencil lines are erased.**

*Summary*

Squinting at an intricate and bewildering subject, such as the rough bark on a tree, will often show you the basic organization of lights and darks that are its basis. This was the approach used to create the sketch shown in figure 6-6, a rough-barked log. This is a good practice subject. Use figure 6-2 as a guide to make your own light working drawing and complete it with a fine pen point and ink.

The fineness or coarseness of the pen point has a significant effect on the finished product. Coarser pen points produce best results when used to produce loose, quick, bold sketches. When a coarse point is used in the same manner as a fine one, the result is sometimes unsatisfactory. Compare the tree in figures 6-11 and 6-13. In the former, the approach was that used for the fine, delicate drawing of the fallen log but a coarse point was used. The coarse point is more appropriate for the loose sketch of figure 6-13. This subject is also a good one for studies with a fine pen and with a coarse one.

When drawing light-colored structures, you must use fewer lines to tone the shaded areas. Shaded light colors are much lighter than shaded dark colors. This is illustrated in figures 6-23 ad 6-24.

When objects are close to the viewer's eye, there must be a convincing amount of detail included. As the subject moves farther toward the background, less and less detail is used and every line becomes very important. Only the most significant features can be included. This is illustrated in figures 6-27, 6-28 and 6-29.

If a stylized approach is used, it should be used consistently throughout the drawing, rather than being mixed with a representational approach. A stylized drawing of a barn is developed in figures 6-30 and 6-31.

# 7
# Drawing Lakes, Streams, and Waterfalls

*Basic Structure*
*Drawing a Rocky River*
*Ocean Waves*
*Reflections in Water*
*Waterfall*
*Tying it all Together in One Study*

# Basic Structure

Water is generally rather easy to draw if one visual principle is kept in mind—line direction tends to model the surface being drawn. Most of the time when you include water in your sketches it will be the flat, horizontal surface of calm or smoothly flowing water. To represent such a surface in your early sketches you should use horizontal lines.

*Horizontal Lines to Represent Water Surface*

Figure 7-1 shows the rocky coastline, used earlier to introduce the chapter on drawing rocks, completed to include some trees and the water. Calm water is indicated here because the lines that texture the water are almost all horizontal. Those that are not horizontal, near the lower right corner of the study, suggest a little wave.

Horizontal lines tend to suggest horizontal surfaces to the viewer. Just what the particular surface represents in any one drawing must be conveyed by the character of the surrounding drawing elements. In figure 7-2 the horizontal lines obviously represent water because of the irregular coastline and the inclusion of sand and marsh grass. In figure 7-3, the drawing elements suggest a roadway where the horizontal lines are drawn. Other sketch elements could suggest that these same horizontal lines are a table top.

*Lines to Model Surface Undulations*

Lines that slope upward or downward model surfaces also. In figure 7-4, a rutted, dirt roadway with a small embankment on one side is drawn. The direction of the lines model the ruts in the roadway and the steep face of the embankment. This use of lines that model directions of a surface is not a hard and fast rule—very credible drawings can be made using just horizontal lines or just sloping lines. While you are learning, however, it is best to simplify some problems in order to get other fundamentals down solidly before you begin to experiment; the use of horizontal lines for flat, level surfaces is a very useful convention.

The use of horizontal lines as well as lines that slant to represent water that is not all flat can be seen in the study of figure 7-5. Here, some small swells on a large body of water are drawn. The water between the swells is drawn with horizontal lines, while the two surfaces of the swells are drawn with lines that slope upward and downward. Note that these swells are modeled a little more by showing one slanted side of each in a slightly darker tone. In this study, the light is presumably at the left, since the right side of each swell is darkened somewhat.

*Reflections*

Water surfaces may often be suggested by the use of reflections. Figure 7-6 shows an almost glass-like water surface that is represented largely by white paper, since it is reflecting the bright sky. A few horizontal lines establish the plane of the surface and the dark reflections of the two mooring posts and the bow of the rowboat complete the idea that the surface is indeed water.

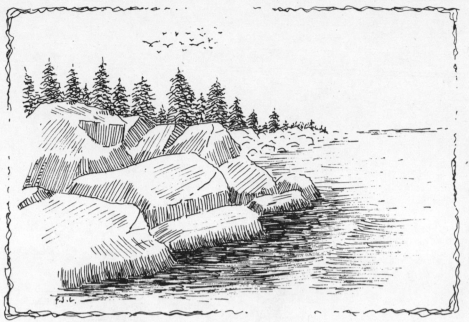

Figure 7–1
Smooth water is suggested by horizontal line work. Departing from horizontal lines at the lower left suggests a little wave.

Figure 7–2
Horizontal lines suggest horizontal surfaces or planes. Other elements of this drawing tell the viewer that the horizontal plane represents water.

Figure 7–3
The other sketch elements tell the viewer that the horizontal surface here is a street or roadway.

Figure 7–4
The line direction models the surfaces being toned. Lines that are not horizontal suggest surfaces that are not horizontal.

**Figure 7–5
Small waves as seen from
a boat.**

**Figure 7–6
The reflections tell the
viewer that the water is
almost calm.**

# Drawing a Rocky River

Countrysides in every country on earth abound with little rivers and streams that tumble downward through, over, and around rocks of all sizes. Such subjects are naturals for pencil and pen studies. Some such scenes were discussed earlier (see figures 5–19, 5–21, 5–22, and 5–31 in Chapter 5, *Drawing Rocks and Stone Walls*). A little rocky river is one of the scenes that can appear to be overwhelmingly complex when first considered. If you remember that when drawing from nature (or from photographs) you must eliminate more than ninety percent of the detail you

actually see, the task of selecting what to include in your study becomes much easier. Outside Gatlinburg, Tennessee, in the Great Smoky Mountains, there are numerous streams or small rivers that present thousands upon thousands of rocks to view at every bend. A study of just such a view can be seen in figure 7–7. In this kind of subject, you have water that is horizontal as well as numerous little cascades that tumble between the rocks. Since these cascades are essentially white water, they are drawn with just white paper and a few vertical flow lines that indicate the surface is vertical. In figure 7–7, I

simplified the immensely complex background of trees, bushes, and branches that I actually saw to a few tones created with just vertical lines. I also simplified the more distant vista with its literally thousands of rocks to just a few curved lines. This left only about thirty individual rocks that I would model with line work, two little cascades, and a patch of flat, running water. This is a considerable simplification of the detail that I actually saw on site, as you can see in figure 7–8 which is the pencil working drawing that I used for this study. The water in figure 7–7 appears dark because it is reflecting the dark foliage and undergrowth that overhangs both banks of the river. In the case of figure 7–6, the water is reflecting the clear sky and therefore appears light.

This rocky river scene is a good one on which to practice. Use the outline in figure 7–8 to make your working drawing in pencil—be sure to make it as light as you can so it will be easily erased after you ink it. Do this study at about the same size as the illustration and use your finest pen point. If you make it much larger, you will have to include more detail than I have shown and you do not have the reference material I used to see this detail. Take a look at figures 5–26, 5–27, and 5–28 in the chapter on drawing rocks to see what I mean about more detail being needed when the rocks are drawn at a larger scale.

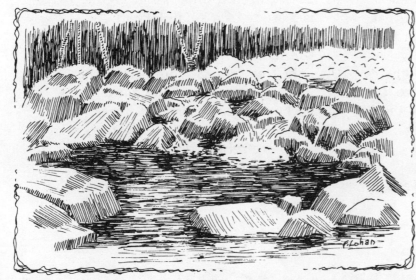

**Figure 7–7
A rocky, cascading river near Gatlinburg, Tennessee.**

**Figure 7–8
The pencil working drawing for the river near Gatlinburg.**

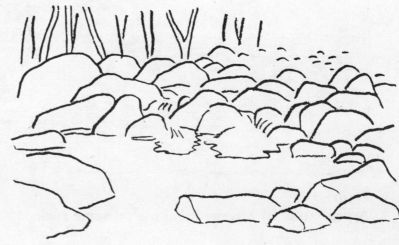

# Ocean Waves

Ocean waves crashing on rocks are the frequent subject of seascape paintings. This is not an easy subject to capture in pen and ink. The crashing wave and the resulting mass of wild, rolling, flying foam presents a pattern of surfaces that are not easily suggested with the pen. For instance, in figure 7–9 I show a pen and ink study of such a scene. Here, I used just horizontal lines to represent the water and the foam, trying to let the different values create the forms—darker for the rising wave and lighter for the foam. An infinite number of planes represented by the mass of foam are not hinted at in figure 7–9, however. Also, the wave has a visible surface that is curved upward and that would appear almost vertical from the perspective shown. A second study working these two ideas into the line work is shown at figure 7–10. Here, I actually use vertical lines to show the wave front and I use curved hatch marks to suggest the complicated pattern of surfaces that the foam presents. This second sketch conveys the idea more fully than the first does. This illustrates the necessity to experiment sometimes to determine which of the many available techniques will be appropriate for the problem at hand. Quick sketches can often lead you to the best compromise.

# Reflections in Water

Earlier in this chapter I showed reflections of some pilings and part of a rowboat in very still water (figure 7–6). In that study, the dark reflections were virtually the only marks showing the water. Sometimes there will be a far shore reflecting in the water and some more complicated line work will be required to indicate it. Figure 7–11 is a study of a small lake in Farmington, Michigan. The scene is in late fall; all the foliage is gone and the light tree trunks from across the lake can be seen against the darker background of evergreen trees. These light tree trunks and dark evergreen trees are reflected in the water. My pencil working drawing showed every one of these tree trunks both on the

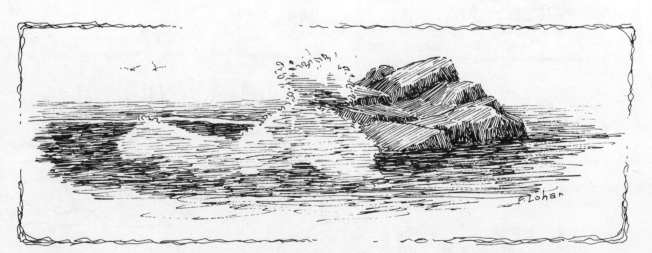

**Figure 7–9**
**A pen study of a wave breaking on some rocks.**

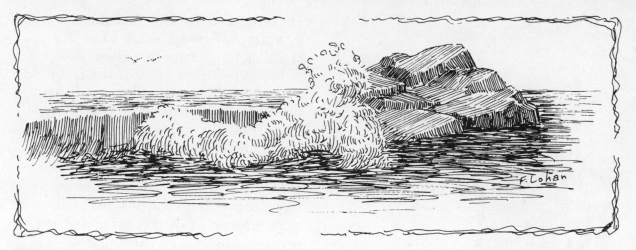

**Figure 7–10**
**Another study of a wave breaking on some rocks. Here the line work defines the wave and the foam more completely.**

far shore and in the reflection of that shore in the still water. These guide lines allowed me to rapidly darken in the trees between the light trunks and then to show the reflected dark areas in the water. Note that I made the reflected darks not quite as dark as the far evergreen trees themselves. When I inked the water, I first left the reflected tree trunks as white paper until I had the reflected darks the way I wanted them. Then I went over the horizontal strokes in the water with more horizontal lines but running over the white paper from the tree reflections to darken them a little. I also toned the

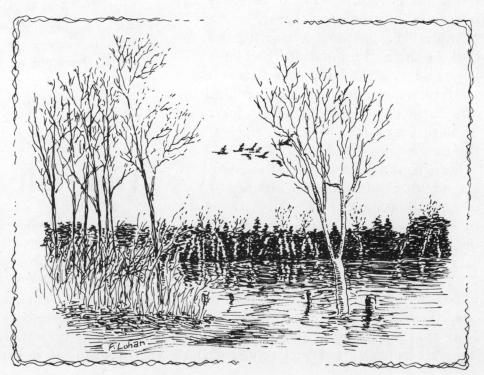

**Figure 7–11**
**A small lake in Farmington, Michigan.**

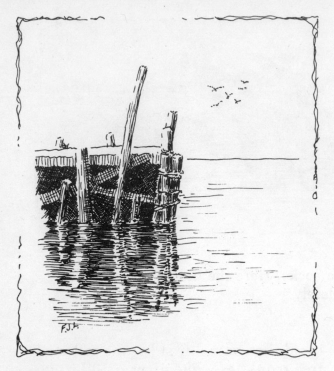

**Figure 7–12**
**Wharf reflections in still**
**water.**

near water with a few horizontal strokes.

Drawing wiry underbrush as at the lower left of figure 7–11 can be easily overdone. I wanted to suggest the mass of underbrush without letting it get as dark as the background. If I had let it get as dark as the background trees, it would have blended in with them and any distinction would have been lost. So here, just a few strokes to suggest the tangle were used.

Foreground reflections of the end of an old wharf are shown in figure 7–12 in a small pen and ink study. A step-by-step breakdown of the development of this study will assist you in using it as a practice subject. First, in figure 7–13, I darkened the underparts of the wharf by hatching. I next crosshatched over these dark areas (figure 7–14A). Note that the hatching and crosshatching were done with very closely spaced

lines. Refer to figures 2–8 and 2–9 in Chapter 2, *Techniques*, for hints on crosshatching properly. Then, as at 7–14B, I textured all the pilings with a few lines running the length of the wood. I pictured the light coming from the left in this study, so I made the right side of each piling darker to suggest the shaded side. At 7–14C, I then added the horizontal hatching representing the shaded sides of the pilings reflected in the water and at D I textured the rest of the wood with a few lines. Figure 7–15A shows how I then shaded the other wooden parts of the wharf with lines that run across the wood, and in 7–15B how I toned the water where the essentially dark wharf is reflected in it. Figure 7–16 shows the finished subject again after I added lines to the water to tone down the white reflections of the pilings and to show the flatness of the light part of the water. I also held the study at arm's length to detect any objectionable white spots and dotted them out. This is another good practice piece. Use figure 7–13 as a guide to draw a pencil working drawing on your paper, about the same size as the illustration, and follow the steps of figures 7–13 through 7–16 to complete it. Use a fine pen for this study. I used my 3×0 technical pen.

# Waterfall

The silvery sheet of a waterfall with the mist generated where it terminates on a mass of broken monoliths is one of the most picturesque of countryside scenes. The water and the mist are probably more suited for drawing with the pencil than with the pen, because the pencil can be coaxed to provide a

**Figure 7–13**
The first step in completing the wharf step is to hatch the dark areas under the wharf.

**Figure 7–14**
(A) Crosshatch the dark underneath. (B) Texture the pilings. (C) Show the dark reflections from the shaded side of the pilings. (D) Texture the other boards on the wharf.

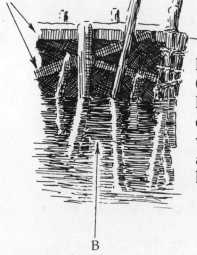

**Figure 7–15**
(A) Shade the boards. (B) Darken the water—darkest close to the wharf, lighter farther away. Use *only* horizontal lines.

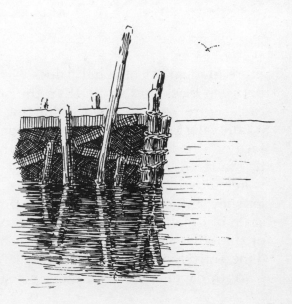

**Figure 7–16**
Add some horizontal lines over the light reflections and in the light water. Add the seagulls.

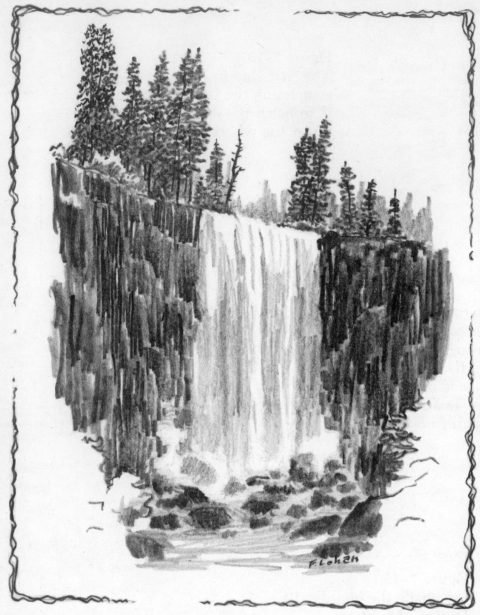

**Figure 7–17
Pencil sketch of a
waterfall and rocky cliff.**

more gradual set of tonal values between black and white than the pen can. Figure 7–17 is a pencil drawing of a tall waterfall cascading over the dark face of a rocky cliff, remnants of which lie scattered in the gorge, which the water uses to continue its relentless journey. Ink could not, at least at this scale of drawing, capture the delicacy of the falling water. This sketch was done entirely with a 4B pencil on smooth paper, the broad point being lightly used to show the basic, light texturing in the water, and being used heavily, with the paper on a hard, flat surface (a piece of glass) to draw the rest.

My pencil working drawing can be seen in figure 7–18—remember, it was actually much lighter than shown here. The trees at the top of the cliff were completed as shown in figure 7–19A. Short squiggly lines were made with the sharp edge of the pencil to suggest

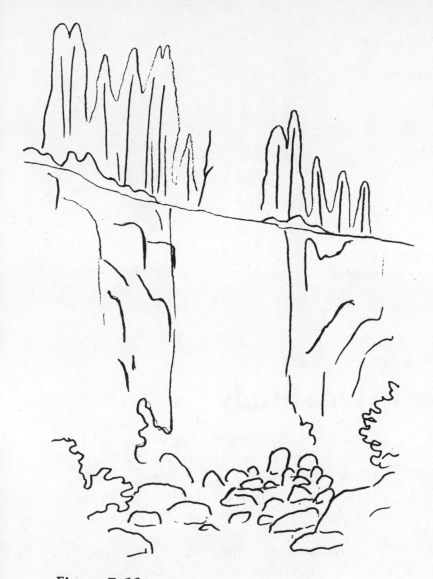

**Figure 7–18**
**The working sketch for the waterfall.**

**Figure 7–19**
**Steps in completing the trees and cliff face.**

the foliage clumps. When all the trees were finished, I used the broad point to tone down the lower parts of the trees, as shown at figure 7–19B. To indicate the jagged, sheer cliff face I used the broad point of the 4B pencil with the paper on a sheet of glass, to draw parallel, vertical lines as at figure 7–19C. Then, as shown at 7–19D, I went over these lines lightly to tone down the white areas that had been left, but to leave the impression of

course upon course of broken rocky cliff face.

The waterfall itself was done with just two tones from the same 4B pencil, as you see in figure 7–20. First, in 7–20A, I very lightly indicated some vertical tone marks leaving about half the paper in this area white. Then, in 7–20B, I added four long, slightly darker lines to give the impression of the irregularity of this sheet of water.

At the bottom of the waterfall I

made a couple of the rocks light to give the impression that they were partly obscured by mist, and made the rest of the rocks darker to bring them forward in the sketch. All of the water in the scene was quite turbulent, so I used just white paper for most of it.

**Figure 7-20
Drawing the waterfall
requires light pencil
work.**

# Tying it All Together in One Study

In the previous chapters we covered approaches to drawing backgrounds, rocks, and wood. In this chapter, water was the subject. Now it is time to tie all this together into one study that will show you how to proceed when all these elements are used together and you must make some decisions regarding tone value so that the different sketch elements do not blend together and lose individual distinction.

You should use your finest pen point for this exercise . . . I used my 3×0 technical pen. Take the pencil working drawing of figure 7-21 and use it as a guide to make your own working drawing over which you will ink. Do not make it larger than the illustration here—about half of an 8½" × 11" sheet. Make those pencil lines light so you will be able to easily erase them when you are finished inking!

Try to follow what I did in the step-by-step hints and come as close as you

can to producing the same effect that I did, but do not be concerned if yours ends up looking a little different. We each have a different touch with the pen and, just as our handwriting differs, so will our pen work in drawings. Just remember to keep your hatching and crosshatching closely spaced and uniform. Nothing will spoil the effect of a pen and ink drawing quicker than nonuniform hatching and crosshatching.

Start by studying the finished drawing in figure 7-22 for a few minutes. Note that the greatest contrasts are in the area of the three lower cascades. These and the rocks immediately above them are the focal point of this study. That is why these rocks are shown somewhat lighter than others farther away from this focal point. The white trees shown in the more distant background help, along with the darker ones I added after the

**Figure 7-21
The pencil working
drawing for the
following pen and
ink sketch.**

inking was all finished, to suggest the
clutter of trees that were actually
visible. The water was done dark, since
it reflected the essentially dark foliage
that overhung the river.

Start with the background (figure
7-23). Proceed as in figure 7-24 filling
in the areas between the white trees.
You see how these trees had to be
planned in advance, since they could
not be added to the background

afterward. The darker ones do not
have to be planned at this point, since
they can easily be added later right on
top of the background lines.

I selected vertical lines for this
background. There is no necessity to
make them vertical; slanted lines would
have worked as well, since all I wanted
was a gray background tone between
the white trees. I avoided horizontal
lines for the background because I did

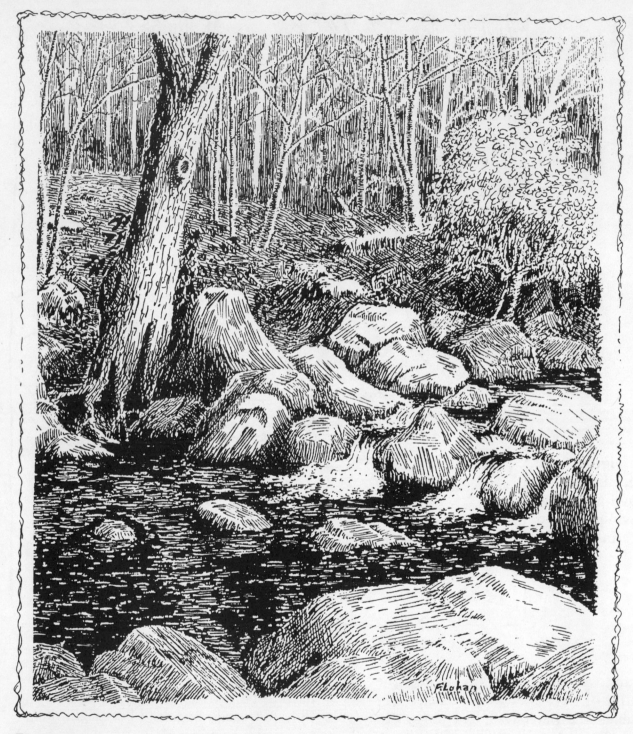

**Figure 7-22**
**Five tiny cascades carry a**
**small river over the rocks**
**near Gatlinburg,**
**Tennessee.**

**Figure 7-23**
**The pencil working drawing of part of the background in the five tiny cascades sketch.**

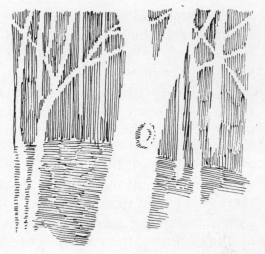

**Figure 7-24**
**The first inking of the background with the pencil guide lines erased.**

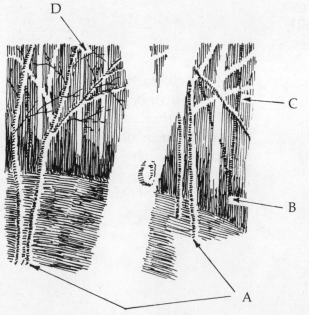

**Figure 7-25**
**(A) Darken the left side of the near trees. (B) Darken to indicate underbrush. (C) Add a few dark trees in the background. (D) Add a few branches to the near trees.**

not want it to resemble the linework I used for the ground and hence tend to blend in with it.

The rest of the background is developed as shown in figure 7–25. The nearest trees were brought forward by giving each of them some shading on the left side. I used very short hatch marks, as you see in figure 7–25A. When you do this, be careful to leave some white paper on the right side of these trees. Then suggest some underbrush by darkening the lower portion of the background tone in 7–25B. Now add some darker trees and saplings over the basic gray of the background, as in 7–25C, and add some thin branches to the closer trees as in 7–25D. At this point, also make the ground tone a little irregular by drawing over it here and there with horizontal lines.

The rocks need little explanation, but note that with all the toning I used there is no need to outline any of the rocks. The use of neighboring tone to do the outlining for you was covered in the earlier chapter on drawing rocks. (see figure 5–33). Just remember to use the lines that you tone your rocks with to show the slope of the rock surfaces. Also, when you complete your drawing, look at it very carefully to see whether you left any unnatural white spaces between the rocks and the water. This fault was illustrated in figure 6–7A in reference to drawing a log.

The big tree on the bank is completed with primarily vertical lines with a sprinkling of very short horizontal ones. There is a definite highlight on the tree trunk. I left a lot of white paper there and at the end I toned it down carefully until I had it where I wanted it. If you make it too

dark to begin with, which, by the way is very easy to do, you cannot easily lighten it again.

The water was completed with just horizontal strokes of the pen. I made it a kind of uniform dark gray tone first, as at 7–26A. Then I went back over it to darken most of it to virtually a solid black, as at 7–26B, but leaving a lot of horizontal white patches to represent the irregularities of the surface catching some light from the sky.

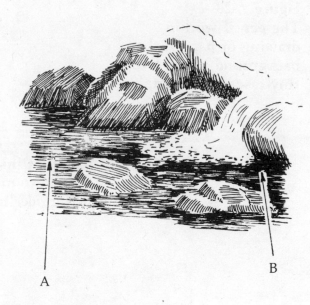

Figure 7-26
(A) Scribble the water in first with horizontal strokes then, as at (B) darken most of it by scribbling over with more horizontal strokes. Be sure to leave some little lighter patches.

*Summary*

The direction of pen strokes tends to model the surface being textured. If the lines slope upward and downward, they suggest surfaces that do likewise. Water is most often represented by horizontal pen lines, just as roadways are, and table tops, anything, as a matter of fact, that is essentially a horizontal plane. The use of sloping lines to suggest non-horizontal surfaces is illustrated in figures 7–4 and 7–5.

Open water is usually seen as very bright and is therefore best represented by white paper. A few tone lines usually are added to suggest that the expanse of white represents a horizontal plane. Any reasonable reflections also help in such cases to establish that the surface represents water. This is shown in figures 7–6 and 7–12.

The pencil allows an almost infinite gradation of tone, much more so than does the pen when drawing very small studies. White water can be very nicely depicted by pencil, since the delicate shades of light gray that form the white water can easily be established. Examples illustrating white water done with the pen are in figures 7–9 and 7–10. Pencil representation of white water can be seen in figure 7–17.

Figures 7–17 and 7–22 are excellent practice pieces, one with the pencil and the other with the pen. Step-by-step suggestions are included for completing each.

# 8
# Sketching in the Southwestern U.S.

# Basic Structures

The southwestern area of the United States has some of the most varied countryside in the world. You have your choice of the mountains of New Mexico, the low desert of Arizona, the high plateau around the Grand Canyon, and just about every intermediate kind of terrain, vegetation, and rocky splendor.

Countryside, in the broader sense that I am applying in this book, includes older buildings such as the Alamo in San Antonio, Texas, and other works of man that go beyond just rural farm structures and covered bridges. This chapter supplements the earlier chapters of this book. It shows you how to sketch buildings and mountain formations, and even an aqueduct, using some of the techniques

that were covered in those chapters on rocks, wood, and water, but also going on to develop textures that were not covered earlier. The subjects used for studies in this section come both from personal knowledge and from photographs taken by others. When you sketch any particular subject, such as the second one I use in this section, Cathedral Rock, it is very helpful to have several sources of reference so that details may be properly interpreted. I have taken photographs of Cathedral Rock during several trips to the Sedona area, but I still referred to calendar and other photographs that were larger than mine to see detail that I could not completely define in my photos.

# Sketching an Adobe Building

Adobe, a sun-dried brick of clay and straw, was a widely used building material in the Southwest, and even today it can be seen in older structures. The subject of this section is an adobe building in Old Tucson, a movie set town near Tucson, Arizona.

The sun shines very brightly in this part of the country, or seems to because of all the reflected light from the light-colored dirt and sand. The following sketches of the adobe building are done using a high contrast, very dark darks and very light lights with almost no middle tone, to try and capture the feeling of the glaring sun. When you are standing in such a brilliantly lit area with bright glare from every surface that is sunlit, your

eyes react to the light by constricting. This reduces the amount of light that enters the eyes and makes the dark areas in your field of vision appear quite black. It is this effect, or impression, that I am trying to illustrate in these sketches.

*With a Medium Pen*
Figure 8–1 is a pen sketch done with a medium-weight point. The individual adobe bricks are evident in many places, especially in the shaded areas. Figure 8–2 is the working pencil drawing over which the inking was done. Remember when you make your working drawing to do it as lightly as you can, just so you can barely see the pencil guide lines. This minimizes the

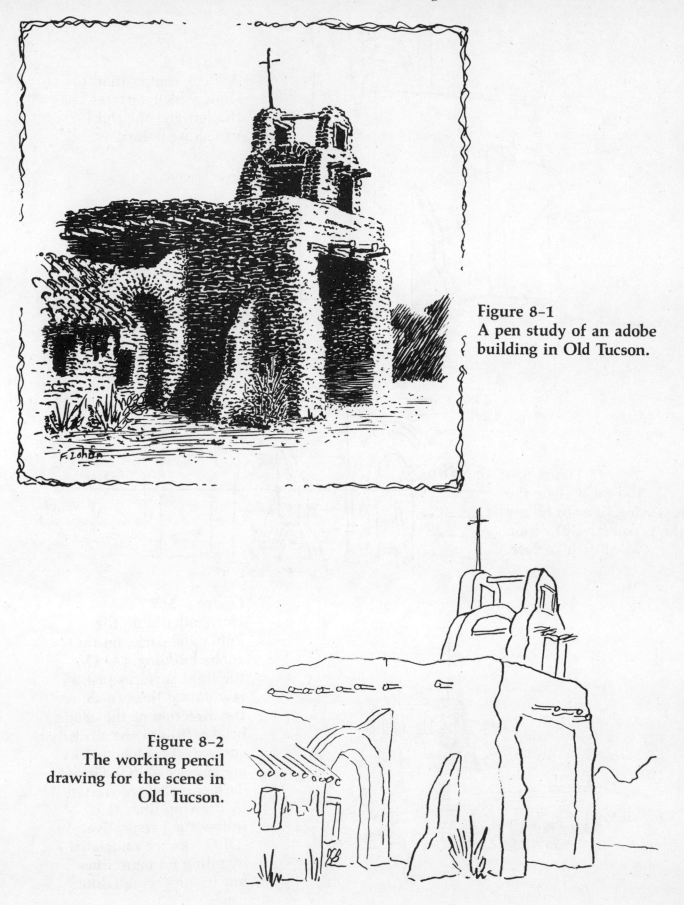

**Figure 8–1
A pen study of an adobe
building in Old Tucson.**

**Figure 8–2
The working pencil
drawing for the scene in
Old Tucson.**

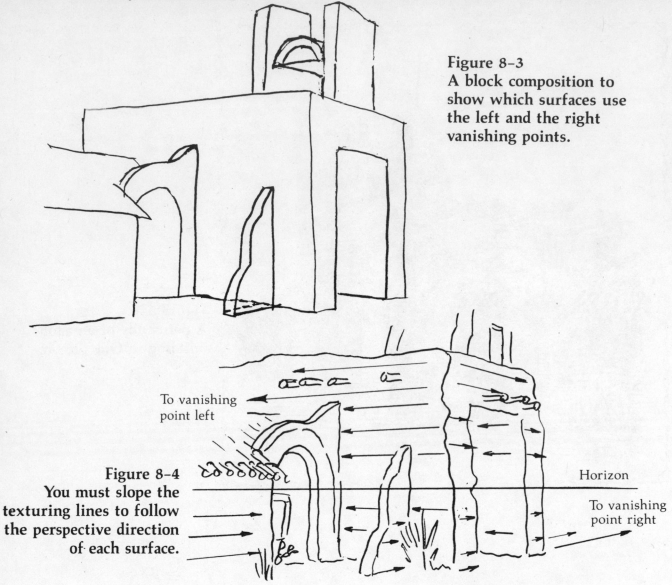

**Figure 8-3**
A block composition to show which surfaces use the left and the right vanishing points.

**Figure 8-4**
You must slope the texturing lines to follow the perspective direction of each surface.

To vanishing point left

Horizon

To vanishing point right

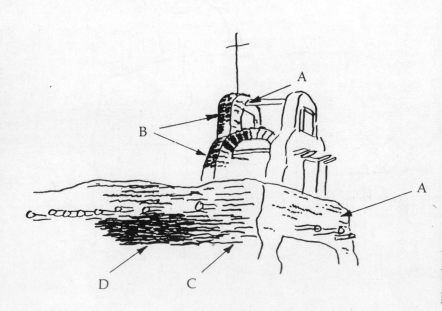

**Figure 8-5**
How to build up the lights and darks on the adobe building. (A) On the light surfaces just a few dotted lines to show the direction of the adobe bricks. (B) On the shaded surfaces the adobe bricks are suggested. (C) The dark surfaces are started by drawing lines that follow the perspective. (D) Darks are completed by piling on more lines but leaving some white paper.

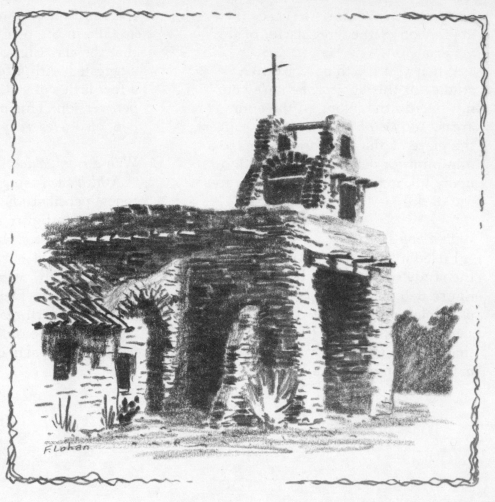

**Figure 8–6
A pencil study of the
adobe building.**

erasing that you have to do later. The working drawings in this book are shown dark only to ensure that they reproduce clearly.

The working drawing just mentioned was developed from the block composition shown in figure 8–3. This was set up from a perspective sketch on which I indicated the left and right vanishing points as shown earlier in figure 3–9 and described there in the related text.

In the sketch of figure 8–1, the rows of adobe bricks are indicated in both the dark and the light areas. These rows must be perspectively correct or the end result will not look right. I put light pencil lines on each of the surfaces shown in my working drawing, as you can see in figure 8–4.

These lines guided my pen marks as I applied the ink texturing. The arrows on figure 8–4 show you which vanishing point I used for each of the buildings surfaces to ensure that the perspective was correct.

The actual inking was done as shown in figure 8–5. In the sunlit areas, I simply put in a few irregular lines to indicate that some of the spaces between the adobe bricks were visible. This is shown at figure 8–5A. In inking the dark areas of the bell tower, I made little brick-like marks, leaving some white paper between as you see in 8–5B. The dark side of the building was done with perspectively horizontal lines in 8–5C that were piled on top of one another in 8–5D. I did not make this area solid black; I left some

horizontal white areas to carry the impression of the irregularity of the material.

When you try to do your own studies of this subject, be sure you do not overdo the inking in the sunny areas. You want these areas to suggest the glare of the very bright sun, so a minimum of detail is required. Too many ink marks will make these areas too dark.

*With a Soft Pencil*

I used a broad-point 4B pencil to do the study of the adobe building in figure 8–6. The same perspective principles were observed as for the pen sketch of this subject (figure 8–1). Note that for the upper right corner of the main building I used a little tone from the pencil instead of an actual outline as I did in the pen version. Also note that the clay tile roof at the left is suggested with a few straight lines and a few little curved ones, just as in the pen version. This pencil study, figure 8–6, also uses very high contrast.

*With a Hard Pencil*

A *high key* (using primarily light tones) pencil study of the same subject is shown in figure 8–7. The same steps were used as for the pencil study in figure 8–6, but hard pencils, 4H with a little bit of HB, were used instead of the softer one. The hard leads do not make very dark marks, yet enough contrast can be obtained to suggest the dark shaded parts of the structure.

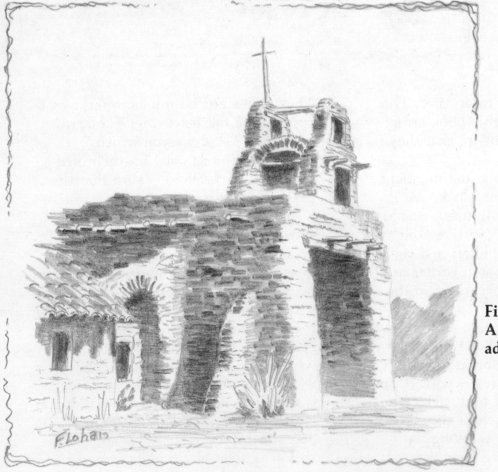

**Figure 8–7**
**A "high key" study of the adobe building.**

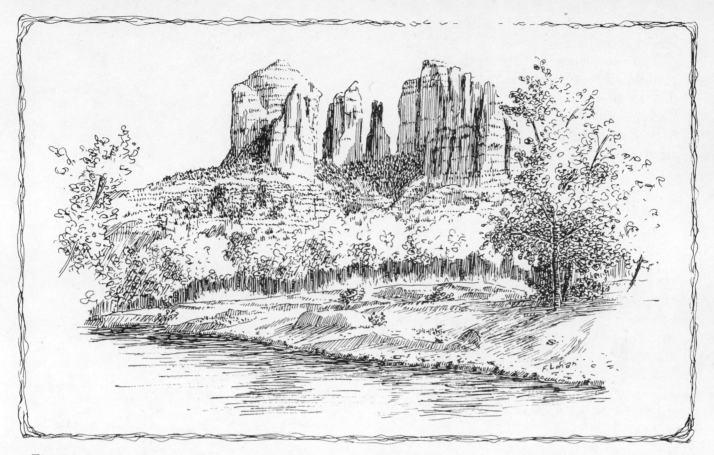

**Figure 8-8**
**A pen study of Cathedral Rock near Sedona, Arizona.**

# Sketching Large Rock Formations

One of my favorite places in the southwest is Sedona, Arizona. This "Red Rock Country" has some of the most beautiful rock formations in North America as well as four mild seasons each year. It is intermediate in altitude between Phoenix and Flagstaff, and does not generally get the extremes of heat that Phoenix gets, nor the cold and snow that Flagstaff, on the high plateau, gets.

*Cathedral Rock*

Figure 8-8 is a technical pen study of one of the more famous of the Sedona areas' many rock formations, Cathedral Rock. When viewed from the river

level, it appears silhouetted against the sky as you see here. The principle features that must be drawn are the horizontal strata marks and the vertical faces of the bulk of the formation. The way I drew these features is shown in figure 8-9, the working drawing for this study. The strata are indicated by horizontal rows of short hatch marks as you see at figure 8-9A, and the cliffs, where they are in shade, by vertical lines. Remember that the direction of the texturing lines tends to suggest the direction of the surface being textured. Hence, we frequently use vertical lines for vertical surfaces just as we use horizontal lines for

horizontal surfaces such as water and level ground.

The remainder of this study was completed following the principles developed earlier in the section on background trees. The trees in figure 8-8 were completed as shown earlier in figure 4-11.

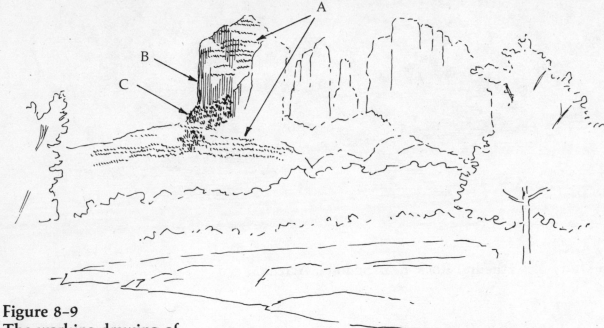

**Figure 8-9**
**The working drawing of Cathedral Rock. (A) The rows of hatch marks to show the horizontal strata. (B) The vertical shading lines to show the vertical cliffs. (C) The clumpy vegetation.**

*Monument Valley*

A study of some great, red rock formations in Monument Valley, Arizona, is shown in figure 8-10. The same use of vertical lines for the vertical surfaces applied here. In this case, a significant portion of background was also visible. I chose to indicate these background formations with horizontal lines to clearly separate the background from the foreground rocks that are the subject of the study. The near foreground is simply sand, so I used a minimum of texturing in this area—just enough to show some of the undulations in the sand.

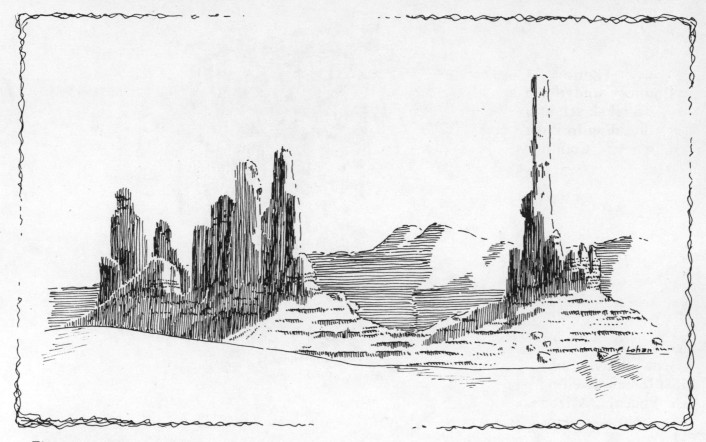

**Figure 8-10**
**A pen study of rock formations in Monument Valley, Arizona.**

# A Pima Indian Dwelling

Figure 8–11 shows my preliminary study for a sketch of a Pima Indian structure that had walls of twigs and brush. This is not an easy texture to draw. The trick is to draw a few twigs in such a manner that those few suggest many others.

After my preliminary study indicated that the approach I had planned to show the brush walls would work, I went ahead with the final sketch (figure 8–12). The approach that I used for the walls can be seen in figure 8–13A and B. I drew a few full-length twigs (8–13A), then filled in the triangular spaces between them with more or less vertical strokes of the pencil. I made sure that these strokes did not blend together too much, because I wanted them to suggest many more twigs between and behind the few that I initially drew. Compare figure 8–13A with 8–13B to see how this worked. When I finished drawing the walls, I added the little shadows under the horizontal sticks that you see in figure 8–13B (1).

This will make an interesting study for you to try. Use a broad-point 6B pencil for the dark areas and a sharp HB pencil to draw all the detail, including the individual twigs.

**Figure 8–11**
**Preliminary study for a**
**pencil sketch of a**
**building in Pima**
**Country.**

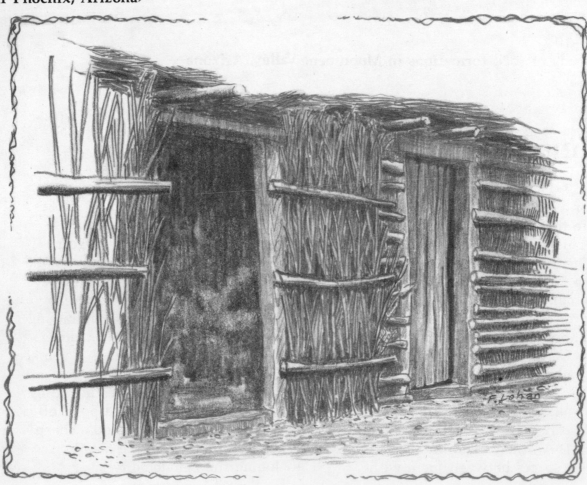

**Figure 8–12**
**A pencil drawing of a**
**Pima Indian dwelling**
**near Phoenix, Arizona.**

A

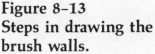

1

**Figure 8–13
Steps in drawing the
brush walls.**

B

# An Old Mission

Some friends of mine traveled to the San Antonio, Texas, area and brought back some photographs of the places they visited. One of these was an old mission (they didn't get the name). I liked the photograph so I borrowed it to use as a subject for this book. It consisted of a more or less square-fronted building with a bell tower only on the right hand side. The area around and above the door was very ornately decorated with sculptured stone work and statues which would have to be tremendously simplified for a sketch the size that I planned. Remember that all the illustrations in this book are drawn approximately the size you see them. This size is small for too much detail.

Figure 8–14 shows the working drawing that I used. Just the major elements of the detail surrounding the door are indicated. My first study was in pencil, as you can see in figure 8–15.

I used a sharp HB pencil for this entire study. With the aid of a magnifying glass I managed to see some of the detail work in the center of the building and worked some of the shadows in to suggest what I could see. The rest of the front was of stucco and stone as nearly as I could judge, with large patches dirty from hundreds of years of exposure to the elements. This sketch required about two-and-a half hours for me to complete—about half that time was spent in getting the working drawing to my satisfaction.

I then did the pen version in figure 8–16 so you could see the differences and similarities in using these different media on such a subject. Having the working drawing, which I transferred to a fresh piece of paper (as described in figure 2–21), it required about an hour to finish the ink drawing with my 3×0 technical pen.

**Figure 8-14
Working drawing for a
mission near San
Antonio, Texas.**

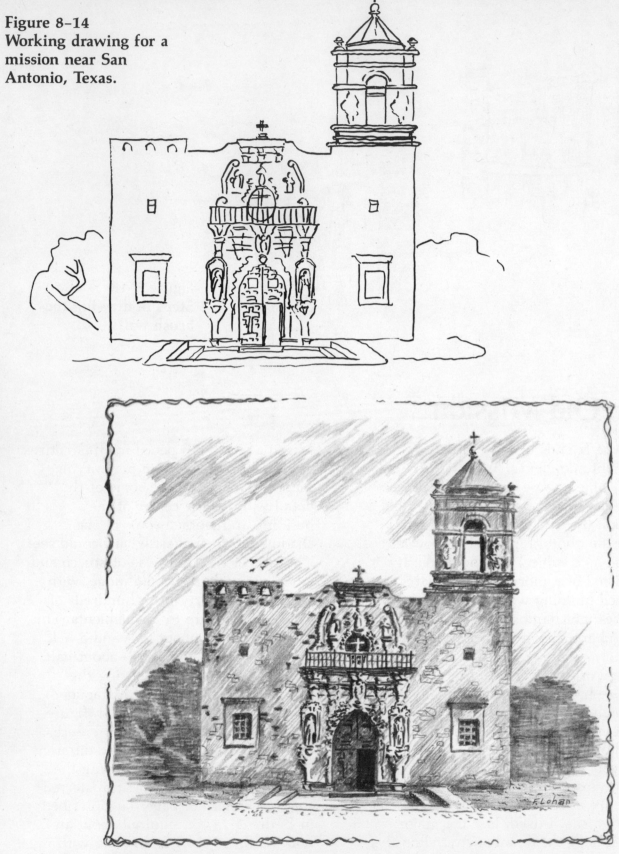

**Figure 8-15
A pencil sketch of a mission near San Antonio, Texas.**

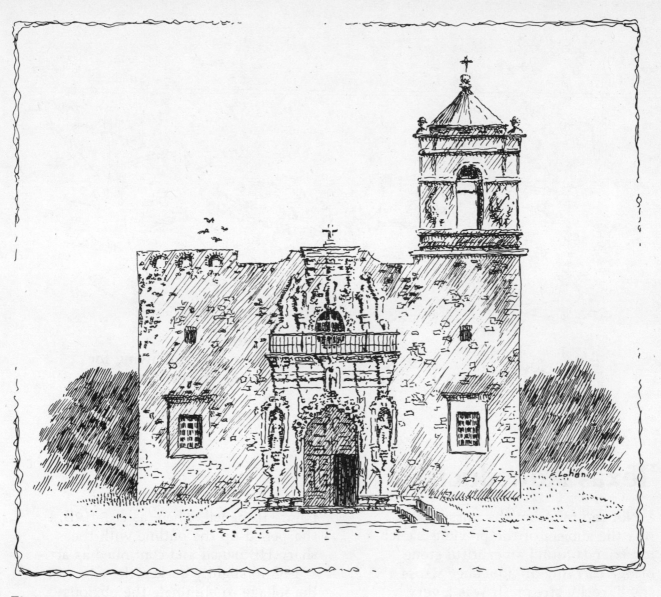

**Figure 8-16**
**Pen and ink sketch of a**
**mission near San**
**Antonio, Texas.**

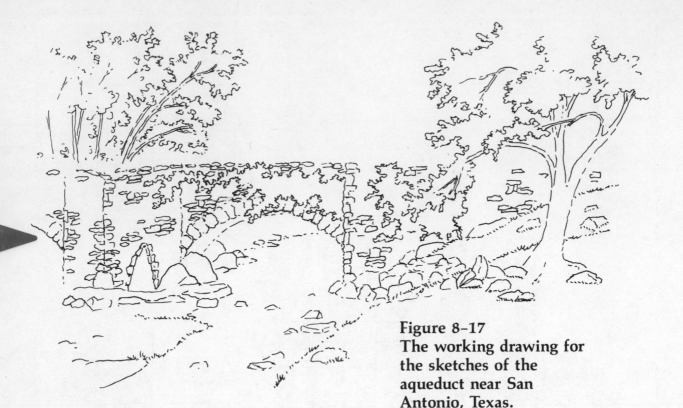

**Figure 8-17**
**The working drawing for the sketches of the aqueduct near San Antonio, Texas.**

# Texas Aqueduct

Not too far from the mission that was the subject of the previous sketch, my friends found a beautiful stone bridge carrying an aqueduct across a small, rocky stream. It was a very picturesque, peaceful scene, so I borrowed the photo to use here. Figure 8-17 is the working drawing that I used for both the pencil and the pen studies.

*A Pencil Study*

Figure 8-18 is the final pencil study of the aqueduct. I used just a sharp HB pencil and a little of a broad-point HB on very abrasive paper and proceeded from the top of the drawing down. The trees on the other side of the aqueduct were completed in three steps (figure 8-19). First, I roughed in the foliage masses as at 8-19A with the broad-

point HB pencil. Then, as at 8-19B, I sharpened up the outline with the sharp HB pencil and continued as at 8-19C to slightly darken the edges of the foliage to eliminate the obvious outline.

The tree on the near side of the aqueduct is lighter in tone than the background ones so that it will stand out and not blend in with the background. I left this foliage as white paper until the rest of the study was completed. Then I toned it just enough without losing it because of adjacent tones.

The stone work of the bridge was partially overgrown with ivy. Ivy always helps a sketch of brick or stone work to succeed because it breaks up somewhat monotonous masses of similar texture. The steps I used to

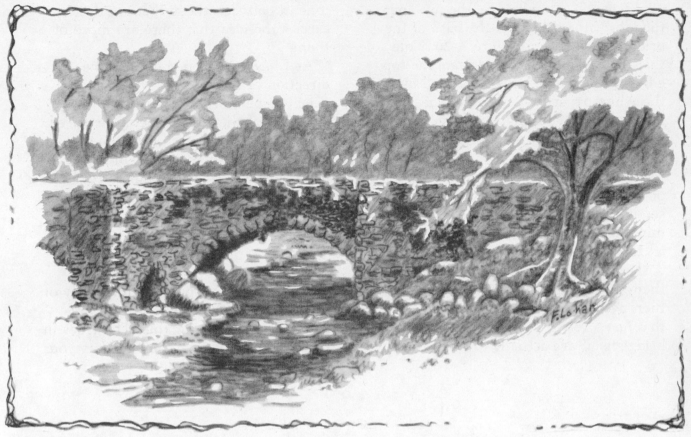

**Figure 8–18**
**A pencil version of the aqueduct near San Antonio, Texas.**

**Figure 8–19**
**Steps in completing the background trees.**

A          B          C

**Figure 8–20**
**Steps in completing the stone aqueduct and the ivy covering.**

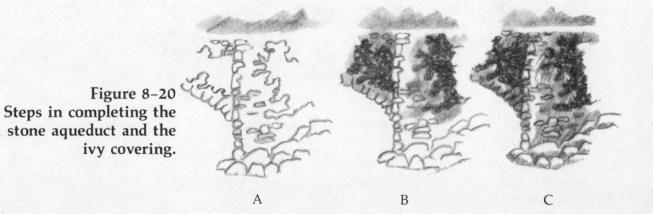

A                    B                    C

complete the stone bridge, the ivy, and the loose stones around the base of the bridge are shown in figure 8–20. Note that no line is drawn to indicate the top edge of the bridge. It is suggested by the white paper that separates the bridge from the background trees. This gives the appearance of sunlight hitting all along the top.

The stones that lie around the base of the bridge were completed as you see in figure 8–20C. I tried to minimize the use of drawn outline, so I let the light stones be shaped by the darker shade of the stones behind them, or by the darker ground where there were no stones behind. Note also that just a few of the stones in the bridge itself are actually drawn—the

tone in between those that are drawn carries the idea that there are more of them.

As I have mentioned earlier, the direction of the strokes, whether of pencil or pen, often suggest the direction of the surface being textured. You can see that I used horizontal pencil strokes for the water in figure 8–18, and that I used sloping strokes on the ground at the right under the near tree to suggest the rise of the ground there.

*A Pen Study*

Figure 8–22 is a pen and ink study of the same aqueduct scene. I used my 3×0 technical pen for this. The trees in the background were completed as you

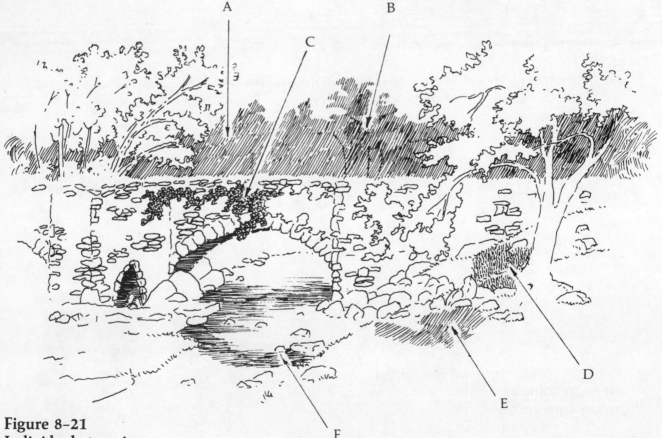

**Figure 8–21**
**Individual steps in**
**finishing the pen sketch**
**of the aqueduct.**

**Figure 8–22
A pen drawing of an
aqueduct near San
Antonio, Texas.**

see in figure 8–21A and B. This is as
described earlier and shown in figure
4–5. The ivy on the bridge was done
with a continuous squiggly line as at
8–21C.

The grass is all done with short,
vertical hatch marks. These marks are
piled close together to show shade in
8–21D. A lot of white paper is left
between groups of grass marks to
show a sunlit area. This can be seen at
the lower left of figure 8–22. The
ground is textured with sloping lines to
show the slope (8–21E), and the water
is shown with horizontal lines (8–21F).

# Using Photographs

When you use snapshots to sketch
from, you will often find that there are
dark areas in which you should sketch
some detail but it is not evident from
the photo. Your only recourse in such
cases is to search out some other
reference photos, such as at the library
or in an encyclopedia, to find out what
detail does exist. If you take
photographs yourself to sketch from
later on, you should take some
additional close-up shots of the detail
in the dark places as you are almost
certain to want to see some of it when
you do your sketching.

**Figure 8–23**
**A pen sketch of The Alamo, San Antonio, Texas.**

**Figure 8–24**
**A pencil sketch of The Alamo.**

# The Alamo

The Alamo is one of the most famous historic buildings in the southwestern United States. I used photographs taken by friends to do the pen and ink study of figure 8–23. This study was similar to that of the old mission earlier in this chapter in that there was a lot of detail around the door that had to be simplified to an extreme degree because of the size of the sketch. Figure 8–23 was done using my 3×0 technical pen. Just a few dots and a line or two had to suffice for the decorative detail. Figure 8–24 is a pencil version of the same subject. Here, just a few smudges of tone carried the hint of detail around the door. A broad-point 4B pencil was used for this sketch.

To show you the degree of simplification in the previous two sketches I dug out a photograph I had taken forty years ago of the left-hand side of the Alamo door. A pen study from this photo is shown in figure 8–25. Notice in this detail study that the methods of figure 5–39 were used to texture the stone.

**Figure 8–25
A close-up detail pen
sketch of The Alamo.**

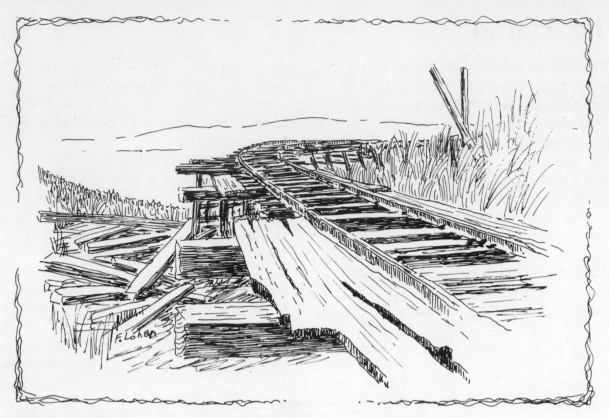

**Figure 8–26**
**An abandoned narrow gauge mine railway in Arizona.**

# Abandoned Mine Railway

There are many interesting relics of past activity in the Southwest. The 3×0 technical pen sketch of an abandoned mine railway in figure 8–26, taken from a photograph, records one of these. It is a simple sketch with the ever-fascinating mystery of a composition that leads the eye around a bend to sights that can only be guessed. I did a lot of simplifying from what I could see in the photograph. There was a lot of wooden debris to the right of the tracks that I simply left out—it would only have added distracting clutter where I wanted the tracks themselves to be the point of interest. The photograph was very black,

showing no detail at all in the lower left, so I just moved some of the debris from the upper right there. Artistic license is always there for you to use to create the emphasis you want in your works. The working drawing is shown in figure 8–27.

This is a simple one-point perspective study. Notice in figure 8–28 how the main compositional lines coverage to one point on the horizon. Notice also that the horizon is not at the base of the mountains but somewhere between the peaks and the base because a low valley lies between the viewer and the distant mountain range.

**Figure 8-27**
**Working drawing for the**
**abandoned narrow gauge**
**mine railway.**

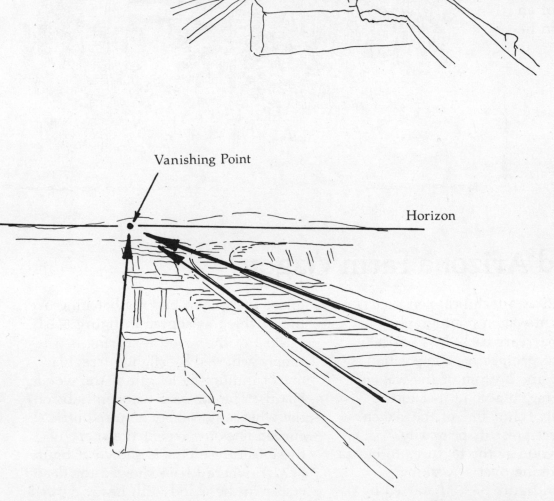

Vanishing Point

Horizon

**Figure 8-28**
**This is a single point**
**perspective study.**

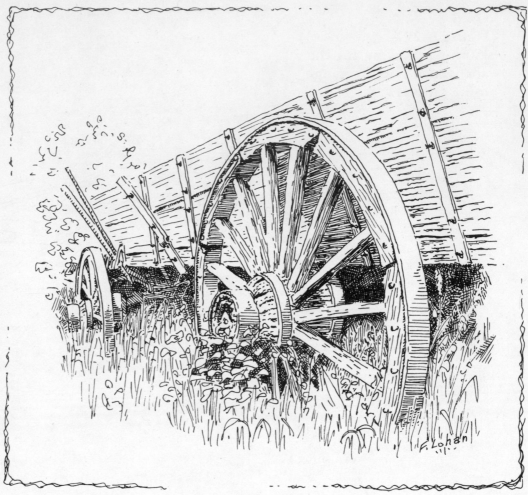

**Figure 8-29
A pen sketch of an
old farm wagon in
Arizona.**

# An Old Arizona Farm Wagon

Figure 8-29 is a technical pen sketch of an old farm wagon photographed in Arizona some years back. It is basically a single-point perspective composition with the top and bottom of the wagon side converging to a point just to the left of the left frame line of the sketch.

This subject presents primarily weeds and wood as the textures to be suggested. Inking over a working drawing as in figure 8-30, I started by drawing a few prominent weeds as in figure 8-31A. I then hatched, using very closely spaced lines, between the weeds I drew. This is shown at 8-31B. The next step was to complete the dark

under the wagon by crosshatching over the hatching as shown in figure 8-31C.

Most of the wood texturing is simply achieved by slightly irregular lines running the length of the wooden boards. The massive wooden hubs on the wheels, however, required little curved lines to present the shape of these features. This is shown at figure 8-32A, where I first showed the deep cracks in the wood with heavy curved lines, then completed these surfaces with dotted curved lines to suggest the visible wood grain.

The shaded parts of the iron bands that held the wheels and the hubs

together were done next as you see in figure 8-32B. Even though the photo showed these iron bands to be a deep rust color, I elected to let the white paper represent the sunlit portions. Figure 8-32C shows the shading of the underside of the wheel, and 8-32D shows the lengthwise lines used to texture the shaded parts of the spokes.

When you practice this study, be sure to add the shadow cast by the wheel on the side of the wagon and to add a lot of vertical grass marks in the foreground in between the weeds.

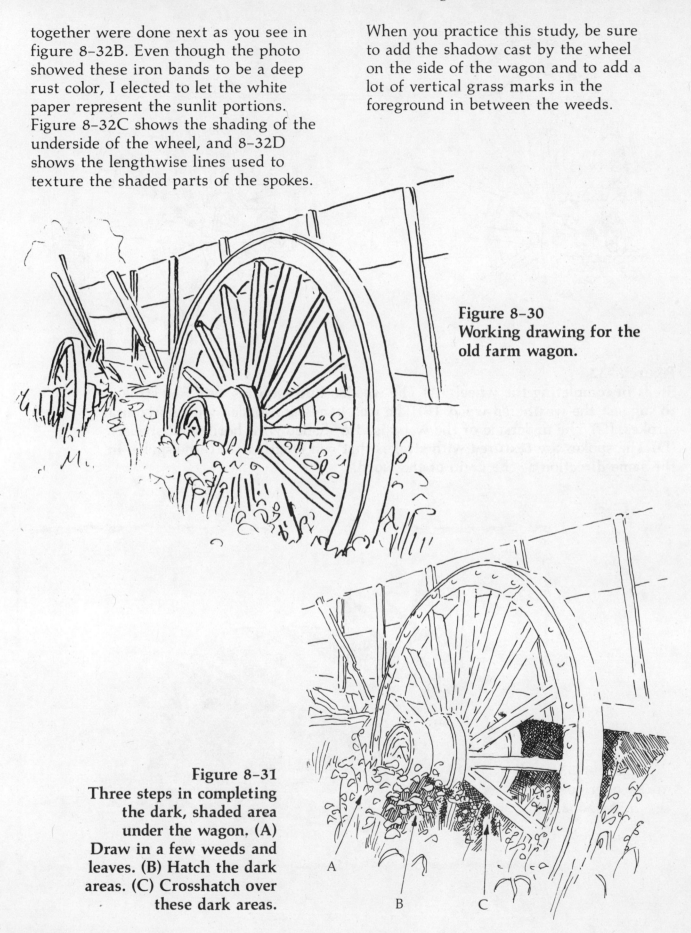

**Figure 8-30**
**Working drawing for the old farm wagon.**

**Figure 8-31**
**Three steps in completing the dark, shaded area under the wagon. (A) Draw in a few weeds and leaves. (B) Hatch the dark areas. (C) Crosshatch over these dark areas.**

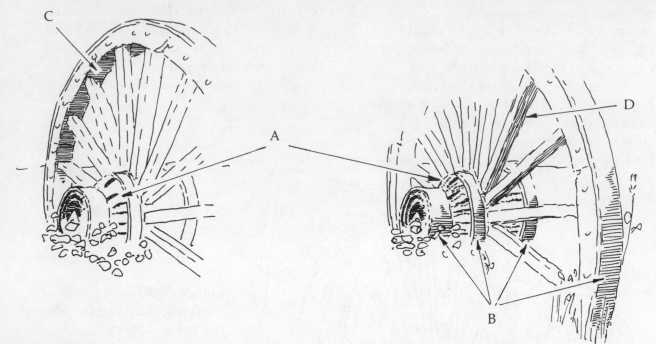

**Figure 8-32**
Steps in completing the wheel. (A) The wooden hub requires very few strokes to suggest the weathered wood. (B) The iron bands are shaded with horizontal strokes. (C) The underside of the wood is also shaded with horizontal strokes. (D) The spokes are textured with strokes that run lengthwise to the spoke, in the same direction as the grain of the wood.

**Figure 8-33**
**A rocky overlook in Arizona.**

**Figure 8–34
An abandoned plow in
Arizona.**

# Pencil Vignettes

Quick little pencil vignettes are a fun way to practice and to record things that you see in your countryside travels. Figure 8–33 is a broad-point 6B pencil study of a rock outcropping near Sedona, Arizona. In doing this study I first lightly outlined the rocks then I put in the sprigs of grass before drawing the cracks and texture of the rocks. I did not want to put these textures over the grass marks.

Figure 8–34 was done from a photograph. I used broad-point 6B and sharp HB pencils. The latter was used to lightly outline the plow and the 6B pencil was used for the rest, including the grass marks which I again put in first so I could add the plow around them. I used the sharp HB to sharpen up the edges of the plowshare and the handles after I toned them with the 6B.

A sharp 4B pencil was used for the top rock in figure 8–35 and a sharp HB for the pillar on which it is balanced. This pillar was banded with layers of lighter and darker red sandstone. The rock on top was of a different, harder composition and was darker in tone than the sandstone.

The vignette in figure 8–36 of the chapel near Sedona was done with just a sharp-point 4B pencil. Such a soft lead does not stay sharp for more than a stroke or two, so I kept sharpening it until I had completed the chapel part of the sketch. Then I let it broaden out as I sketched the rock masses on which the chapel rests.

**Figure 8–35
Pencil study of a
mushroom rock near
White Mesa, Arizona.**

**Figure 8–36
Pencil study of the
Chapel of the Holy Cross,
Sedona, Arizona.**

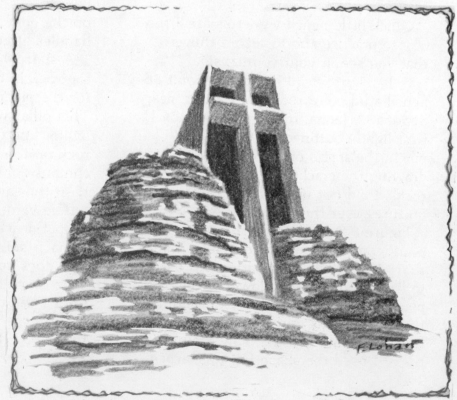

# 9
# Sketching Mountain Countrysides

# Basic Structures

Mountain countrysides offer an extremely wide variety of scenery and vistas to sketch. In this chapter I will show you, step by step, how to create effects that will suggest some of the mountain features to the viewer.

Panoramic scenery is, of course, characteristic of mountain country. But then so are quiet roads, streams rushing from dark forests, cabins, barns, and rugged promontories. Each of these subjects will be developed in this chapter. You can sketch on the spot if you travel to mountain country in decent weather, or you can travel there in any season and take photographs for later use for sketching in the comfort of your studio. You can also use the photographs of others for reference material in your practice sketching. The photographs you use should be large enough and clear enough so that you can see the features you want to include in the works, otherwise, you will have to be creative and invent what should be, but can't be seen in the photos.

# A Four-Tone Snowy Mountain Scene

The first study in this mountain chapter is a simple four-tone ink sketch of a panoramic snowy mountain vista. Figure 9–1 contains three landscape features: a foreground lake, a partially forested, snow covered, middle-ground ridge, and a distant mountain range. In keeping with the principles of aerial perspective, where things appear to get lighter as they recede into the distance, the darks on the farthest mountain range in this sketch are not as dark as those in the middle and foreground. Except where it is in shade, the white paper alone speaks for the snow.

I only used drawn outlines where tone could not be used to define the boundaries of the sketch elements. The left-hand side of the farthest mountain peaks, and the snow slopes in the lower left are the only places where an actual outline was drawn.

The four tones, created with my 3X0 technical pen, are shown in figure 9–2. As I mentioned earlier in the chapter on techniques, you must be able to control your hatching and crosshatching to carry off any sketch that uses them as shading and texturing techniques. The line spacing and line weight must be reasonably uniform. Compare the line spacing in the two crosshatched sections shown in figure 9–2 C and D . The difference in darkness between them is brought about simply by a slight difference in the spacing of the lines used in the cross hatching.

The photograph I used for this study showed the distant mountain side bathed in sunlight as bright as that on the middle-ground ridge. I elected to bring this middle-ground ridge visually forward in this sketch by toning the distant mountain with hatching to suggest shade and to let this carry the outline of the nearer ridge. Remember, you have the right to exercise your artistic license for the purposes of bringing emphasis where you want it in your art work.

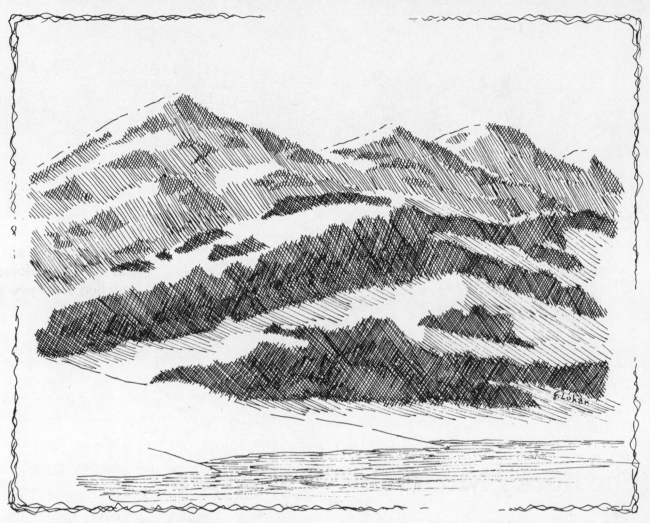

**Figure 9–1**
**A four-tone ink study of a snowy mountain scene.**

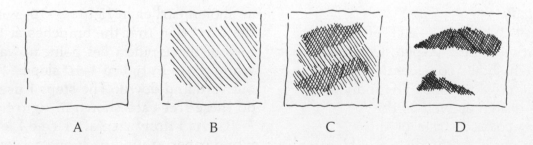

**Figure 9–2**
**The four tones used in the snowy mountain scene. (A) White paper. (B) Widely spaced hatching for all shaded areas. (C) Closely spaced crosshatching over the widely spaced hatching. (D) Crosshatching with very closely spaced lines in each direction for the closest trees.**

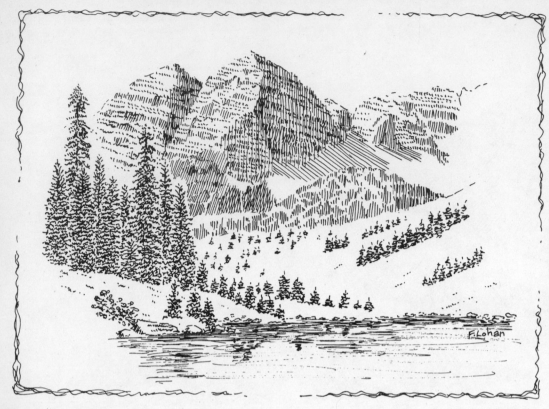

**Figure 9–3
A snowy mountain vista near Aspen, Colorado, sketched with pen and ink.**

# The Rocky Mountains Near Aspen

The previous subject was primarily a study of tones used to create the illusion of distance and landscape features. There really is no detail as such drawn in figure 9–1.

*An Ink Study*

Figure 9–3 is a pen sketch of a mountain view near Aspen, Colorado. This sketch shows considerable detail, unlike the previous one. The individual trees are drawn as well as the differently colored strata of the mountain peaks in the distance. Here again, I used my 3×0 technical pen for the fine line it produces. The first step was to draw a light pencil working outline of the main features that I wanted to include in the sketch. This outline was the guide then for the ink

work. You can see some of this in figure 9–4A where the pencil lines still show along with the ink strata marks. Figure 9–4B shows the shaded areas added and the pencil lines erased.

The pine trees at the left are drawn as shown earlier in figure 4–10, with the exception that the branches at the tops of these pine trees point upward while those in figure 4–10 slope outward and down. The steps I used to do these trees are shown in figure 9–4C. As I drew tree after tree I left white paper around each one as you see at 9–4D. When I was finished with the entire sketch, I went back and narrowed these white spaces so that each tree maintained some distinction, but that the white left around each one was not obvious.

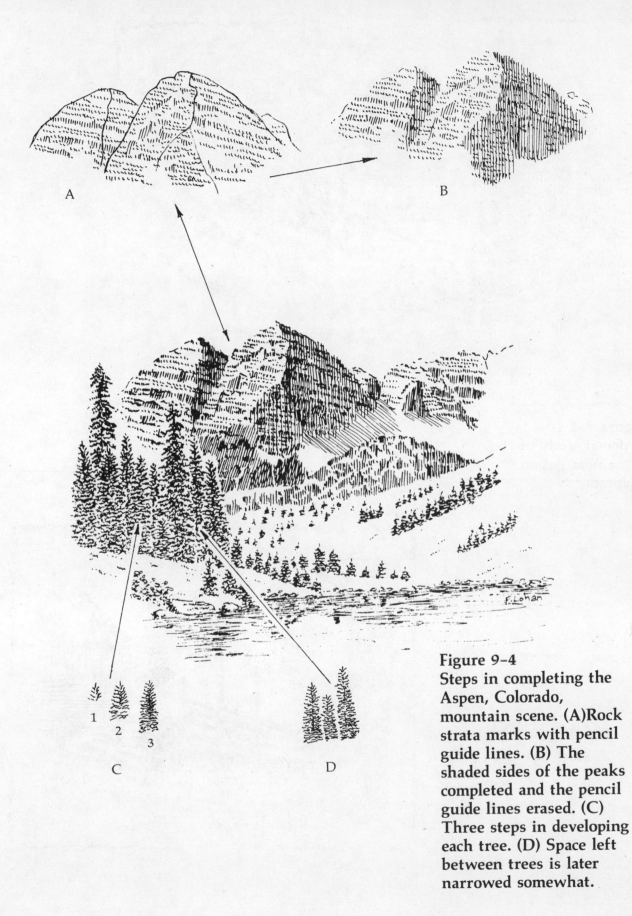

**Figure 9-4**
**Steps in completing the Aspen, Colorado, mountain scene. (A)Rock strata marks with pencil guide lines. (B) The shaded sides of the peaks completed and the pencil guide lines erased. (C) Three steps in developing each tree. (D) Space left between trees is later narrowed somewhat.**

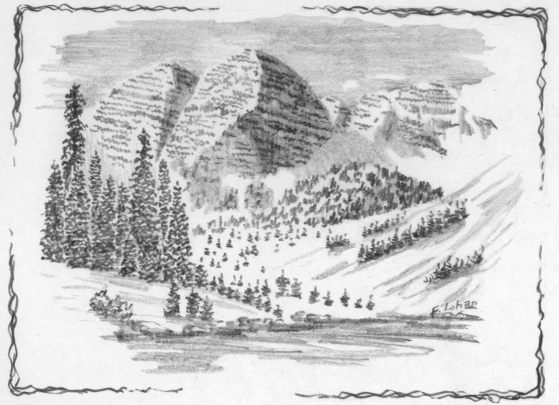

**Figure 9–5**
**A pencil study of the**
**scene near Aspen,**
**Colorado.**

**Figure 9–6**
**A stock loading chute in**
**Idaho.**

*A Pencil Study*

I used a sharp HB pencil to do the study in figure 9–5, and a broad-point HB to draw the sky, the shaded areas on the snow, and the water. I used the sharp point to make hatch marks for the strata indications on the mountains and to make the marks that build up the tall pine trees. The broad-point pencil toned the sky and helped form the light side of the distant peaks and give them a bright, sunlit appearance. Notice that I left a little white showing around each pine tree just as I did in the pen version of this subject.

# Vignettes

*A Stock Loading Chute*

Sketches of the things that you see in the mountains can include small, individual vignettes as well as the panorama generally associated with mountains. Figure 9–6 is a small, quick pen sketch of an old livestock loading chute in an Idaho mountain valley. Note that the mountains are treated in the simplest manner possible—just suggested by outline. All the detail is reserved for the chute, which is the subject of the study, and for the rugged tree trunk in the left foreground. The handling in this sketch is representational and straightforward.

*Mountain Road—a Pencil Study*

An out-of-the-way unpaved mountain road curving downward and out of sight is the setting for the pencil sketch of figure 9–7. It is the subject of the sketch, although it does not occupy much of the total drawing area. The trees are there to establish the overall setting. I used broad HB and 4B pencils for the tree foliage, the toning of the mountain in the background, the vegetation on the hillsides, and for texturing the roadway. A sharp HB pencil sharpened up the edges of the foliage and of the tree trunks and added a few branches to the trees. The process of drawing the tree foliage is shown in figure 9–8: at 9–8A, you see how the tone is placed with the broad points, and at B, 9–8 you see how the sharp points are used to sharpen the edges of the foliage and to add some of the tree trunks. When sharpening the foliage masses, as indicated at the two arrows in 9–8B, you do not want to create a bold outline; rather, you just want to eliminate the indistinct edges of these masses that were left by the broad-point pencils. This tends to bring such features forward in the drawing, something you generally want to do with foreground trees and other foreground foliage.

**Figure 9-8
Steps in drawing the
foliage. (A) Broad points
to put the basic foliage
tone down. (B) A sharp
point to crisply define the
edges of the foliage.**

A                                                                    B

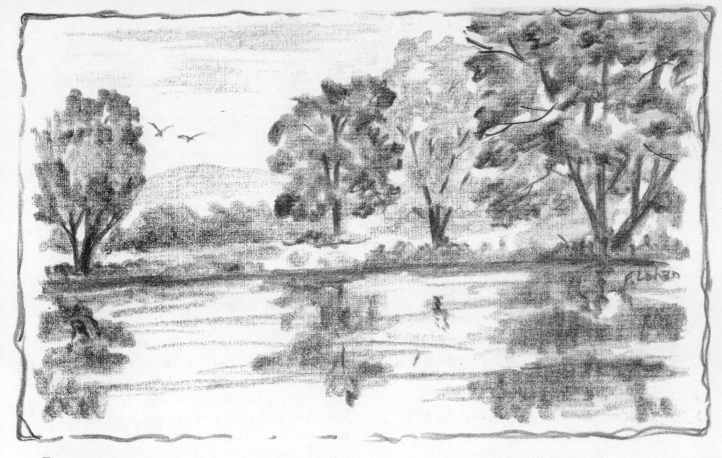

**Figure 9–9**
**A pencil study of a**
**mountain pond drawn on**
**linen paper. This shows**
**how alternating light and**
**dark tones can be used to**
**give definition to**
**overlapping trees.**

*Mountain Pond—a Pencil Study*

Whenever you draw massed trees, you have the choice of making them all one tone or of trying to show that individual ones are a distinctly different kind. You only have tone to work with in making such distinctions. Figure 9–9 is a pencil study on linen paper of some trees as viewed from across a small mountain pond. There are four trees, grouped one and three, with the three overlapping one another. I elected to make the center one of the three light and the flanking ones dark. I used a sharp HB pencil to make a faint outline of the trees. Then I used a broad-point 4B pencil to tone the dark masses and put in the trunks. A broad-point HB did the light foliage, the distant mountain, the sky, and some of the lines in the water. Unlike in the previous study, I did not sharpen up the edges of the dark tree foliage in this sketch; I liked the softness of the somewhat indistinct edges.

# A Mountain Rain Forest Scene

One of the more complex subjects for the pen is a view into a busy forest. There is so much visible that it at first can seem totally overwhelming. This kind of subject is best practiced a few times from photographs so that you learn how to simplify the unimaginable detail that you see and how to suggest a multitude of features by drawing only a few.

The rain forest scene in figure 9–10 is from a photograph taken in the rain forest of the western Olympic Peninsula in the state of Washington. A visit to this beautiful mountain countryside is truly an unforgettable experience. The sheer luxuriousness of the vegetation is awesome to those who see it for the first time; a beautiful contrast to the square mile after square mile of devastation the lumbering operations created some miles to the east.

The rain forest is wet and rarely sunny. Moss and lichen are everywhere and cover virtually everything. The study in figure 9–10 shows a little stream pouring down a mountainside valley twisting and turning through moss covered rocks. The view into the forest is dark, but some light breaks on the stream and rocks. My working drawing is shown in figure 9–11. Note that I indicated the few foliage masses and trunks of the near trees, and all of the rocks in the foreground.

The rocks are completed in simple stipple. I left all of them quite light until I completed the rest of the drawing. Then I darkened them up by adding more stipple until I had the tones I wanted. I could not tell just how much would be enough until I had all the other dark tones established.

I did not touch the tree trunks nor the foliage until I had the background completed. Figure 9–12 shows the steps I used in completing the background and the nearer trees. First, I drew vertical hatching across the entire background as at 9–12A. I was careful to dodge around the trunks and foliage areas. Then I completed the background by indicating some smaller, darker trees farther off as at 9–12B. These were done with vertical lines placed over the initial vertical hatching. I also added some vertical lines to the lower part of the background to suggest growth and clutter at ground level. Then I completed the tree trunks as you see at 9–12C, leaving the right sides lighter to show the light coming from the upper right. Finally, I toned some of the foliage masses with more widely spaced vertical lines, as at 9–12D. I wanted to get the feeling of this little pool of light in the dank forest so I only wanted a few sketch elements left light—a few rocks and foliage clumps. This stage proceeded with a lot of my holding the sketch out at arm's length to see how the light and dark areas were building. This method of doing the background is a slight variation on that shown in Figure 7–22.

Although it is not evident from the reproduction, figure 9–10 was drawn on ledger paper. This is a beautifully smooth, hard-surfaced paper that is green in color and ends up printed with the usual lines that you see on accounting paper. I like to try out different papers whenever I get a chance to. I obtained some of the ledger paper before it had the lines printed. It has a really good surface for taking ink.

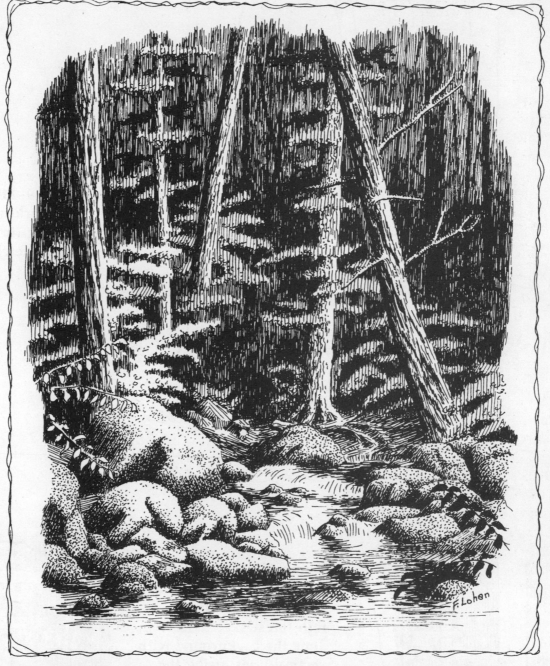

**Figure 9–10**
**A forest scene based on the rain forest of the Olympic Peninsula**
**in Washington State.**

**Figure 9-11
The working pencil
drawing for the rain
forest sketch.**

**Figure 9-12
Four steps to completing
the background in the
rain forest sketch. (A)
Tone the background with
vertical lines, using the
pencil lines as guides. (B)
Use additional vertical
lines to show the dark
detail in the background.
(C) Tone and texture the
near tree trunks. (D)
After erasing the pencil
guide lines, use widely
spaced vertical lines to
tone the foliage that is in
shade.**

A      B

C                    D

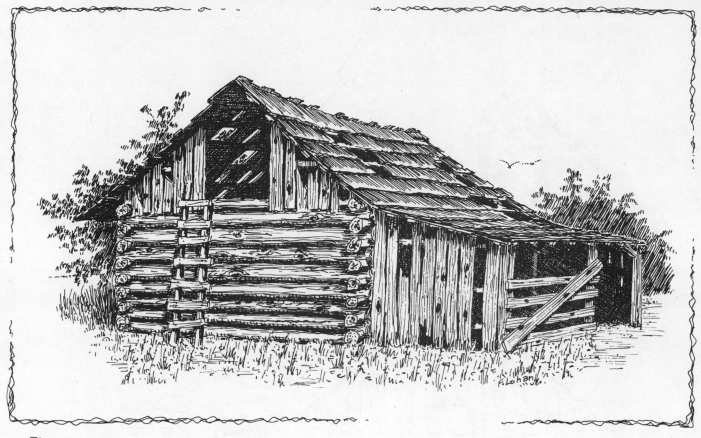

**Figure 9-13**
**A pen sketch of a mountain barn.**

# A Mountain Barn

High in the Rocky Mountains, not too far from Winter Park, Colorado, was the inspiration for the mountain barn sketch in figure 9-13. This drawing was done from memory after seeing a log barn from horseback in that area. The background trees are in the style of figure 4-7 and the logs and wood of the barn are treated in a representational manner with hatch marks along the length of the wooden elements.

The approximately twenty-six steps that I used to complete the barn are illustrated in figure 9-14. My working pencil drawing was as you see in the center of figure 9-14. It was, of course,

drawn very lightly so that the later erasing of the pencil marks was easy.

I first hatched the interior of the loft and the underside of the roof overhang with parallel lines, as in 9-14A. Then I crosshatched over these with horizontal lines as you see at 9-14B. I felt that the two layers of ink, being done with closely spaced lines, was as dark as I wanted. If it had not been dark enough, I would have placed a third layer of hatching on top.

The roof came next. At 14C, you see the hatching of the shingles that project above the ridge. At 14D, I indicated the edges of the large shingles and at 14E, I completed the

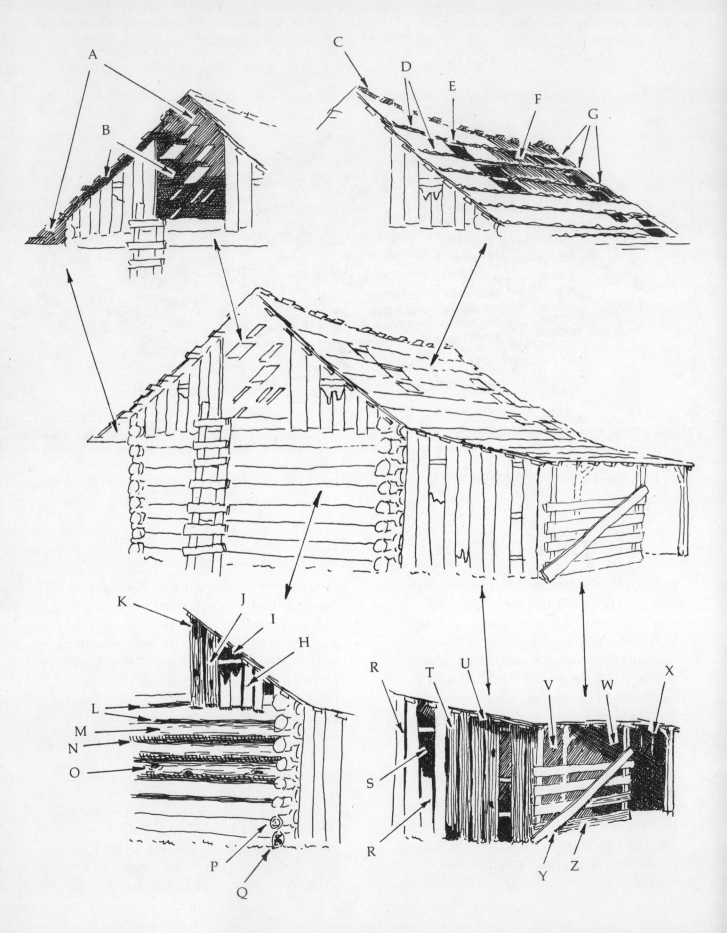

darks where shingles were missing. When you do this, be sure to leave some indication of the boards to which the shingles are nailed.

Figure 9-14F shows the hatch marks that I used for the shingles. Note that the edges of the shingles were left unhatched to define them by a little glare, as you see at 14G.

The vertical boards on each side of the loft entrance were completed by first indicating the dark space between them, at 14H. Then the dark interior seen between the broken boards, as at 14I, was done. The wood grain itself on the boards was done using lines running the length of each board as at 14J, and a shadow from the overhang was added at 14K.

To complete the horizontal logs of the visible side of the barn, I first darkened the shaded underside of each log (14L). Then I added a few texture marks, like those in 14M, before I modeled the curved underside of each log by crosshatching as at 14N, and added the knot indications, as at 14O. The visible ends of the logs were treated with a few circles to suggest the end grain of the wood, as at 14P, and by a few crack suggestions, as at 14Q. Without some toning, these log ends were too white and jumped out of the sketch.

The attached lean-to was the final part of the barn to draw. I first drew the dark spaces visible between the boards, as at 14R, then crosshatched the dark interior where the broken boards were, as at 14S. I textured the boards with lengthwise lines as at 14T, and the overhang shadow as at 14U. The dark interior seen through the open end of the lean-to was done with crosshatching as you see at 14V and 14W. Note that I left some long white slivers (14X) to suggest the light coming through the spaces between the boards. A little shadow from the diagonal board is shown at 14Y, and the lengthwise hatching to texture the remaining boards is shown at 14Z.

When the barn itself was complete I added the trees at the left side and those in the background at the right, then finished it off with the grass marks.

**Figure 9-14**
**Twenty-six steps in completing the mountain barn.**

**Figure 9–15
An abandoned cabin
in Idaho.**

# Three Studies of an Idaho Cabin

In a high valley in Idaho is a little abandoned cabin, nestled under a clump of large trees not far from a small river. This section deals with three pen and ink studies of that cabin. The overall setting is shown in figure 9–15. Note that here again the distant mountains are simply suggested by a thin outline. Any texturing of these mountains would have brought them forward in the drawing and tended to confuse them with the texturing of the trees. I worked from about six photographs of the little cabin to do

the three studies covered in this section.

Figure 9–16 shows you how I went about drawing the various parts of the subject. You can see in this figure the pencil working drawing over which I did the inking. Be sure to keep your working pencil drawing very light. In 9–16A, I outlined each foliage clump with an irregular, leaf-like line before completing the texture with little circles and leaf marks, as in 16B. When all the foliage was drawn, I added the tree trunks, as in 16C, and some finer branches, as in 16D. Then I put in the background trees with essentially horizontal groups of hatching (16E). I was careful to keep this tone lighter than that of the tree trunks so that I would not lose the tree trunks in the background. Next I did the roof of the cabin. I kept it light so it would not become confused with the background tone (16F).

Slanted hatch marks depicted the muddy shore line of the little river, as in 16G, and horizontal lines did the job of suggesting the water, as in 16H.

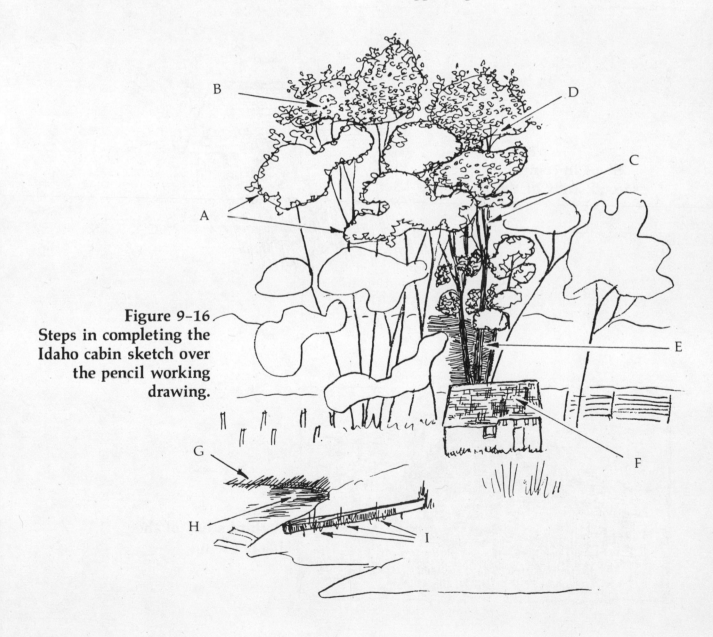

**Figure 9–16**
**Steps in completing the Idaho cabin sketch over the pencil working drawing.**

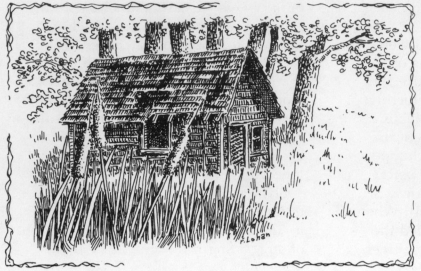

**Figure 9-17**
**A second study of the Idaho cabin.**

**Figure 9-18**
**Steps in completing the second study of the Idaho cabin.**

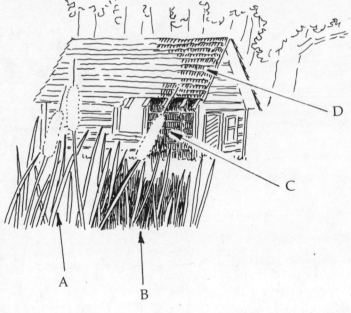

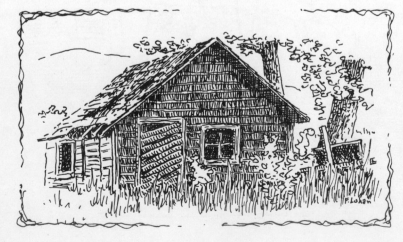

**Figure 9-19**
**A third study of the Idaho cabin.**

When I drew the beam lying in the grass, I first indicated a few grass clumps in front of the beam and then used vertical lines to texture the beam, avoiding the grass marks I had just applied 16I. If you look at this area in figure 9–15, you can see how this gives the impression of the grass being in front of the beam.

The second study of the little cabin is shown in figure 9–17. This shows the cabin as viewed from across a small cattail marsh. I wanted to get a few of the cattails in the near foreground superimposed on the cabin, so when I textured the cabin, as you see in figure 9–18, I let the cattails remain untouched by the ink until last. Only then could I tell just how much ink I could add to them and not have them blend into the cabin. The steps used to complete this second study are shown in figure 9–18. I had to suggest all the cattail leaves in the foreground, so I simply drew a few as at 9–18A and filled in between these with vertical hatching to suggest some more leaves, as you see at 9–18B. I outlined the cabin elements as you see, then filled in each area separately with vertical hatching as at 9–18C. The roof was completed with hatch marks that run the length of each shingle. Note that these hatch marks follow the slope of the roof and that I left a little white paper to indicate glare on the edges of the shingles.

The third study of the same cabin, figure 9–19, shows the front with the boarded-up door. This study has the front in shade and the glare of the sun suggested by the absence of detail and texturing on the roof and on the left side of the cabin. Again, the mountain is simply suggested by a thin outline.

# Echo Rock, Mount Rainier

This study of Echo Rock was done from a photograph taken from Lookout Point on Mount Rainier in Washington state. Figure 9–20 shows the rocks of Lookout Point in the foreground, a snow or ice field in the middle distance encroaching on the talus slope of Echo Rock, and another slope of Mount Rainier in the background. The pen technique used in this study is just like that used in the last chapter for figures 8–8 and 8–10, but this subject is considerably more complex than the earlier ones. The complexity comes from the highly fractured rock on Mount Rainier. The earlier, desert scenes tended to have smoother rock outcroppings and promontories. This scene presents a quite complex pattern of shadows and highlights because of the innumerable irregularities in the rock surface.

I started with the simple pencil working drawing you see in figure 9–21. I first attempted to indicate in pencil, on the Echo Rock outline, where all the darkest of the shaded areas were. This became too confusing very quickly, so I just worked from the simple outline of figure 9–21 and took one area at a time from the photo to show the darkest areas with vertical lines, as you see in figure 9–22A. Then I went over this a second time to emphasize the very dark areas that were within as at 9–22B. I then added

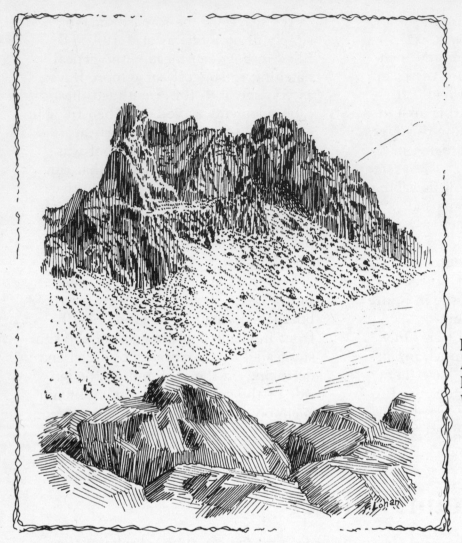

**Figure 9–20
A pen sketch of Echo
Rock, Mt. Rainier,
Washington.**

the intermediate darks by hatching over the light areas of my sketch with slightly wider spaced vertical lines as at figure 9–23A. Next, I went in and added some of the finer, dark details as at 9–23B. I continued this process across the whole sketch. I left the few brightest areas of the rocks as white paper as in figure 9–24A. Then I added some of the large, individual boulders that were on the talus slope, as at 9–24B. The final step was to complete the talus slope itself. If left untextured, it would have suggested snow, so I used rows of dots to suggest the stony

nature of this slope. These rows of dots slope to show the direction that the talus slope takes—down and to the right at 9–24C and down and to the left at 9–24D.

The foreground rocks were of a dark material in the photo, so I did not leave any bright highlights when I hatched them. The technique here was to indicate the planes of the surfaces with the direction of the hatching.

Observe that a perfectly credible background mountain could be represented by the minimal texturing of figure 9–22 without the addition of

Figure 9-21
The initial working
drawing for the Echo
Rock sketch.

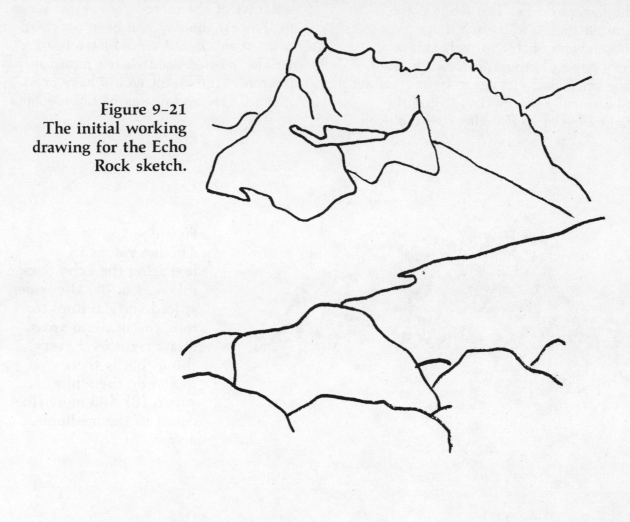

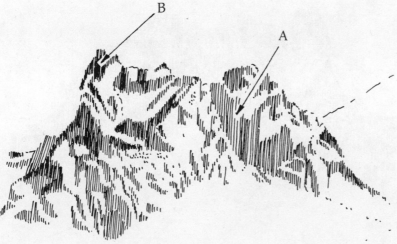

Figure 9-22
The first steps in
texturing the Echo Rock
ink sketch. (A) Use
vertical lines to indicate
the primary dark areas.
(B) Go over these lines
with more vertical lines
to show the very darkest
darks.

the darker darks. The white areas remind the viewer of snow.

A subject such as this requires a very good photograph to work from. The one I had was taken by my son on a beautifully sunny day, at just the right time of day to allow all the deep shadows of the incredibly rugged scene to show. If the day had been overcast, none of this detail would have been visible; if I had used such a photo as reference, the result would have been much flatter and not as highly modeled as this study.

Figure 9-23
The next steps in texturing the Echo Rock ink sketch. (A) Use wider spaced vertical lines to tone the medium areas. Draw right over every thing that is there including the white paper. (B) Add more fine detail in the medium areas.

Figure 9-24
The final steps in texturing the Echo Rock ink sketch. (A) Leave the lightest areas as white paper. (B) Add rocks on the talus, the debris slope at the base of the cliffs. (C) Add rows of dots to tone the talus and to indicate the slope, which at C is down and to the right. (D) In this area the talus slopes down and to the left.

# 10
# Sketching Rural North America

*Basic Structures*
*Homestead at Cades Cove*
*The Bales Place Near Gatlinburg*
*The Mill at Glade Creek*
*A Covered Crib at Cades Cove*
*A Pennsylvania Barn*
*Old Wooden Barn*
*An Old Manure Spreader*
*A Farmland Stream*
*A Covered Bridge*
*A Unique Barn*
*A Wooden Mill Wheel*

# Basic Structures

As a countryside artist you have absolutely no shortage of subject matter regardless of where you travel in rural America. You, or your relatives or friends, may have a cottage for weekend and summer retreats. You can quickly sketch such a structure as I did in figure 10–1 with my technical pen. Older buildings like this have an honest charm about them that you can try to capture in small studies with the pen or with the pencil.

When you travel on vacations you can accumulate a wealth of subject matter for later sketching at home; and the best part is that you can use your camera to record details about your subjects that might not show in the photographs available or in the ones that you take of overall scenes. Once you try to use your existing photos as subject matter you will see what I mean. Most of the time, unless you took photos specifically for the purpose of later sketching, you will find that you cannot see enough detail to do a

good job of it at home. You then learn to photograph an overall subject for a composition, then move in and get details recorded on film that you may need later, and to get close-ups in the darker areas that show up as solid black on your more distant shots.

Figure 10–2 is a study from a vacation photograph taken of the mill at Pigeon Forge, Tennessee. I used my 3×0 technical pen here. You can see from this figure that there really isn't much detail. The area of the drawing is too small to actually draw the clapboards on the building. I suggested them in the sunny portions and drew them in the shaded areas to get the tone that suggests shade. Another pen study, again with my 3×0 pen, from a vacation photograph can be seen in figure 10–3. This shows the railroad station at Goderich in Ontario, Canada. Since the popularity of rail transportation in North America has declined, you can find many such old stations, most of which are no longer

**Figure 10–1**
**A simple rural scene.**

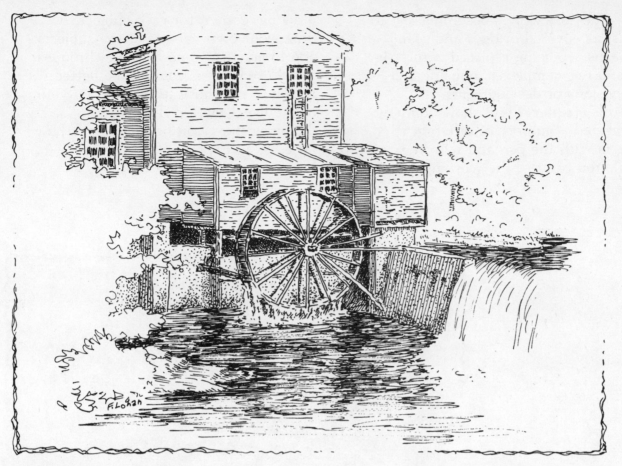

**Figure 10–2**
**The mill at Pigeon Forge, Tennessee.**

**Figure 10–3**
**The railroad station at Goderich in Ontario, Canada.**

used. They are slowly becoming lost to us just as covered bridges and grand old barns are being replaced with strip malls, office complexes, housing and subdivisions or developments.

In this chapter, I will show you how I developed a number of different rural subjects with the pen and with the pencil. You can use the working drawings shown for each subject to draw your own version of the subjects and to practice some of the techniques that I used. Then you will be better armed to try those techniques on your own subject matter. The working drawings show you how much, or how little, detail I start out with when I begin a composition.

**Figure 10-4
A restored homestead at
Cades Cove, Tennessee.**

# Homestead at Cades Cove

The Cades Cove area, about twenty miles from Gatlinburg, Tennessee, is a beautiful valley that has been restored to its pioneer day condition. There are a number of buildings and a mill there, some of which are subjects for this chapter. As you enter the area one of the first buildings you come to is a log homestead. A sharp HB pencil was used to do figure 10-4, a detailed, but small, study of the homestead. The pencil is capable of very detailed work when you use sharp, harder leads. The pencil is also excellent for capturing generalized impressions that the pen cannot do in as short a time. For quick impression drawings you use a soft, broad point, somewhat as in figure

10-9, which is a quick (five-minute) study of another building near Gatlinburg.

When I drew the homestead I started with a light working pencil drawing as in figure 10-5. Remember these working drawings are shown dark in this book so they will reproduce well. Actually, they should be as light as you can make them on your paper.

I started with the stone chimney in figure 10-4, using short irregular lines to indicate the stones. Then I did the roof. I planned from the outset to have the roof lighter at the left and darker at the right to help form a center of interest at the near corner of the building by having the greatest contrasts there. Then I did the wide logs on both visible faces of the building, leaving the lighter caulking simply as white paper. After the background mountain and trees were added with a broad-point HB pencil, I used it also to tone over the stone work in the chimney and to carefully tone the light caulking between the logs. With the sharp HB point, I emphasized the edges of a few of the logs and sharpened up all other edges on the homestead. The key in a drawing such as this is to work carefully, using the photograph as a compositional guide, but using your artistic sense to produce tone variations not visible in the photo to create a drawing with artistic merit, rather than to just copy what the photograph does much better. A small, detailed pencil sketch such as this takes as much time to complete as a pen sketch of the same size would.

**Figure 10-5**
**The working drawing for the homestead at Cades Cove.**

**Figure 10–6**
**The Old Bales Place near**
**Gatlinburg, Tennessee.**
**This was drawn this size**
**with a 3×0 technical pen.**

# The Bales Place Near Gatlinburg

All of the art work in this book, unless noted otherwise, is reproduced at very close to full size. This allows you to observe all the strokes and to learn the various techniques by trying to duplicate them. You have to know, however, if you see some beautiful pen work reproduced somewhere that you want to use for practice, that chances are it has been reduced considerably before being printed. This means that you will not be able to obtain the same effect you see because you just can't draw lines as thin as those you are using as guides. Figure 10–6 is a 3×0 technical pen sketch of the Bales place outside Gatlinburg, Tennessee. Compare this sketch with the one in Figure 10–7. Note that they are the same size and that the lines appear much finer in 10–7 than in 10–6. This is because figure 10–7 is reduced from

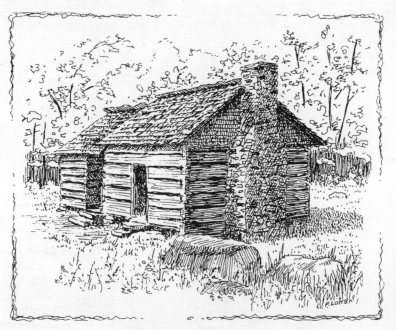

**Figure 10–7**
**This sketch was drawn fifty**
**percent larger than the previous**
**one, then reduced to this size.**
**Note how much finer the line**
**work is than that in the**
**previous figure.**

its original size. The original, shown in figure 10-8, is twenty-one square inches, while the reduced version in figure 10-7 is about fourteen square inches. You have to remember this when you do use reduced pen work as practice subjects. In such cases, you should make your drawing larger than the one you are working from. Another example of the effect that reduction has on pen work can be seen in the next subject, the Glade Creek Mill. When you have a tiny drawing, you can only get so many ink lines in a given area. Somewhat larger drawings allow you more flexibility in this

regard. Compare the toning of the shaded side of the building in both figures 10-6 and 10-7 to see what I mean. There are many more lines drawn in 10-7 than in the same areas of 10-6 to create the same tone.

For contrast, I have included a five-minute pencil study of the same subject in figure 10-9. A broad-point 4B pencil was used here. Tone studies such as this are good practice pieces before you start to complete a more detailed pen or pencil drawing of a specific subject. They help you to plan your lights and darks so that your center of interest is well established.

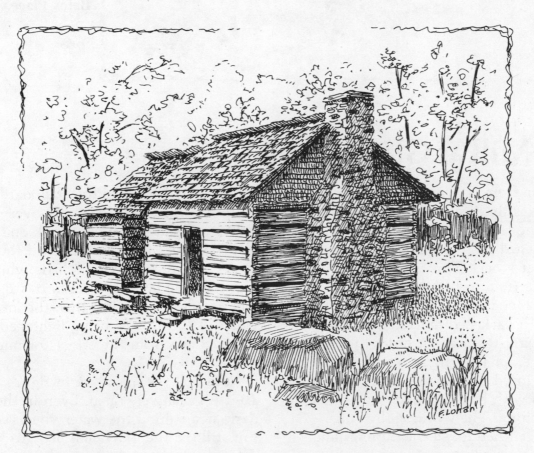

**Figure 10-8**
**The Old Bales Place near Gatlinburg, Tennessee. This is drawn
half again larger in area than the smaller one in figure 10-6.
This allows more delicate treatment of the detail. This sketch is
shown reduced in figure 10-7.**

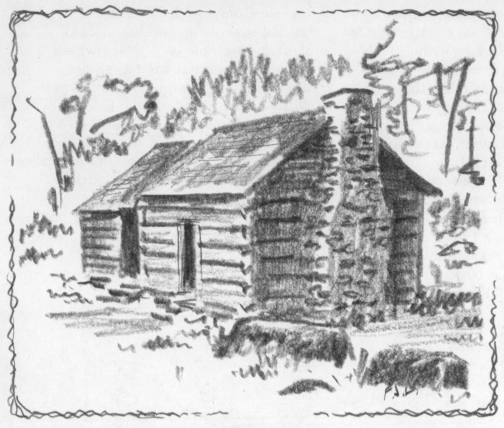

**Figure 10-9**
**A five-minute pencil sketch of The Old Bales Place.**

# The Mill at Glade Creek

Not far from Babcock, West Virginia, is the Glade Creek Grist Mill. It is a wooden clapboard building that has darkened with age and has a big, iron water wheel. This is the subject of figure 10–10, a technical pen study.

The clapboards and the light-colored stone with darkened mortar were the predominant features. In order to properly emphasize these features in my drawing, I elected to use an outline approach with hatching and crosshatching. The working drawing then, after I had inked the outlines and erased the pencil lines, was as you see in figure 10–11. The techniques I applied here aren't much different from those discussed earlier, except perhaps

for the way I hatched the clapboards. Note that instead of hatching over entire areas at one time, I took one clapboard at a time and hatched the upper part of it, leaving a little white paper on the bottom of each board. The building looks like this, the lower edges of each board being lightened considerably from the effects of rain and sun.

Note that the ink work in figure 10–10 is relatively open. Even in the dark area behind the waterwheel, you can still see the individual pen strokes. This approach works best when you intend to have a drawing reduced and printed. Figure 10–12 is a severe reduction of the full-size drawing, yet

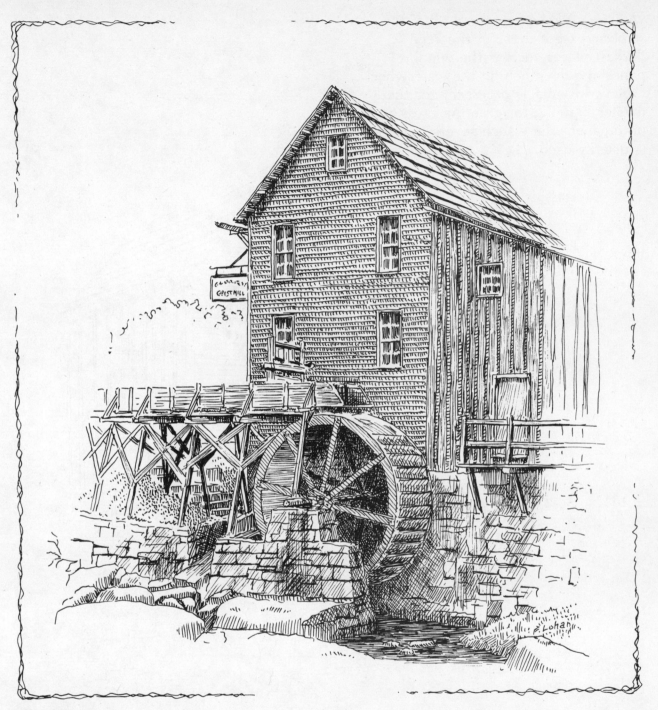

**Figure 10-10**
**An ink study of the mill**
**at Glade Creek, West**
**Virginia.**

you can still see just about all of the
strokes, except those in the very
darkest places such as the window
panes and deep behind the waterwheel.
Open pen work is necessary for the
master drawing for greeting cards and
note paper where such severe reduction
is usually used.

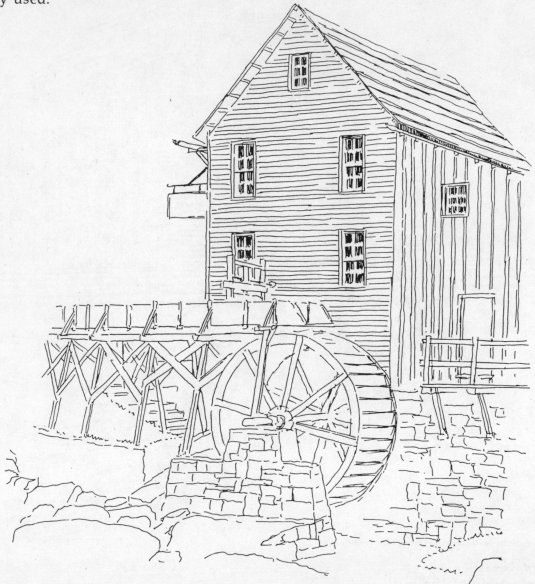

**Figure 10–11
The working drawing for
the sketch of the Glade
Creek Mill.**

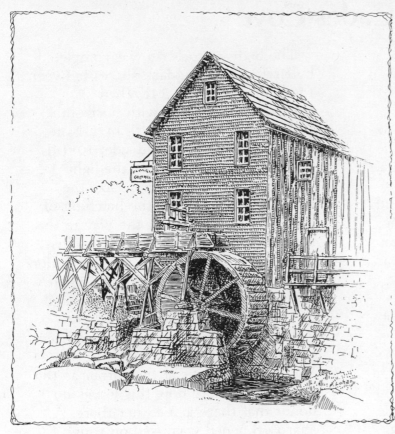

**Figure 10–12
A reduced copy of the ink study.**

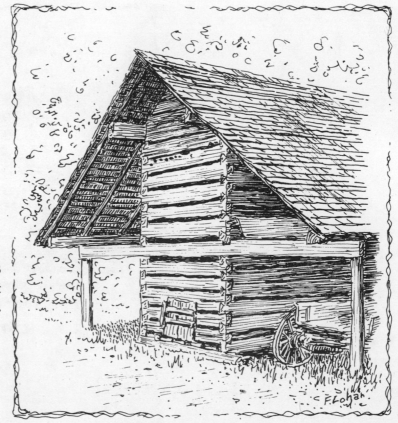

**Figure 10–13
A covered corn crib at
Cades Cove, Tennessee.**

# A Covered Crib at Cades Cove

One of the many reconstructed, pioneer-day buildings at Cades Cove, Tennessee, is a covered crib. This structure is covered in a way that provides shelter for farm vehicles also, something like our present day carports. It is open on all sides with a large expanse of roof overhang.

Figure 10–13 is a technical pen study of the crib. The working ink drawing, after the pencil lines were erased, can be seen in figure 10–14, along with an indication of the step-by-step completion procedure. I first drew indications of the horizontal slats that formed the roof under the shingles as you see at 10–14A. Then I hatched each slat individually as at 10–14B. The spaces between the slats was then darkened as at 10–14C. The underside of the roof was completed by toning the rafters as at 10–14D.

The body of the crib was completed by first inking the dark spaces between the boards as at 10–14E, then texturing the boards with horizontal lines as at 10–14F and 10–14H. Note, however that the shaded side, 10–14F, has denser hatching than the light front of the crib. To emphasize the corner I did not bring the hatching of the front of the crib all the way to the corner—I show this at 10–14G. This emphasis prevents losing the distinction of the corner as often happens when the tones of each side, the darker and the lighter, are too close together.

The pencil study of the same subject, shown in figure 10–15, uses the same highlight emphasis at the corner as the ink version. Note how this leaves no doubt that there is a corner there. A sharp 4B pencil was used on rough paper for this sketch.

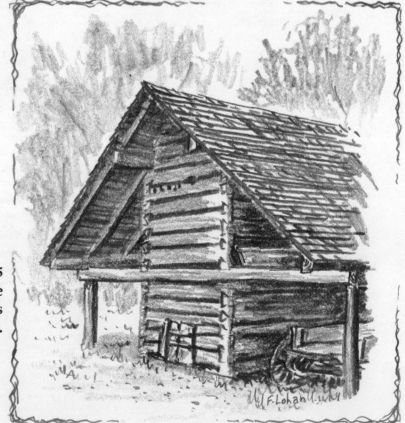

**Figure 10–15
A pencil sketch of the covered crib at Cades Cove.**

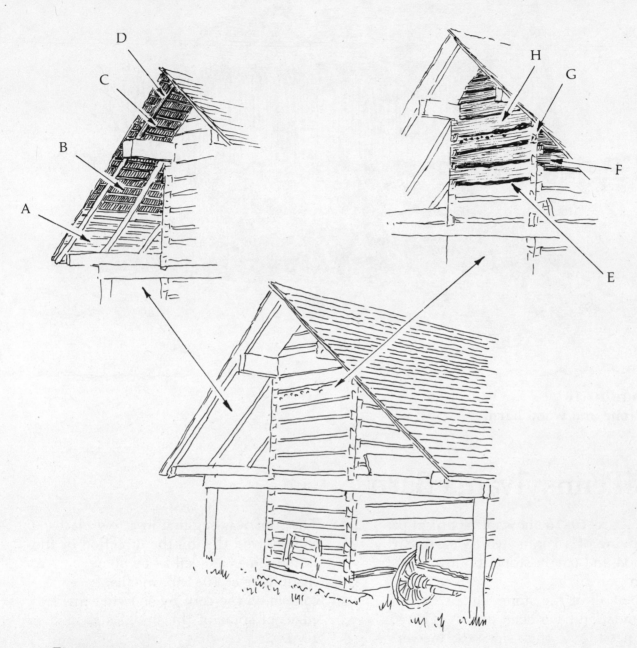

**Figure 10–14**
**The working ink drawing**
**and some steps in**
**completing the sketch of**
**the covered crib at Cades**
**Cove.**

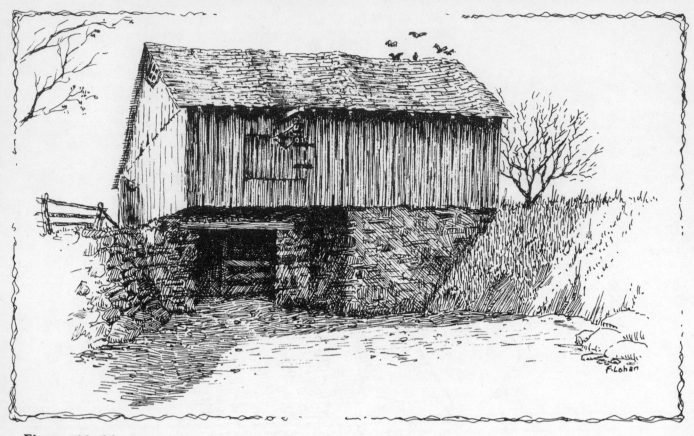

**Figure 10-16**
**A stone and wood barn.**

# A Pennsylvania Barn

Figure 10-16 shows a technical pen drawing of a Pennsylvania barn, partly wood and partly stone, built into a bank of earth.

Not all of the stones in the barn foundation have been drawn. There is no need to do this, since the viewer's eyes will fill in the missing ones and the clutter of so many of the same thing is avoided.

Figure 10-17 is the working pencil drawing over which I inked. Remember to make your working pencil drawing very light and easily erasable. Some of the steps I used to complete the sketch are shown in figure 10-18.

I started with the roof as in 10-18A by indicating the lay of the shingles.

The roof was sagging in a few places, so I showed this by the direction of the shingle lines as well as by some shading as at 10-18B. Finally, I completed the roof by showing the edges of some of the shingles as in 10-18C.

The stone foundation was started as at 10-18D, by drawing some of the stones and making a few of them darker than the others. Then I hatched over the stones and the blank paper between them to get the shading on the back wall. I used hatch marks that were closer together to show the darker shading on the barn wall under the overhang (10-18F).

I did the interior in two steps. First, I

crosshatched the dark areas, then I hatched the woodwork so that it receded into the interior without blending completely into the dark crosshatching. This is shown at 10–18G.

The stones on the bank at the left were completed one at a time, as you can see at 10–18H. I drew the ground using groups of short hatch marks, each group varying a little from the horizontal, to show the irregularity of the ground where the animals all walk. The tree at the right of the barn was done as shown in Chapter 5, *Drawing Rocks and Stone Walls*, figure 5–49.

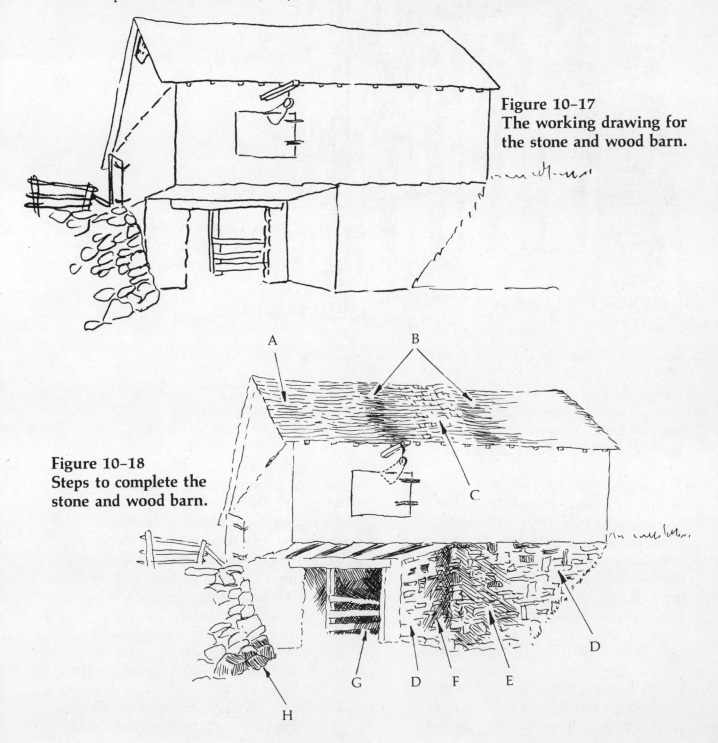

**Figure 10–17
The working drawing for the stone and wood barn.**

**Figure 10–18
Steps to complete the stone and wood barn.**

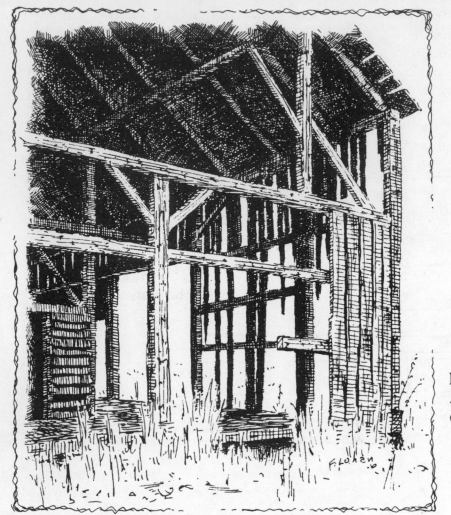

**Figure 10–19
An old barn being
dismantled.**

# Old Wooden Barn

The partly dismantled barn shown in figure 10–19 was near Farmington Hills, Michigan. The land on which it stood for many years was cleared for a housing development. I took a series of photographs before it was completely destroyed; this sketch is from one of them. I was attracted to the contrast between the dark, silhouetted, vertical boards and the light, horizontal ones on the near side.

My working drawing, shown in the inked stage in Figure 10–20, was done from a large perspective set-up just

like that shown earlier in Chapter 3, *Perspective Shortcuts*, figure 3–9. Getting the perspective correct is very important in a drawing like this, as any large errors show up quite prominently. The primary challenge here was in inking the underside of the roof. I wanted all the beam and rafter structure to be visible as opposed to disappearing in the dark. I proceeded as shown in figure 10–20A by inking the darker cracks between the roof boards. Then, as in 10–20B, I put down a layer of hatching over the whole roof. Next,

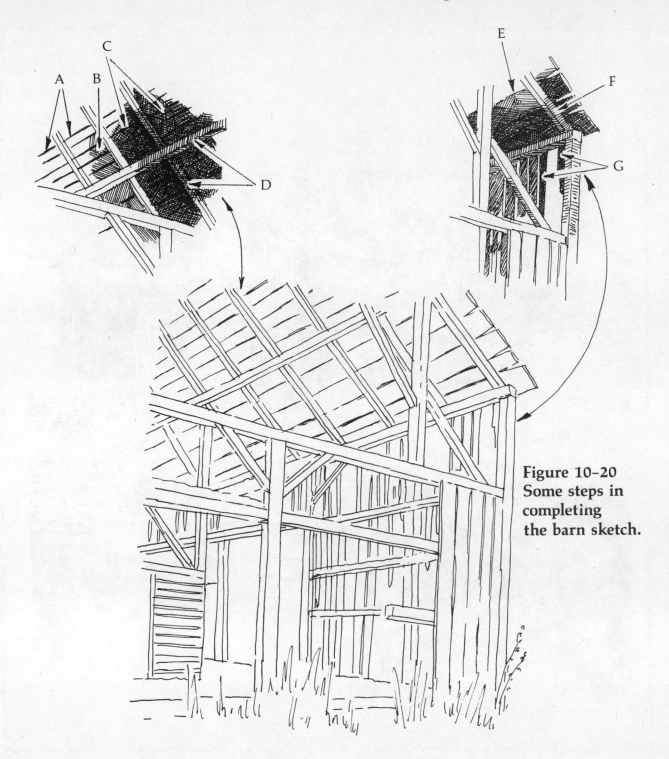

**Figure 10-20
Some steps in
completing
the barn sketch.**

this was followed by a layer of crosshatching as in 10-20C. Until this was done, I left the beams and rafters as white paper. Then I hatched these as you can see in 10-20D. A similar set of steps is shown at 10-20E and F for the corner of the roof. The silhouetted boards on the far side of the barn were completed by using closely spaced hatching and crosshatching, as you can see in 10-20G.

The remaining steps in completing this sketch are evident from Figure 10-19.

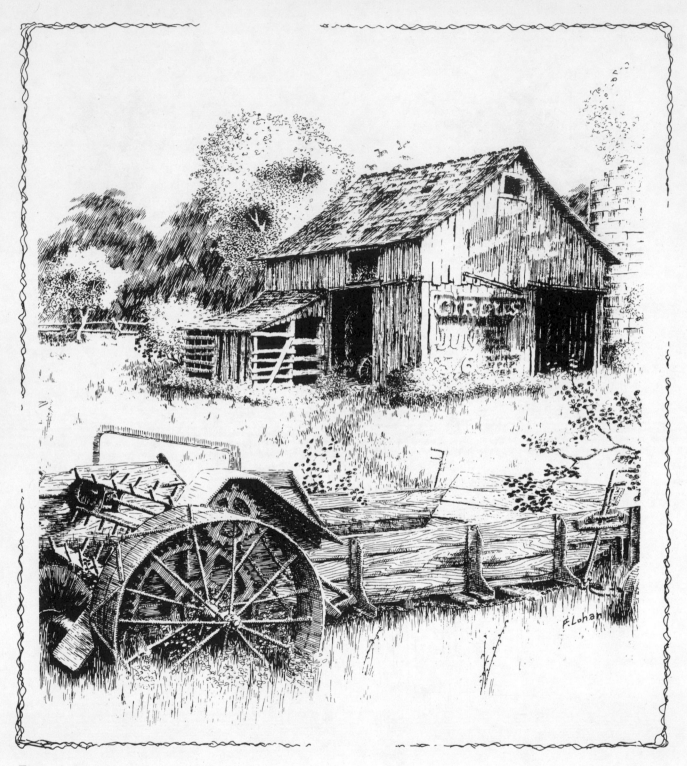

**Figure 10–21**
**Old barn and manure**
**spreader. This illustration**
**is about one half the size**
**of the original.**

# An Old Manure Spreader

Old farm vehicles are disappearing as rapidly as old farms and farm buildings are. When you see something from our agrarian past, get some photographs, as these items make excellent sketch subjects.

The old manure spreader in the foreground of figure 10–21 was drawn from photographs taken by a friend of mine who commissioned me to do a large drawing of a farm scene incorporating the spreader. Figure 10–21 is a portion of that drawing, reduced to about half the size of the original. Correct perspective is important in a drawing of a piece of machinery such as this. I used the principles discussed earlier in the chapter on perspective to establish a box that looked "right," then I drew the spreader inside the box. Figure 10–22

shows you the working drawing of the spreader at the reduced size of figure 10–21. I started to complete the inking of the spreader in figure 10–23 so that you might see the difference in the pen strokes. I used my 3×0 technical pen for both drawings—the original, large size one that is reduced in figure 10–21, and the partially completed drawing of figure 10–23. By comparing these two illustrations you can see that there are fewer lines in any given area in the smaller drawing. Remember this when you use reduced line work as practice subject matter: you cannot obtain quite the same delicacy of line work when you draw a subject smaller as you can when it is drawn large.

Nothing about the barn in the background of figure 10–21 was done differently than in other barn studies

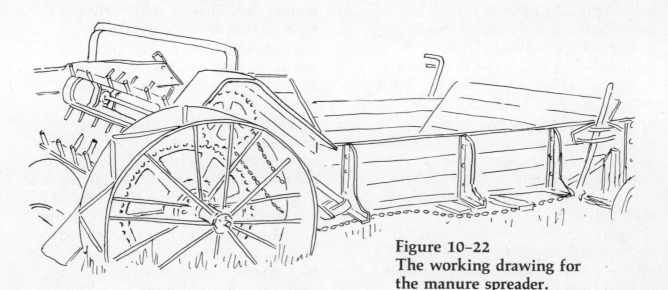

**Figure 10–22
The working drawing for
the manure spreader.**

in this book. The background trees are
partly like those in figure 4–5 and
partly like figure 4–11 in Chapter 4,
*Backgrounds, Composition, and Drawing
Techniques.*

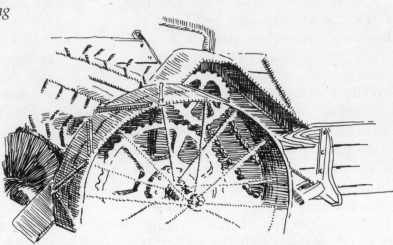

**Figure 10–23
The manure spreader
partially inked.**

# A Farmland Stream

Rural sketching need not be confined
to structures. There will be many
really picturesque bends in country
roads and quiet streams that border
once cultivated land that you will run
across in your countryside wanderings.
These too are fit subject matter.

Figure 10–24 shows a little stream
running through a pasture that is
bordered by woodland. This
composition would serve as well for a
country road setting by drawing a dirt
road as in figure 10–25 instead of
drawing the stream. Notice that the
roadway is suggested by using groups
of hatch marks, basically horizontal,
but varying slightly in their angle to
give the impression of irregularities in
the roadway.

Figure 10–26 shows my pencil
working drawing before I started
inking. I completed the stream sketch
by using the steps shown in figure
10–27. The pencil working drawing is
shown at 10–27A. Using the pencil

guide lines, I first completed all the
clumps of foliage as at 10–27B. Then I
did the tree trunks and branches as at
10–27C. I imagined the light coming
from the right so I left some of the
trunk areas light on the right side to
suggest this. I did the background trees
with slanted lines as at 10–27D and
with vertical lines for the darker
interior as at 10–27E. The grass and
weeds are done with more or less
vertical lines, packed close together
where I want shade suggested.

A setting like this requires a great
deal of simplification from what you
see in nature or what you see in a
photograph. The sort of continuous
mass of foliage must be simplified to a
few major clumps, and the background
must be reduced to just tone. If you
tried to use little leaf strokes for the
background trees in this sketch, they
would all simply blend in with the
nearer foliage and destroy any sense of
depth and distance.

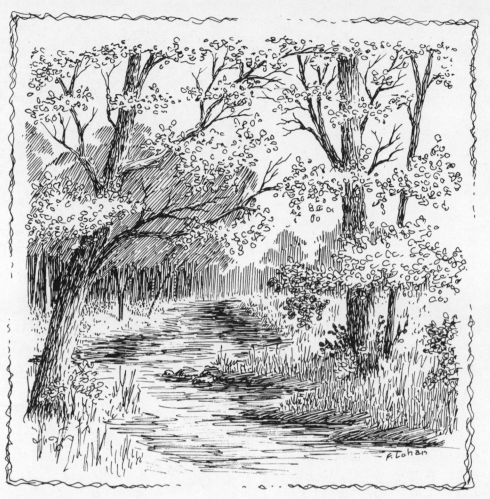

**Figure 10–24**
**A farmland stream.**

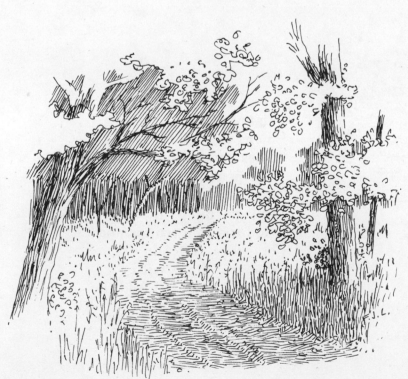

**Figure 10–25**
**A country road.**

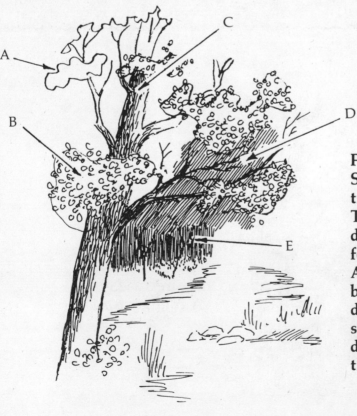

**Figure 10-26
The working pencil
drawing for the farmland
stream sketch.**

**Figure 10-27
Steps in completing the
trees and background. (A)
The pencil working
drawing. (B) Draw all the
foliage clumps first. (C)
Add the tree trunks and
branches. (D) Add the
distant foliage with
slanted lines. (E) Add the
dark under the distant
trees with vertical lines.**

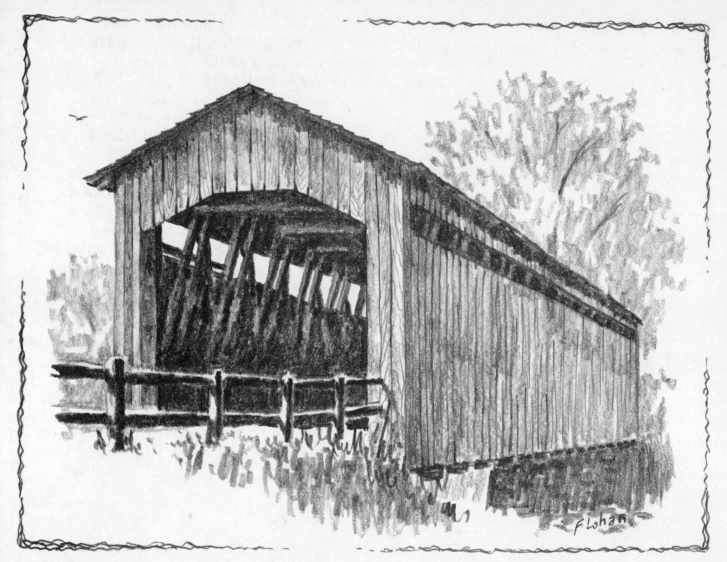

**Figure 10–28**
**A covered bridge on the Thornapple River near Ada, Michigan.**

# A Covered Bridge

Figure 10–28 is a pencil sketch of a covered bridge on the Thornapple River near Ada, Michigan. No two covered bridges are alike, it seems, but any of them are great sketching subjects.

My pencil working drawing for this bridge is shown in figure 10–29. Since a pencil sketch does not allow for erasing the underlying working

drawing the way a pen sketch does, it is doubly important to make the working drawing as light as you can when doing pencil work. The steps in finishing the interior of the bridge are shown in figure 10–30. I used a broad-point 4B pencil as well as a sharp 4B in doing the interior. First, with the broad point I placed the darkest darks, as in 10–30A. Then I used the same point

lightly to tone the lighter beam faces, as in 10–30B. The same pencil then did the dark, shaded sides of the little fence as at 10–30C. Finally, I used the sharp 4B point to sharpen up the edges of all these darks.

The outside of the bridge was done as you see in figure 10–31. First, a tone was placed all over the outside, as in 10–31A. Then the shadow from the overhang was put in as at 10–31B. The broad-point 4B pencil was used for both of these steps. Then, using a sharp HB pencil, I indicated the cracks between the boards, as in 10–31C. Next, with the broad point again, I

darkened some of the boards as at 10–31D before I took the sharp HB to indicate some of the wood grain in the nearer boards, as in 10–31E. The exterior of the bridge basically was done as explained in Chapter 2, *Techniques*, in figure 2–5 and related text.

The broad-point 4B pencil was used for the grass and tree indications also.

To emphasize the near corner of the bridge so that it would not become indistinct, I pressed my kneaded eraser on the sunny side right at the corner to make it a bit lighter, and I slightly darkened the shaded side at the corner.

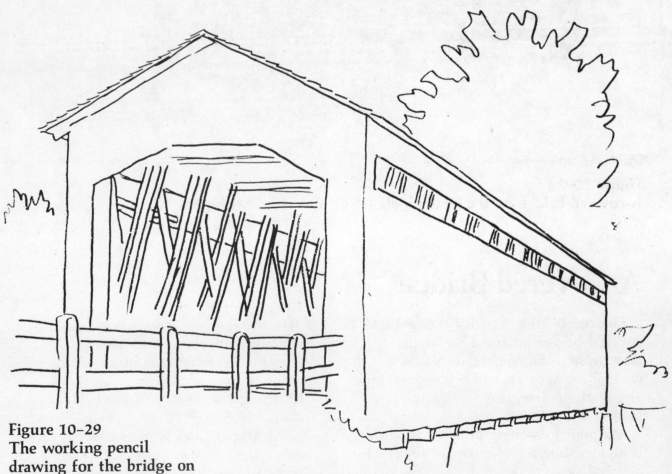

**Figure 10–29**
**The working pencil**
**drawing for the bridge on**
**the Thornapple River.**

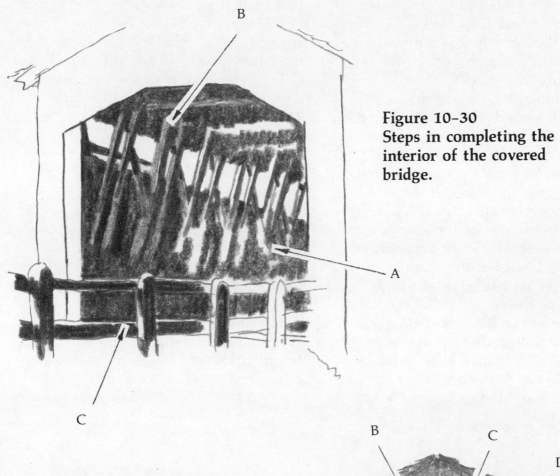

**Figure 10–30**
**Steps in completing the interior of the covered bridge.**

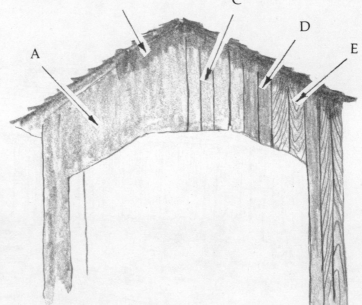

**Figure 10–31**
**Steps in completing the exterior of the covered bridge.**

# A Unique Barn

One of the restored farm structures at Cades Cove near Gatlinburg, Tennessee, is a barn that is built over two cribs. A pen sketch of the barn is seen in figure 10–32.

The working drawing for this subject, as it looked after I inked it and erased the pencil lines, is seen in figure 10–33. The marvelous shingled roof was the first element I completed. First, I drew irregular lines to indicate the rows of shingles (figure 10–34A). Next, I toned the underside of the shingles that projected above the ridge as in 10–34B, and I hatched the shadow from these in 10–34C. The shadows from some of the shingles that did not lie flat were next added (10–34D), and finally some texture lines completed the roof (10–34E and F). When you do this step, do not uniformly cover the whole roof. Note that in figure 10–32

that I left the middle of the roof lighter in this sketch than the two ends. This suggests a highlight and breaks up the monotony of a uniform roof.

The side and end of the barn were completed as you can see in figure 10–35. First, the spaces between the boards were drawn (10–35A), then some of these spaces were exaggerated (10–35B). The shadow from the overhang was then added (10–35C). The texturing of the side boards was done as you see in 10–35D and E, with the corner being emphasized as in 10–35F, with the bright side being left very light and the dark side being darkened.

The lower part of the barn and the ground can be completed by observing figure 10–32 and reviewing the steps of figure 10–14E, F, G, and H.

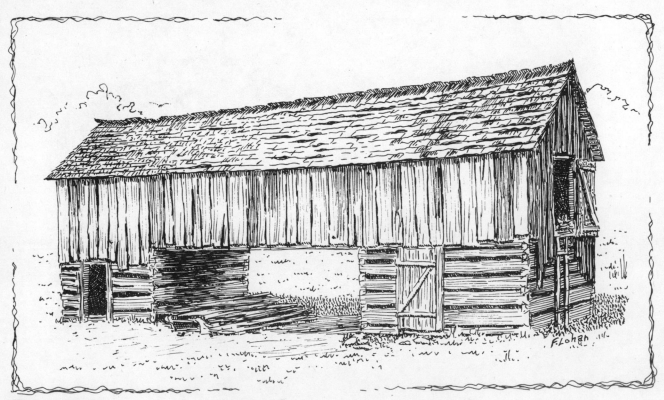

**Figure 10-32**
**A barn built on two cribs, Cades Cove, Tennessee.**

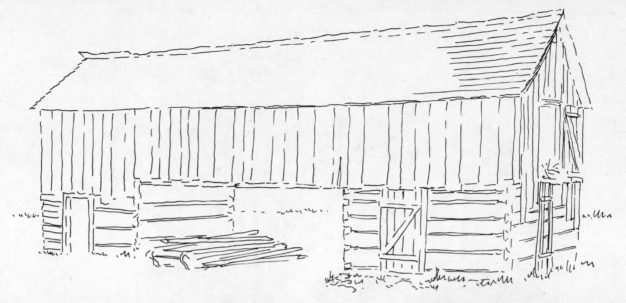

**Figure 10–33
Working drawing of the
barn.**

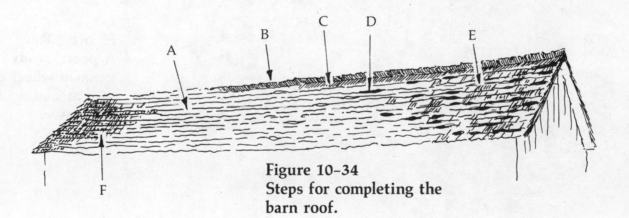

**Figure 10–34
Steps for completing the
barn roof.**

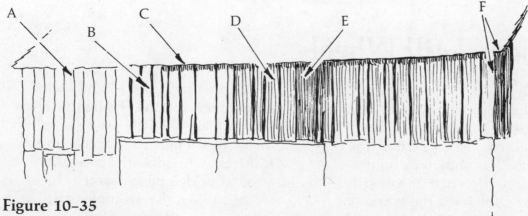

**Figure 10–35
Steps for completing the
side of the barn.**

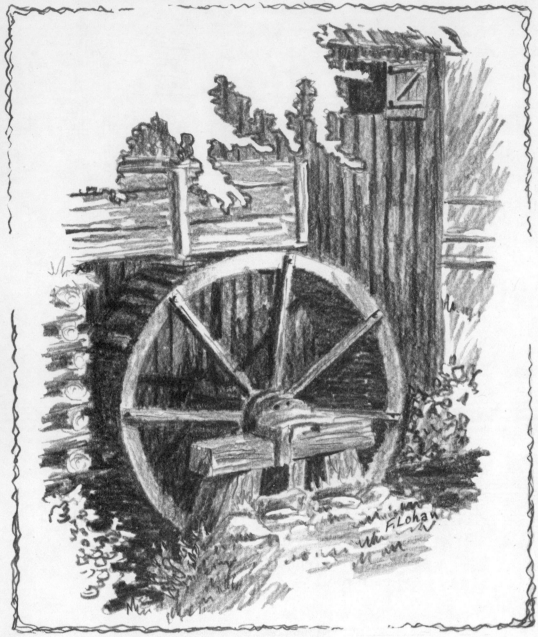

**Figure 10–36**
**A pencil study of the**
**wooden wheel on the**
**mill at Cades Cove,**
**Tennessee.**

# A Wooden Mill Wheel

The mill at Cades Cove uses a wooden mill wheel. The wheels on the other mills used as subjects in this book were all iron. My sketch of the Cades Cove Mill is shown in figure 10–36. I used a 4B pencil on smooth paper here and followed the working drawing of figure 10–37. I completed the darks first, then I lightly used the same pencil to tone the lighter areas. This is a simple little study in which I made no attempt to sharpen up the features as I had with the earlier covered bridge pencil sketch. I just wanted this to be a simple, soft impression of the wheel.

**Figure 10-37**
**The working drawing of**
**the mill at Cades Cove.**

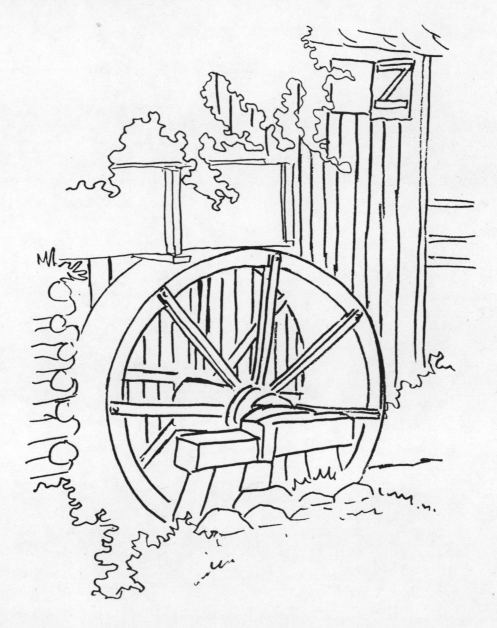

# 11
# Sketching the English Countryside

*Basic Structures*
*Sketching English Gardens*
*Sketching English Country Churches*
*Sketching Castles*
*Sketching Stone Circles*
*Sketching at Lee Bay*
*Sketching Thatched Roofs*

# Basic Structures

Anyone who has traveled beyond the major urban areas of England knows the variety of beauty that the English countryside contains. To Americans a pioneer cabin from the late eighteenth century is "old" and charming. In Britain, you can see countless stone works, obviously the work of man, that are said to have been constructed about 5,000 years ago. One such is the remains of the great stone circle at Avebury, which is sketched later in this chapter.

The English countryside contains a wealth of material for all artists, the problem being not that of finding suitable subject matter but rather selecting from the overwhelming choices available. This chapter contains a small selection of pencil as well as pen and ink sketches that cover some of the breadth of the subjects available in Great Britain. Many of these sketches are examples of the application of techniques described earlier in the basic chapters. Some of the sketches go beyond the techniques covered earlier, and for these I have included step-by-step instructions for what is new. In the case of the more complex subjects, I have included full-size working drawings so that you may practice the techniques yourself by doing essentially the same drawing that I did, and, what is often important when trying to learn particular techniques, doing the drawing the same size as I did.

As I stated many times in the early chapters, the artist's primary problem is often that of abstracting the essential elements of a complex and confusing scene to capture the essence of the subject and to ignore or repress much of the nonessential detail. If you are a beginning artist, this will seem to be a confusing thing to try to do. The following example will show you what I mean.

West of London is the old, pretty town of Abingdon. It lies in the Thames valley near Oxford where the Ock River joins the Thames. The view of Abingdon from the road along the Thames as you come around a curve in the river is dominated, as so many English town scenes are, by a church tower. There are many trees on both sides of the river, and there are many buildings clustered around the church and spreading out beyond and on both sides. It is truly a quaint scene. I used a photograph I had taken of this scene as the source for the sketch in figure 11-1. This is a very quick impression sketch of that scene. Of everything that the photograph presented, I felt the vertical church spire and the tall, vertical chimneys of the older buildings along the river immediately around the church were the essence that I wanted to capture in this study. So I simply ignored all the rest in the photo and further made the tree outlines as simple as I could to emphasize the triangular impression that you see in figure 11-1. This is what I mean when I talk about simplifying a subject. It involves a mental process of elimination.

The sketch of Abingdon is a very simple one; however, it is not just panorama that needs simplification when you choose a subject. Figure 11-2 shows a small part of the Hailes Abbey ruins in Gloucestershire, England. Here, I wanted to portray the interesting, jagged remnants of a once

**Figure 11–2
A pen study of
Hailes Abbey
ruins,
Gloucestershire,
England.**

**Figure 11–1
An impression of
Abingdon, on the Thames
River.**

**Figure 11-3**
**The working drawing for**
**the Hailes Abbey study.**

highly decorative stone window. My primary simplification here was to eliminate all the complex expanse of ruins that I could see through the window. The lower part of this sketch was used as an example of how to draw smooth stone earlier in figure 5-39. The Hailes Abbey sketch is also a very simple one. You can see this by comparing the working drawing of figure 11-3 with the completed study of figure 11-2. All that completion required was the addition of some lines to indicate the texture of the stone and the shadows that fell across half the archway. The next subject requires a somewhat different approach to simplification.

**Figure 11–4
The garden by a stone
house at Filkins, near
Oxford, England.**

# Sketching English Gardens

English gardens are often an orderly
but profuse arrangement of flowers
and shrubs. Such subject matter is
frequently incomprehensible to the
beginner who contemplates sketching
it. The simplification approach needed
here involves a reduction of the
overwhelming detail that the flowers

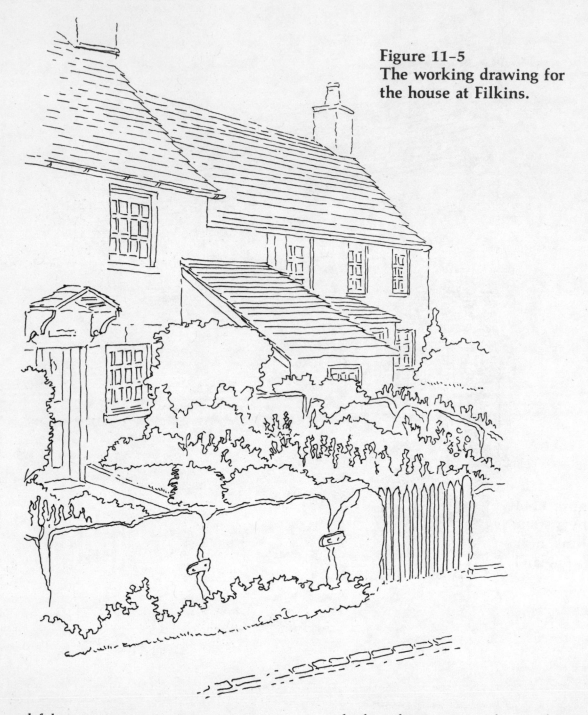

**Figure 11-5
The working drawing for
the house at Filkins.**

and foliage presents to view to a grouping of relatively few *masses*. This approach led to the sketch of figure 11-4, the garden in the front yard of a stone house at Filkens, near Oxford, England. There are only a dozen and a half individual *masses* of vegetation visible in this sketch. To verify this,

look at figure 11-5, the working drawing of the garden scene, and count them. Here I did not draw leaves and flowers, rather, I outlined the *masses* of vegetation to which I had simplified the luxuriant growth that my photograph showed.

The only way you can create visual

Figure 11-6
**The steps in completing the ink drawing of the garden at Filkins. (A) With a continuous line, darken and texture the lower part of each floral grouping so it silhouettes the light tops of the grouping in front of it. (B) Then put a few leaf marks in, leaving the tops as white paper. (C) Tone the shaded side of the light stone slabs.**

separation of sketch elements that have similar values (tones) is to somewhat distort those tones and alternate lights and darks. If you do not, everything becomes one solid, intermingled mass with no individual distinction. You can see in figure 11-4 how this principle allows each of the groups of flowers and shrubs to be distinctly evident. Figure 11-6 shows the steps I took to complete the vegetation part of the drawing and that allowed me to retain the visual distinction. After drawing the outlines as in the left half of figure 11-6, I used a continuous line squiggling around and over itself to darken the lower part of each mass and leaving a light silhouette of the mass immediately in front of it. This kind of line is useful to represent foliage as it suggests the myriad of individual florettes and leaves in a scene such as this. I often use this line also to represent tree foliage when drawing small sketches. When I had all the individual masses darkened as shown in

**Figure 11–7**
**A reduced reproduction of the garden and stone house at Filkins.**

figure 11–6A, I then made the foliage groups "rounder" by adding some tiny circles and leaf-like squiggles above the dark indications. This is seen in figure 11–6B. I was careful not to overdo this, however, because the round impression is achieved by graduating the value (tone) from dark at the bottom of each mass through medium in the middle to light at the top. The light tops also give the impression of sunlight striking the mass. Then, as shown in 11–6C, I shaded the stone slabs that fenced the garden by using slanted hatch marks. This choice of line was deliberate so that the toned stone slabs would look

different from the toned foliage masses and thereby not blend in with them.

The line work in figure 11–4 is all relatively open. By this, I mean that there are no places where the lines pack so closely together that they tend to form a solid black. Such open line work reduces rather well without losing its character. You can see this in figure 11–7, a reduced copy of figure 11–4.

In the remainder of this drawing, I utilized techniques covered earlier in this book. The stone in the buildings was light in color, so just a few of the stones were indicated by thin lines. The stone slabs forming the fence around

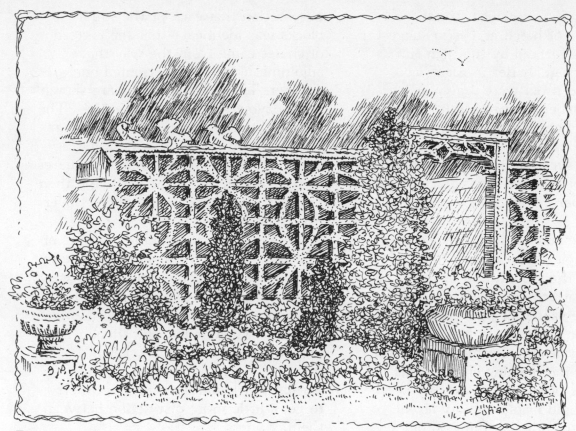

**Figure 11-8**
A pen and ink impression of Jims Garden in Abingdon, Berkshire,
England. The geometric pattern of the wall is the focal point of the sketch.

**Figure 11-9**
The layout sketch for
Jims Garden. Note that
there is only one pattern
for each square in the
wall, as you
see at (A).

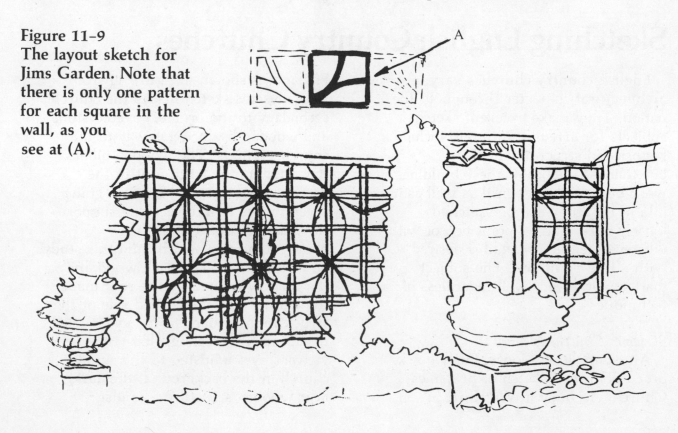

the garden were somewhat rough, so I used clusters of hatch marks to suggest the shadows formed by the high sun under the irregularities in each slab. The shingled roofs were drawn as described earlier. Be careful, however, to get some light pencil indications of the correct perspective lines before you start to ink such roofs. Nothing spoils the sketch of a house more quickly than improper perspective in the roofing.

Often, the simplification necessary to make a complex subject easy to sketch comes with the recognition of the geometric patterns involved in the subject. The sketch of Jims garden, in Abingdon, in figure 11-8 has as its focal point a beautiful cement wall with a pattern of interlocking circles. This wall is made of square blocks, so the first thing I did in making my layout sketch was to establish the grid of squares. Then I made use of my

observation that each of the square blocks was identical—that the pattern of circles came from the way that adjoining blocks were oriented one to another. These observations are shown in my layout sketch in figure 11-9. The little illustration at 11-9 A shows the one pattern used for all blocks. Using this, I drew the circles over the squares as you can see in figure 11-9, and then I drew the shrubbery and flowers over this.

The light, pencil working drawing of this garden scene took quite a while to do, but the inking was then rather easy to complete. Note that in figure 11-8 I used the same principle of alternating the values to complete the shrubbery as in the previous garden sketch. In this case, I also made some of the shrubs a little darker than the others to get a little more distinction between them.

# Sketching English Country Churches

English country churches vary in architectural character throughout the nation. They make excellent sketch subjects for artists wanting to include historic old structures in their portfolios. Sketches of these buildings work beautifully in pencil as well as in ink; in ink, they can be sketched loosely with a broad-point pen or with whatever degree of detail is desired with a fine-point pen. The subject matter works very well regardless of technique.

*St. James Church, Avebury*
    An example of a loose, fairly quick, broad point pen sketch of St. James Church, Avebury in Wiltshire,

England, is shown in figure 11-10. Actually, this sketch makes the church secondary to the ornate, covered stone and wooden beamed gateway to the church grounds. The wooden pillars that support the large roof of the gateway have curved members going several ways to intersect and support the massive roof. I took the photograph from which I did this study on a sunny day. The dark wood and the shadow created by the roof made the interior and the shaded side of the structure quite dark to the eye. I tried to capture this feeling, that with the viewer's eyes adjusted to the sunlit church in the background, the dark, near wooden structure was just

**Figure 11–10**
**A loose, quick pen study of St. James Church, Avebury, Wiltshire, England.**

"underexposed" to the eyes. Therefore, I did not show any of the details of the support members, even though they were closer to the viewer. This lack of detail and the perspective lines of the gate roof tend to pull the viewer's eyes to the church bell tower in the middle ground of the sketch. Note that the treatment of the foliage on the tree that lies between the gate and the church is as suggested earlier in Chapter 4, *Background, Composition, and Drawing Techniques*, figure 4–12.

*St. Materianas Church, Tintagel, Cornwall*

This building lies on the rugged, rocky, windswept north coast of the Cornwall peninsula, about seven or eight hours from London. It is near the ruins of Tintagel Castle, the reputed birthplace of King Arthur. A quick pencil study of St. Materianas Church is shown in figure 11–11. The pathway leading to the door passes among many gravestones and stone crypts. I hinted at these in the foreground of figure 11–11, but did not develop them in any

detail because I wanted the center of interest to be the church bell tower. Much detail in the foreground elements would tend to distract from the bell tower. This sketch was done on smooth paper with a broad-point HB pencil. The few sharp lines were done with a sharp HB pencil. The working drawing for this sketch is shown in figure 11–12.

Figure 11–12 was reduced using a grid overlay as described in Chapter 2, *Techniques*, around figure 2–19, to do the smaller pen sketch of the same subject in figure 11–13. I used my artist's fountain pen for this sketch. As I mentioned earlier, this pen has a somewhat broad point, even though it is called "extra fine." Note the I suggested the stone work of the church with short horizontal lines. It was impractical to draw individual stones at this scale with such a broad point.

Bolder pen work holds up very well when photographically reduced. You can see this in figure 11–14, which is a reduction of figure 11–13. Keep this in mind if you do sketches for use on note paper or postcards. Scale the size of your image area up, do the drawing large and with a bold, open approach to the line work, reduce it to the size you need for printing. You will be very pleased with the results.

**Figure 11–11**
**A quick pencil study of St. Materianas Church, Tintagel, Cornwall, England.**

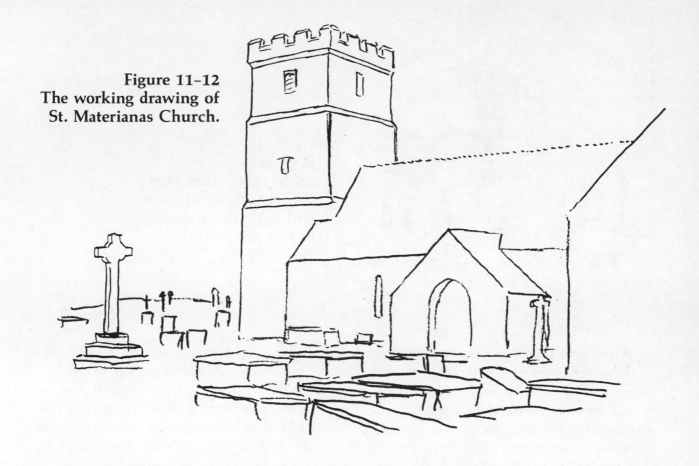

**Figure 11-12
The working drawing of
St. Materianas Church.**

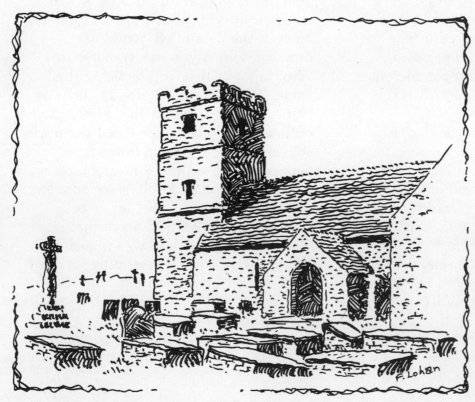

**Figure 11-13
A quick pen impression of
St. Materianas Church
using a bold point.**

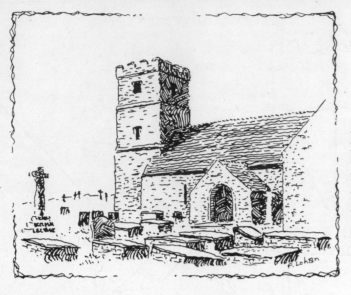

Figure 11–14
Bold, open pen work
reduces well. Compare
the line reproduction here
with a similar reduction
of fine pen work in
Figure 11–7.

When you try using figure 11–12 as a guide for practicing this subject, be sure that you use some very light pencil lines to indicate the correct perspective for the short lines that represent the stone work. Any drawing like this one, or any one showing a building, can be ruined if the perspective of the stone or brick work is incorrect. Make the lines light, however. They can be erased if you complete the drawing with pen and ink, but they cannot if you complete it in pencil.

*Monument in Woolsery Church,*
*Woolfardisworthy*

Not far from the tourist attraction of Clovelly, on the north coast of Devon, is the little village of Woolfardisworthy West. It is just a mile or two south of the main road along the North Devon coast. In addition to the Farmers Arms Pub (this is a sketch subject later in this chapter) there is a beautiful old church. Within the church I photographed a monument to Richard Cole. This photo was the basis for the sketch of the monument in figure 11–15. The photograph was taken in the dark interior of the church, the light came from a high window to the right of the monument. This gave some strong side lighting that made the intricate decorative work above the reclining figure easier to suggest. This kind of drawing requires a careful and accurate working drawing that locates most of the detail. My working drawing, which you can transfer to your paper to use for practicing this subject, is shown in figure 11–16. Notice in figure 11–15 that I only used outlines where I really needed them to suggest some of the undrawn decoration. I used the tone as much as possible to define the shape of adjacent features. I also used the device of eliminating all detail in areas that I wanted to appear brightly lit, such as the upper part of the reclining figure. I used my 3×0 technical pen for this drawing.

I have mentioned several times in other places in this book how open pen work reduces well. Several reductions

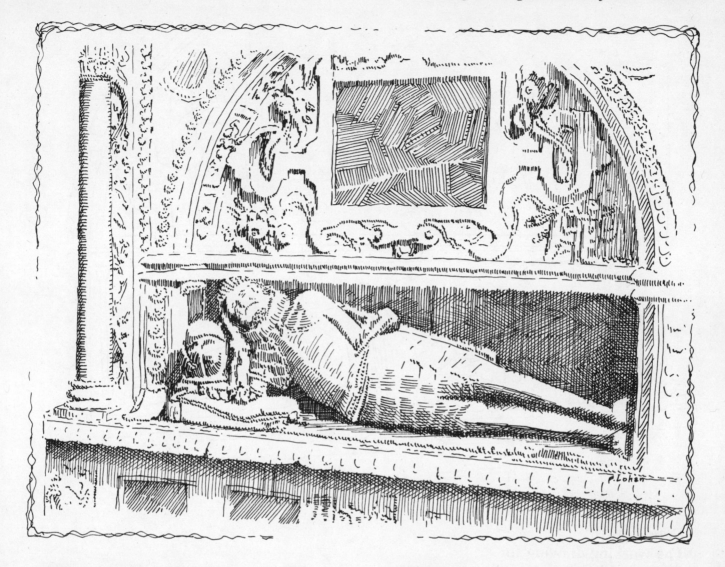

**Figure 11-15**
**An ink sketch of the 17th century monument to Richard Cole in Woolsery Church, Woolfardisworthy West, North Devon, England.**

of bold line work were shown as examples. The drawing of the monument was done in an open manner even though it was with a very fine pen point. This kind of work also reduces well, as you can see in figures 11–17 and 11–18. The latter is carried a bit too far as some of the lines have disappeared, but I felt that an example would show you the extent to which you can reduce pen work.

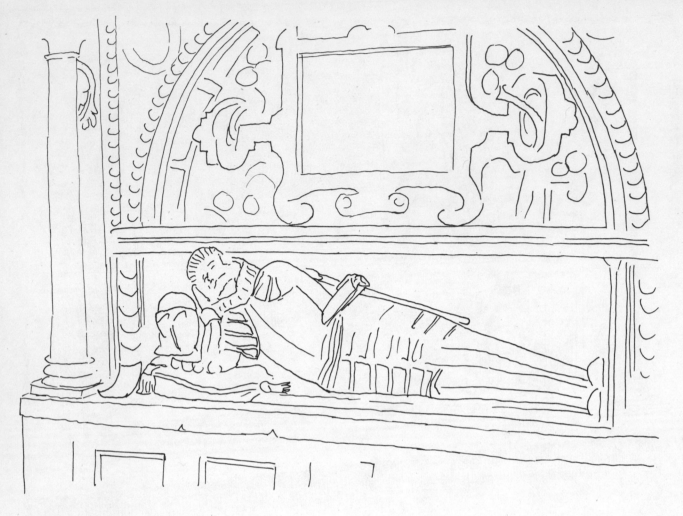

**Figure 11-16**
**The working drawing for**
**the Richard Cole**
**Monument sketch.**

**Figure 11-18**
**Open pen work can**
**tolerate great reduction**
**before the line work**
**begins to deteriorate.**
**This reduction of the**
**Richard Cole Monument**
**sketch is at or perhaps**
**beyond the limit, as some**
**of the lines have**
**disappeared and others**
**have run together.**
**Compare this with**
**figures 11-17 and 11-15.**

**Figure 11-17**
**This is a moderate reduction of the Richard Cole Monument sketch. The open line work of the original holds up well under reduction.**

*Church at Eastleach Turville*

The village of Eastleach Turville lies near the southern part of the Cotswold district west of Oxford. The pretty little church with its (typical) adjacent graveyard is sketched with a bold pen in figure 11-19. The working drawing, for your use in practicing this subject, is shown in figure 11-20. This sketch was large enough, even though I used a bold pen point to draw it, that I could draw little rectangles to indicate some of the stones in the church walls. Earlier in this chapter, in figure 11-13, I did not use rectangles, but just lines to indicate the stones. Notice that in this somewhat stylized technique, the gravestones in the shadow at the back of the church, to the right, are simple white spots against the dark shadow. A bold pen drawing like this requires the elimination of even more detail than would normally be the case if a fine

point were being used. You have to learn by a lot of practice how to suggest certain features by using a bare minimum of line.

Figure 11-21 shows you a photo reduction of the full-size drawing. It would be an interesting practice exercise for you to reduce the working drawing of figure 11-20 to this size then complete it with a fine-point pen and compare your result with figure 11-21.

Pencil on abrasive tracing vellum produces a bold, interesting result. I reduced the working drawing of the Eastleach Turville church and placed a sheet of tracing vellum over it. Then I did the drawing of figure 11-22 directly on the tracing vellum with no need to transfer my working drawing, since I could see clearly through the vellum to the outline beneath it. I used

**Figure 11–19**
**A stone church at Eastleach–Turville in the Cotswold District of England.**

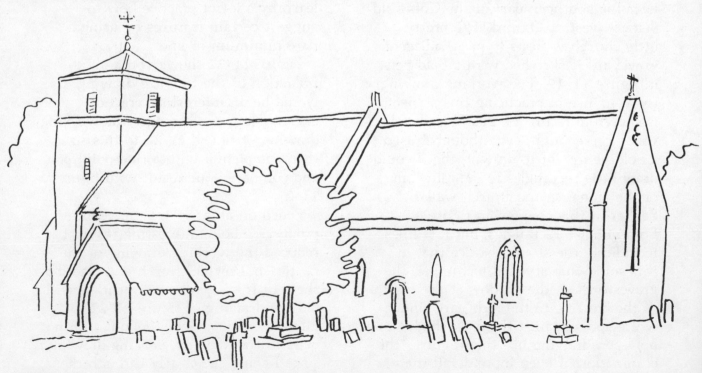

**Figure 11–20**
**The working drawing for the church at Eastleach–Turville.**

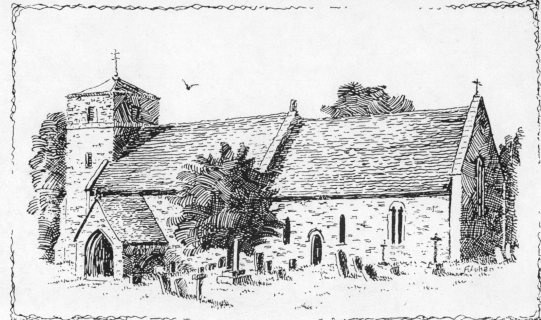

Figure 11-21
A reduced
reproduction of the
church at Eastleach–
Turville showing how
well the bold pen lines
reproduce when
reduced.

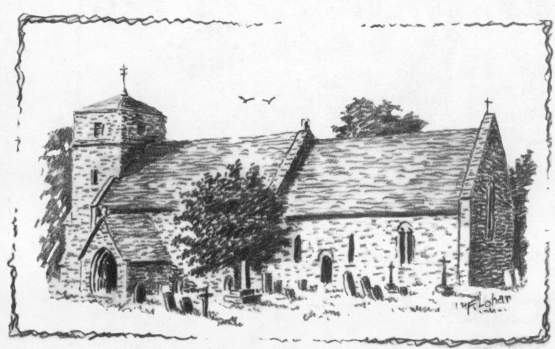

Figure 11-22
A pencil study of the
church at Eastleach–
Turville.

a sharp HB pencil (actually, a mechanical pencil with 0.5 millimeter lead) to draw figure 11–22. This is a great way to do tone compositions to try out different lighting before you start a larger drawing. Notice that I indicated the shaded parts of the church with little, broad strokes of the pencil packed closely together to indicate stones. I did this instead of just using random lines as I did in the pen version of figure 11–19.

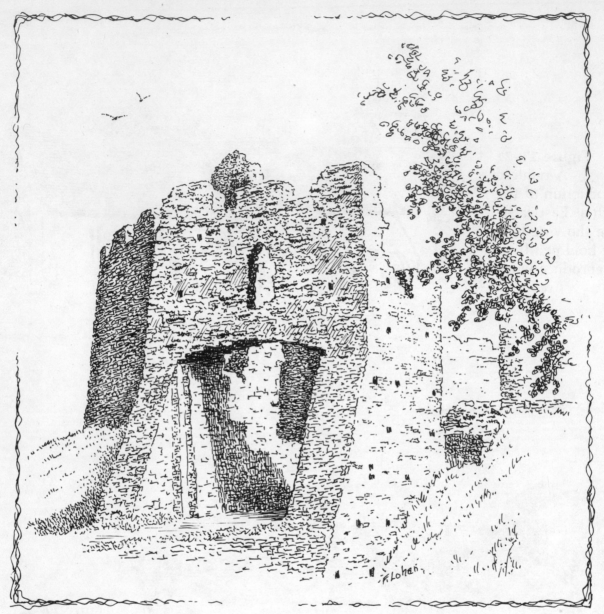

**Figure 11–23**
**A pen and ink study of Restormel Castle, near Lostwithiel, Cornwall, England.**

# Sketching Castles

Almost all castles and castle ruins in England are stone. Some of the techniques for rendering stone that were covered earlier in Chapter 5, *Drawing Rocks and Stone Walls,* apply to this subject, but frequently your point of view will include so much of the structure that you will not be able to do much about drawing individual stones. This was the case with the previous subjects under the heading of churches. The challenge is to suggest the stone work by the judicious use of short lines that carry the proper perspective and indicate that there are horizontal rows of stones making up the walls. This was the case in figure 11–13.

*Restormel Castle*

Just outside the Cornish town of Lostwithiel stands the ruin of a small, round castle called Restormel. The castle is in the center of a beautifully kept park, an enormous grassy area on a hilltop that overlooks miles of the countryside. Figure 11-23 is a technical pen sketch of the entrance of the castle. The working drawing was simple, just as you see in figure 11-24. I used very light lines in addition to those you see to give me the proper perspective for the courses of stone in the walls. What I did was similar to what you see in figure 8-4.

In this sketch of Restormel Castle I used the device of showing more of the stone work when I wanted to darken the tone to show shaded portions of the walls. The alternative was to use hatching instead as in figure 11-13. To indicate sunlit parts I just showed less of the stonework.

This sketch reduced nicely also, as you see in figure 11-25.

A pencil study of the reduced-size working drawing can be seen in figure 11-26. This study was done on the rough finish tracing vellum that I mentioned earlier. I used a 0.5 millimeter mechanical pencil with HB lead and worked by placing the tracing vellum directly over the working drawing and doing the pencil work directly with no intermediate transferring of the outline. Just as with the ink version, I simply showed more of the stonework where I wanted to darken the values to show shaded walls. This use of tracing vellum allows you to quickly try different value schemes without the bother of redoing the basic outlines for each. Drawings on tracing vellum do not have to be

**Figure 11-24
The working drawing
of Restormel Castle.**

**Figure 11–25**
**This kind of open pen**
**and ink line reduces well.**
**Compare this with the**
**full size drawing of**
**Figure 11–23.**

**Figure 11–26**
**A pencil study of**
**Restormel Castle.**

just "preliminary" either. They can be backed up with white paper and matted and framed just as any drawing on opaque paper can.

### Bodiam Castle

South of London, in Sussex, is one of the prettiest castles in England— Bodiam Castle. It lies in the center of a moat that is more like a pond or small lake. Bodiam is constructed from large, smooth stones, so its texture is quite different from that of the churches and the previous castle that were just covered. In these cases the stones were all small with rough surfaces.

Figure 11-27 shows you one way of sketching such smooth stone. It is basically an outline approach, with a fine-point pen, that indicates some of the narrow cracks between the massive stones. This sketch is essentially a two-tone study—there are just the sunlit walls and those that are shaded. There is nothing wrong with a simple approach like this to record an interesting structure that you saw while traveling. Not all of your drawings have to be fully detailed studies.

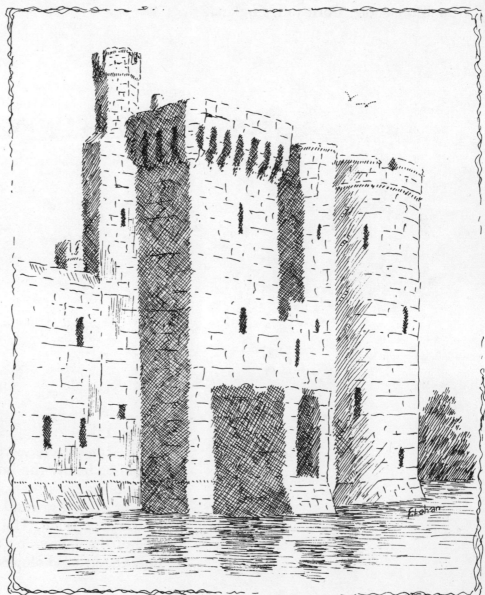

**Figure 11-27 An ink study of Bodiam Castle, Sussex, England. This is a simple two-tone study.**

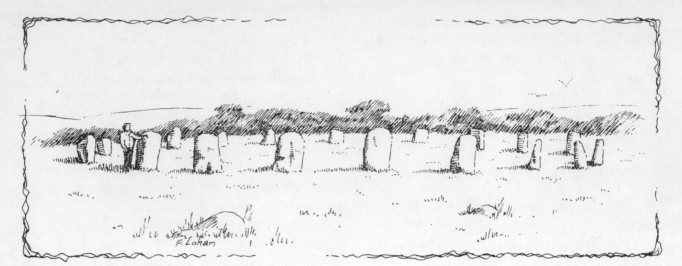

**Figure 11-28**
**The Merry Maidens prehistoric stone circle**
**near Mousehole, Cornwall, England.**

**Figure 11-29**
**If the stone circle were in a depression, all**
**would be below the horizon and the**
**clusters of grass marks would contour both**
**the horizontal ground and the sloping sides**
**of the depression. The shadow at the right**
**side of the depression also serves to indicate**
**how the ground slopes.**

# Sketching Stone Circles

There are many prehistoric stone circles throughout Great Britain. It is fascinating to walk among the stones and realize that thousands of years ago people were also walking there and touching the same surfaces.

## The Merry Maidens of Mousehole

The stone circle called The Merry Maidens, located west of Mousehole on the southern Cornish coast near Land's End was the subject in the backgrounds section. See figures 4-23 to 4-25. Here in figure 11-28, I drew the complete circle of all nineteen stones. These are small stones compared to those used in many of the other circles. The human figure included in the sketch gives you an idea of the size of the stones. When you draw something like this, where there is no reference for the viewer to determine the size of objects, you should include a figure or some familiar item that will establish the scale. This study was done with my 3×0 technical pen.

A subject like this requires some perspective preparation so that the foreshortening will be proper. I actually made a layout as you see in figure 11-30, with the perspective ellipse as the base for the stones. Then I drew the stones around the perimeter of this ellipse, using the horizon as a guide for their height. You can see from the figure included for size that the tops were all below eye level. This meant, as you will recall from the chapter on perspective, that the tops of all the stones must be slightly below the horizon line. This made it easy to locate each stone and get its height correct. The ground was level—I indicated this fact to the viewer by showing the clumps of grass marks all running horizontally. The grass marks are always used to indicate the slope of the ground.

If these stones had been arranged in a depression in the ground, they would all have been below eye level. Figure 11-29 shows what the study would then look like. Three things tell the viewer that all is below ground level: the stones are all below the horizon, the clumps of grass marks show the slope of the depression, and the shaded right-hand side of the depression also helps to show its configuration. Figure 11-31 shows the layout for this study, with the double arrows indicating how the clumps of grass marks are used to show the ground configuration. Notice also that the ellipses that define the circle are opened up since they are farther below eye level.

## The Great Stone Circle at Avebury

The village of Avebury in the Wiltshire countryside lies partly within a large stone circle complex, parts of which are said to date from five thousand years ago. Many of the 180 original stones have been removed through the centuries and used for construction purposes in the area. The ones that remain testify to the huge size of those that were taken away. I took several photographs at Avebury and used one that showed the great size of the stones and also showed part of the village that now lies within the ancient circle for the sketch in figure 11-32. This is a pencil sketch on vellum tracing paper on which I used both broad-point and sharp-point HB pencils. The sketch was done directly

Horizon

**Figure 11-30**
**These are the perspective considerations for sketching the stone circle on level ground. The grass marks should all be horizontally grouped as the double arrows show.**

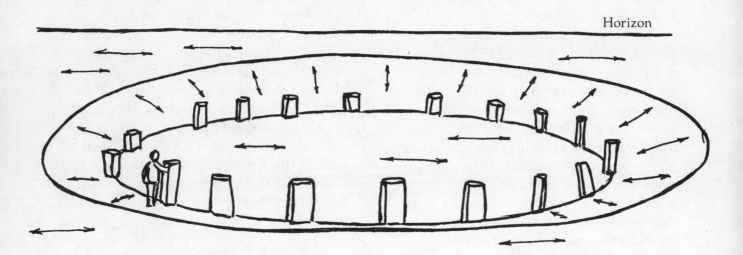

Horizon

A

B

**Figure 11-31**
**If the stone circle were in a depression, these would be the perspective considerations. The grass marks would contour the depression as shown by the double arrows and at B. On level ground the grass marks would be horizontal as at A.**

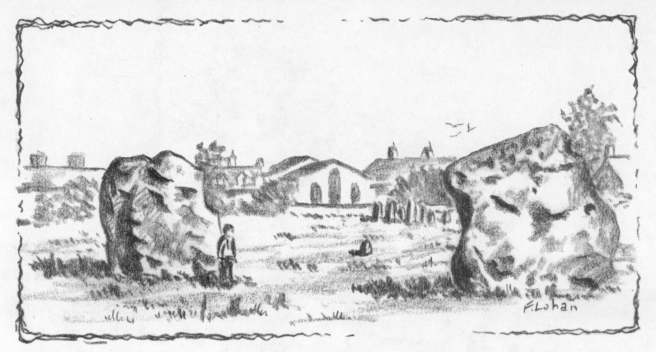

**Figure 11–32**
**A pencil study of some of the great stones still remaining at Avebury, Wiltshire, England. This was drawn on tracing vellum.**

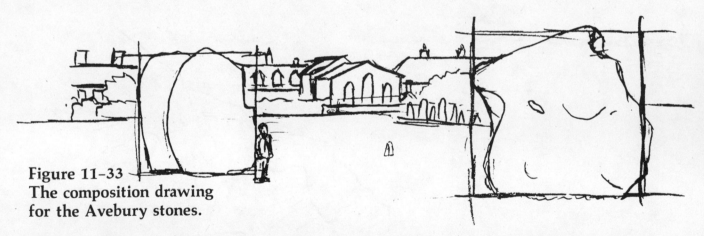

**Figure 11–33**
**The composition drawing for the Avebury stones.**

on the vellum when it was placed over the composition sketch shown in figure 11–33. When I finished this sketch, I took my kneaded eraser and pressed it on the background trees and buildings where they came up to the stones. I lightened these background elements by doing this to gain a little aerial perspective (the farther away an object is, the lighter it seems) and to thereby give a little more prominence to the two foreground stones.

The composition of figure 11–32 is relatively simple. I had to observe that the two stones I wanted to include in the sketch were each proportioned as squares with the spacing between about one and a quarter times the width of the near stone. Placing the two squares as you see in figure 11–33 then allowed me to properly place the remaining few elements relative to the stones in my photograph.

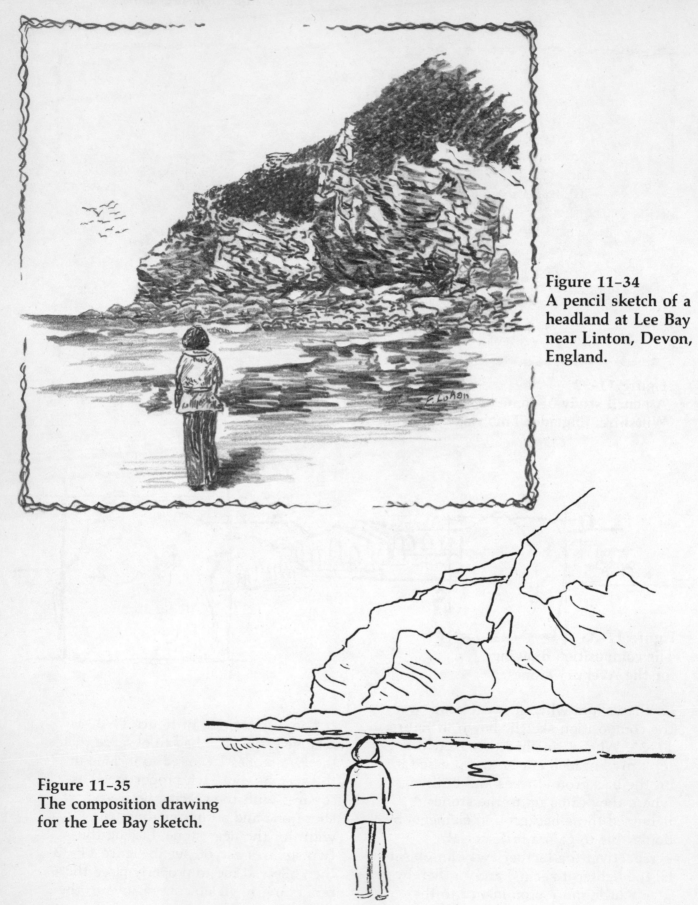

**Figure 11–34**
**A pencil sketch of a**
**headland at Lee Bay**
**near Linton, Devon,**
**England.**

**Figure 11–35**
**The composition drawing**
**for the Lee Bay sketch.**

# Sketching at Lee Bay

Much of the north coast of Devon is rugged and rocky. At Lee Bay, a few miles west of Linton in North Devon, the low tide exposes a vast beach that allows some interesting views of the rocky headlands that border it on the east and west. Figure 11–34 is a pencil sketch of the view seen more than a quarter mile seaward from the high tide shoreline. This sketch was done with sharp 3B and HB pencils on rough paper. In the working drawing, seen in figure 11–35, I established the shape of the headland and indicated where the rocky face was visible and where the vegetation covered the rocky surfaces. I drew the vegetation as you see in figure 11–36. At 11–36A, I used the sharp 3B point to make little dots with white paper between them. Then, as at 11–36B, I went over these dots with a slightly broadened HB point to darken the remaining white paper but not completely remove the dots. This then gave me a texture that suggested the foliage I could see.

Drawing the rocks required a good deal of simplification of what I could actually see. I squinted at the photograph to eliminate some of the visible detail and to determine how the primary dark lines of the cracks in the rocks ran. Then I drew just these cracks, about as you see in figure 11–37A. Then, to get some visual separation between successively receding cliffs, I darkened alternate ones as you see in 11–37B.

The human figure was added to provide more interest in the setting by looking at the headland. This simple device tends to direct the viewer's attention toward what the sketched figure is looking at.

The dark patches between the figure and the headland represent the very wet sand reflecting the dark rocky cliffs. The rest of the sand was not as wet and appeared lighter in color.

**Figure 11–36
Steps in finishing the vegetation on the Lee Bay headland sketch.**

A

B

**Figure 11–37
Steps in rendering the rocky part of the Lee Bay headland sketch.**

A

B

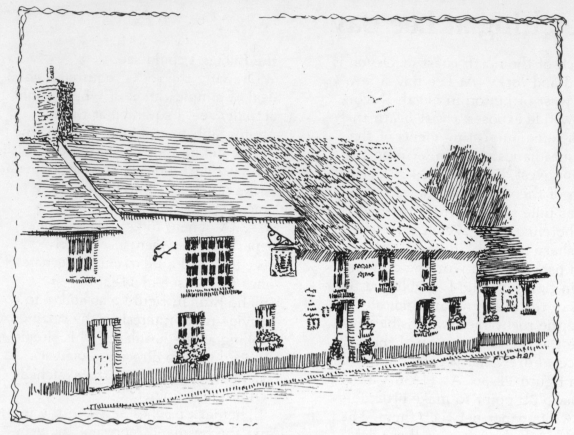

**Figure 11-38**
**The Farmers Arms, Woolfardisworthy West, North Devon, England.**

# Sketching Thatched Roofs

One cannot admire the quaint British countryside without admiring dozens of thatched roofs. They are simple to sketch in either pen or pencil. All that is required to indicate the thatch is layered lines following the slope of the roof.

A pen and ink example of a thatched roof is seen in figure 11–38, a sketch of the Farmers Arms Inn and Pub at Woolfardisworthy West in North Devon. The buildings are painted white and, at the scale drawn here, show no features of bricks or stone. The doorways and windows were all slightly recessed into the walls, so I just indicated this with the lines of hatching that suggested the shadows cast because of the recesses.

A thatched cottage in the hills of Bossington, in Somerset, is shown in the pencil sketch of figure 11–39. This too was a white building, and was surrounded by beautiful stone walls and shrubbery. The shrubbery was drawn as you can see in figure 11–40. This is the same technique as in figure 11–36, but this time a mechanical pencil with 0.5 millimeter lead was used on rough paper. The round chimneys were an interesting feature of this cottage.

The Barley Mow in Clifton Hampden near Abingdon in Berkshire

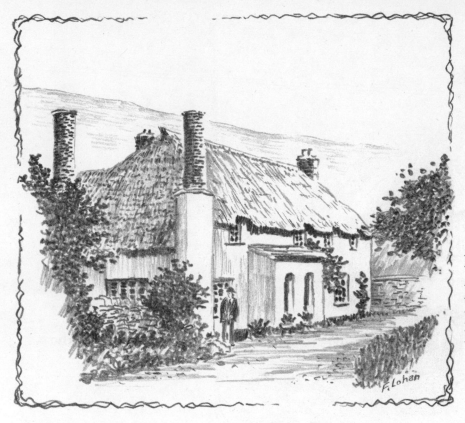

**Figure 11-39**
**A pencil study of a thatched roof cottage in Bossington, Somerset, England.**

A

B

**Figure 11-40**
**Steps in completing the foliage in the pencil study of the thatched roof cottage. (A) Dots with a slightly dulled sharp point. (B) Toning over the dots with a broader point pencil.**

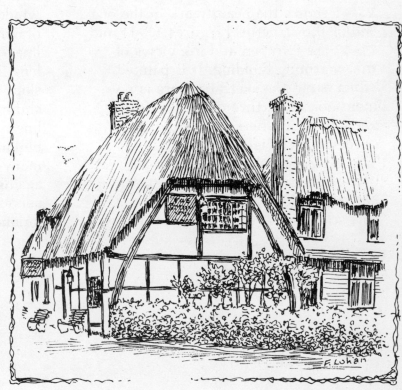

**Figure 11-41**
**A pen study of the Barley Mow, an inn in Clifton Hampden, Abingdon, Berkshire, England.**

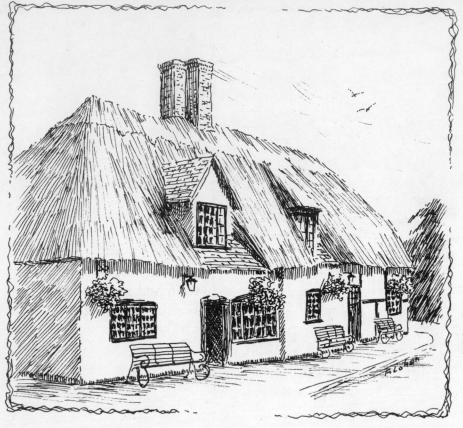

**Figure 11-42
Another study of the
Barley Mow.**

is a uniquely constructed inn. Figure 11-41 shows the beam work in the one end of the structure. Figures 11-41 and 11-42 are two pen and ink views of this charming building. It is painted white, so in the sketches there is no indication of texture or color in the walls, except where they are in the shade as at the left in figure 11-42. These two sketches were done with a 3×0 technical pen on smooth paper. Not much detail is actually drawn at this scale, but a lot is hinted at. Many little panes of glass are evident in each window even though each pane is drawn with just two or three vertical lines. The thatch is suggested by the long, loose hatch marks that follow the slope of the roof. The bricks in the chimneys are suggested by a few short lines. The essential shape of the building, the dark beams and the dark, many-paned windows contrasted against the white walls are the necessary features to document this unique building.

# 12
# A Parting Word

The subject of sketching is endless, since there is as much variety in the techniques one can apply as there are people sketching. There is no one way to draw anything; each of our drawings will be as personalized as our signatures. However, just as we all had to learn to write our names by having someone say ". . . do it this way," learning to draw can be made easier by practicing the techniques that others have learned. Then, later when they feel more natural to you, these techniques can be used in doing your own original work. When you reach the stage where you are working from your own original subject matter, your

personal approach will begin to develop. I hope that some of the suggestions in this book, along with the illustrations of how I approach the creation of certain effects in black and white, help get you further on the road to your own artistic individuality.

If you use your travels to take photographs and accumulate other subject matter for sketching, you will find that the thrills of the discoveries made as you travel are multiplied because you relive them when you use your photographs as sketching reference material.

Good luck with your countryside sketching!

# Other Books by Frank Lohan

*Pen and Ink Techniques*, Contemporary Books, Inc., Chicago, 1978, 93 pages.

A pen and ink sketching book for the beginner, it describes the materials required and gives ten basic step-by-step demonstrations as well as reference sketches covering a wide variety of subjects.

*Pen and Ink Themes*, Contemporary Books, Inc., Chicago, 1981, 106 pages.

This is a sketch-filled idea book that shows artists how to look around themselves to find sources of subject matter to sketch.

*Pen and Ink Sketching Step By Step*, Contemporary Books, Inc., Chicago, 1983, 130 pages, indexed.

Thirty-six step-by-step pen and ink demonstrations are included in this book. The subject matter covers barns, owls, raccoons, mountain lions, deer, ducks, songbirds, toads, stone lanterns, boats, and more.

*Wildlife Sketching*, Contemporary Books, Inc., Chicago, 1986, 240 pages, indexed.

Chapters on materials, drawing techniques, and basics of perspective introduce this book on how to sketch songbirds, trees, animals, flowers, mushrooms, water birds, reptiles, amphibians, and more. More than 600 individual drawings are included to show the artist how to draw each subject in pencil and in pen.

# Bibliography

Guptil, Arthur L. *Pencil Drawing: Step By Step*. New York: Watson–Guptil, 1949.

———. *Rendering In Pen and Ink*. Edited by Susan E. Meyer. New York: Watson–Guptil, 1976.

Lohan, Frank. *Pen and Ink Techniques*. Chicago: Contemporary Books, 1978.

———. *Pen and Ink Themes*. Chicago: Contemporary Books, 1981.

———. *Pen and Ink Sketching Step by Step*. Chicago: Contemporary Books, 1983.

———. *Wildlife Sketching*. Chicago: Contemporary Books, 1986.

Norling, Ernest. *Perspective Drawing*. Tustin, Calif.: Walter Foster Art Books.

Pitz, Henry C. *Ink Drawing Techniques*. New York: Watson–Guptil, 1957.

———. *Pen, Brush, and Ink*. New York: Watson–Guptil, 1949.

Sloane, Eric. *An Age of Barns*. New York: Funk & Wagnalls, 1967.

Watson, Ernest W. *Outdoor Sketching*. New York: Watson-Guptil, 1946.

# Index

257